20 WAYS TO DRAW
EVERYTHING

WITH **135** NATURE THEMES
FROM CATS AND TIGERS TO TULIPS AND TREES

LISA CONGDON + JULIA KUO + ELOISE RENOUF

A Sketchbook for Artists, Designers, and Doodlers

QUARRY

Quarto is the authority on a wide range of topics.

Quarto educates, entertains and enriches the lives of our readers—enthusiasts and lovers of hands-on living.

www.QuartoKnows.com

First published in the United States of America in 2016 by
Quarry Books, an imprint of
Quarto Publishing Group USA Inc.
100 Cummings Center
Suite 406-L
Beverly, Massachusetts 01915-6101
Telephone: (978) 282-9590
Fax: (978) 283-2742
QuartoKnows.com
Visit our blogs at QuartoKnows.com

10 9 8 7 6 5 4 3 2

ISBN: 9781631592676

This content first appeared in *20 Ways to Draw a Cat* by Julia Kuo, *20 Ways to Draw a Tree* by Eloise Renouf, and *20 Ways to Draw a Tulip* by Lisa Congdon (all Quarto Publishing Group USA Inc., 2013).

Design: Debbie Berne

Printed in China

MIX
Paper from
responsible sources
FSC® C016973

CONTENTS

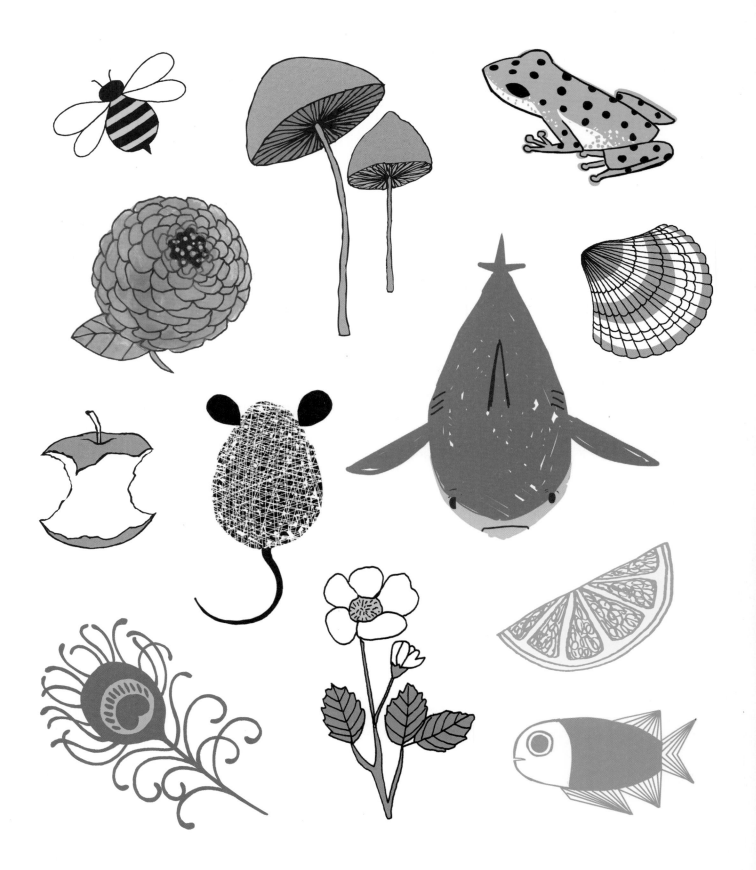

INTRODUCTION

Let's learn how to draw EVERYTHING together! There are few things more fascinating and beautiful on earth than animals, flowers, plants, and trees. They come in all shapes and forms—from tiny birds to gigantic elephants, elegant tulips to wild orchids, geometric snowflakes to patterned pinecones.

Like most things in nature, these subjects have both organic and geometric qualities, as well as naturally balanced compositions. Learning techniques to render them can be a really enjoyable, inspiring experience.

This book is divided into three sections with 45 themes in each, though you will see that there is some overlap. Each of those themes features 20 examples of ways you might draw it. All in all, there are 2,700 images in this book to inspire you!

Even something as simple as a leaf comes in so many varieties that it's impossible to draw just one kind. At first glance, a collection of maple leaves might look very similar, but if you look closely, you will notice that each one has individual features, different angles, and unique veins.

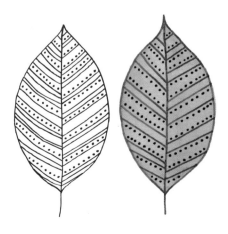

HOW TO USE THIS BOOK

No matter what you decide to draw first, you will soon realize that each item presented is made up of a combination of lines, shapes, and patterns. To begin, look for squares, circles, straight lines, and squiggly lines to help break down the pictures, then try copying different drawings using those simple elements.

Draw the big shapes and lines first, then add in the smaller details. If you have tracing paper, you can trace the drawings directly—and don't worry about getting them exactly the same. Then, when you think you have gotten the hang of it, try drawing your own!

When examining a drawing of a flower, you might ask yourself: How many lines and circles do I see? You might break down the elements: What shape are the petals? Is the flower symmetrical? How can I render the interior stamen? Do I want the stem to appear straight or crooked? Are the leaves perfectly uniform or slightly askew? There are so many quirks in nature, and including those quirks will make your drawings much more interesting!

Start out with a pencil and eraser so that you're not afraid of making mistakes. When you feel more comfortable with drawing, explore different types of tools—pens, colored pencils, markers, paints. Color in the existing drawings and then your own. If you are feeling especially adventurous, you can cut out paper shapes and paste them on the blank pages. It's always fun to try as many things as possible to decide what you like the best.

See how many different pictures you can come up with of your favorite plants and animals. How many ways can you draw a turtle shell? You can make it a circle, square, or irregular shape. Think about what you can draw inside the shell. You can fill it with stripes, little spots, big spots, squares of different sizes, or just a solid color. You can also decide to draw nothing inside the shell if you think it looks best that way!

Don't forget to show your friends and family when you're done. Or even better, ask them if they want to draw their favorite EVERYTHINGS too!

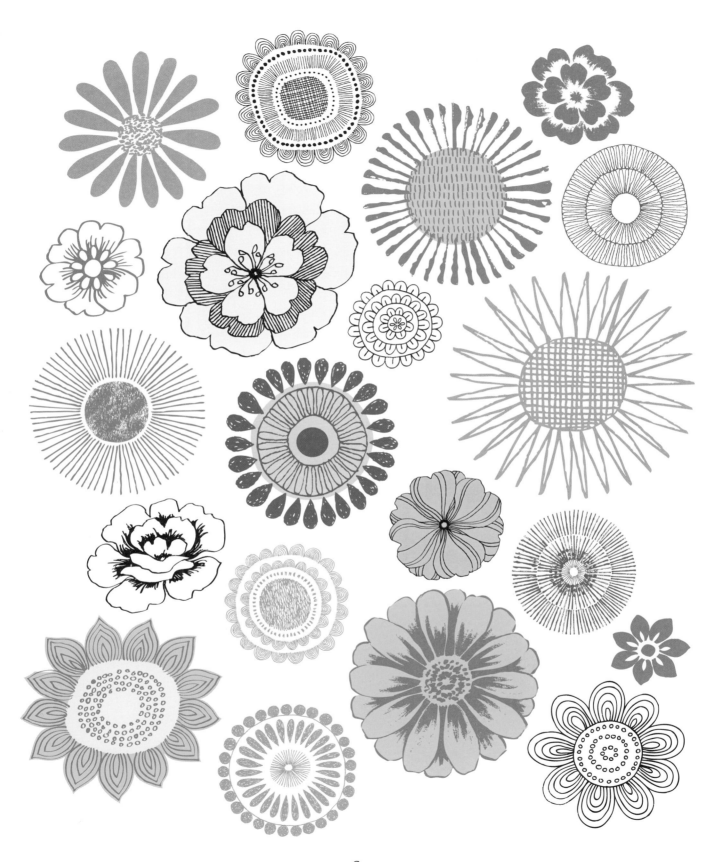

SECTION 1
ANIMALS
Illustrations by Julia Kuo

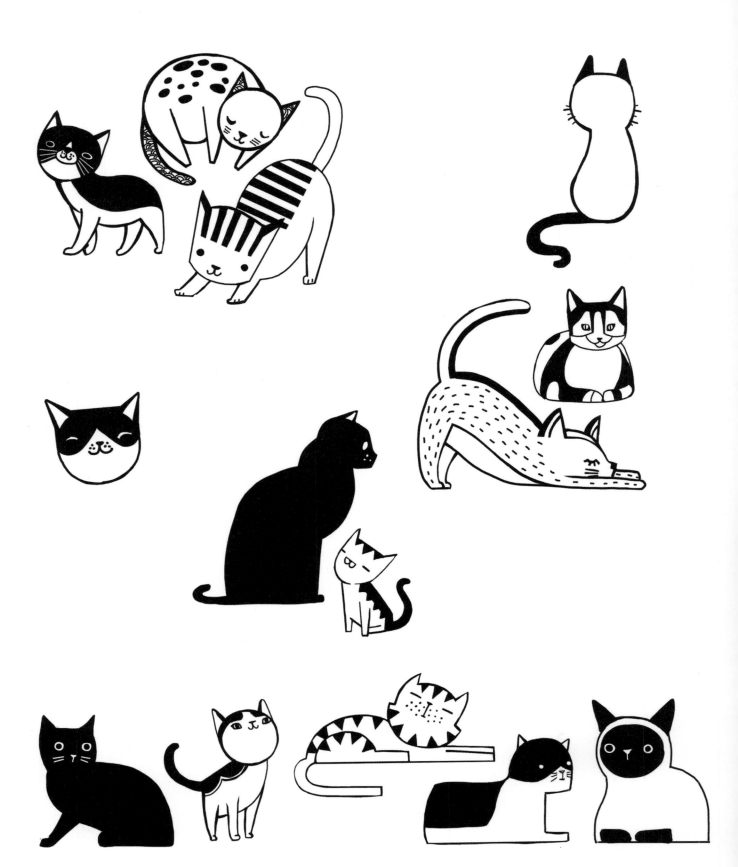

DRAW 20
cats

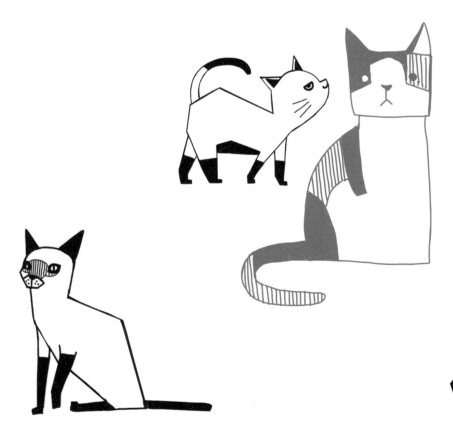

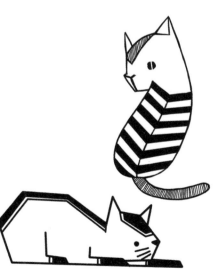

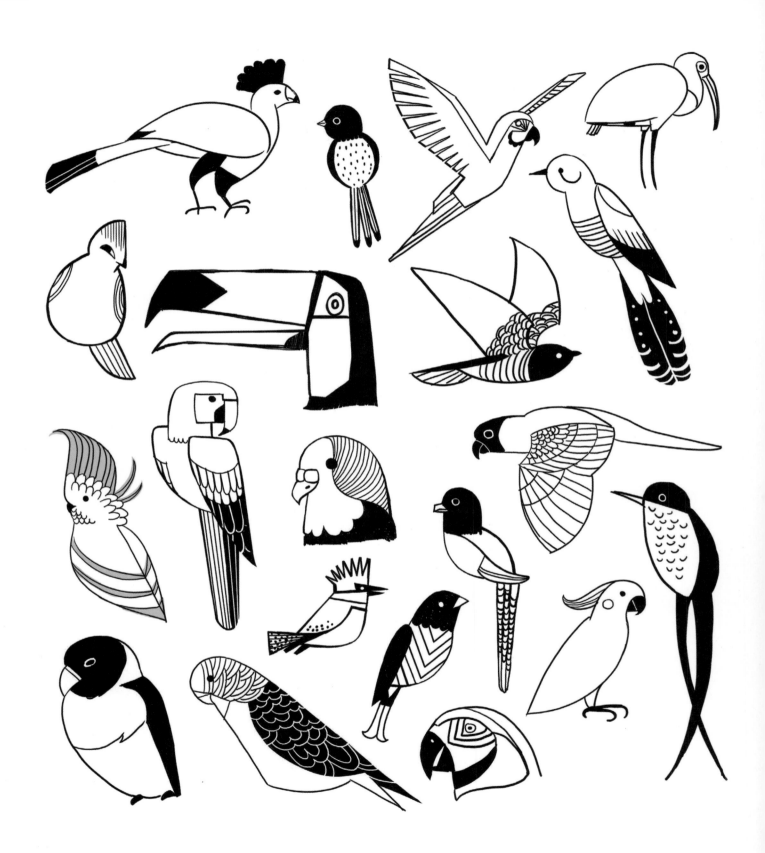

DRAW 20
TROPICAL BIRDS

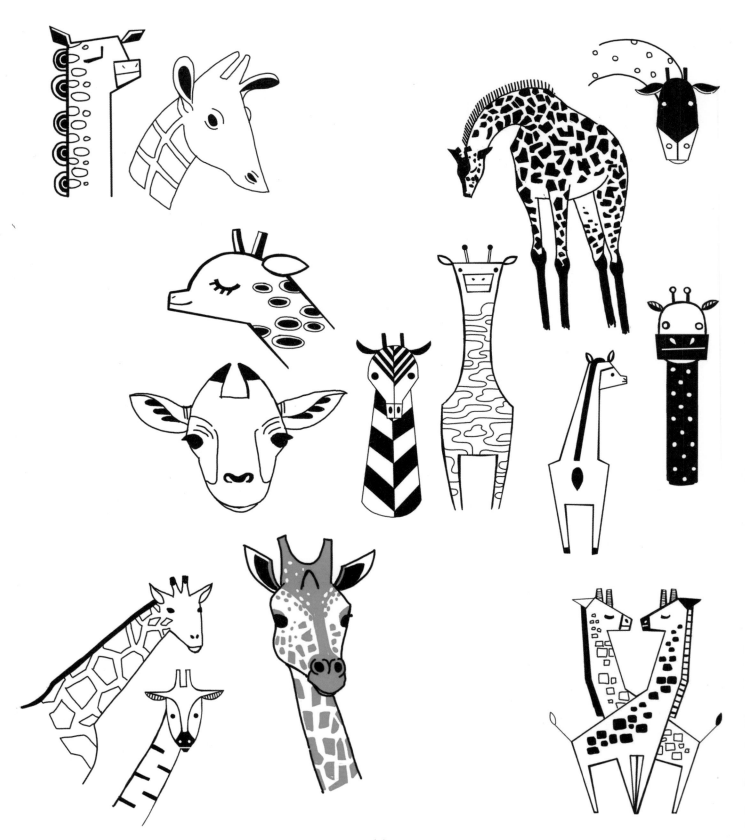

DRAW 20
Giraffes

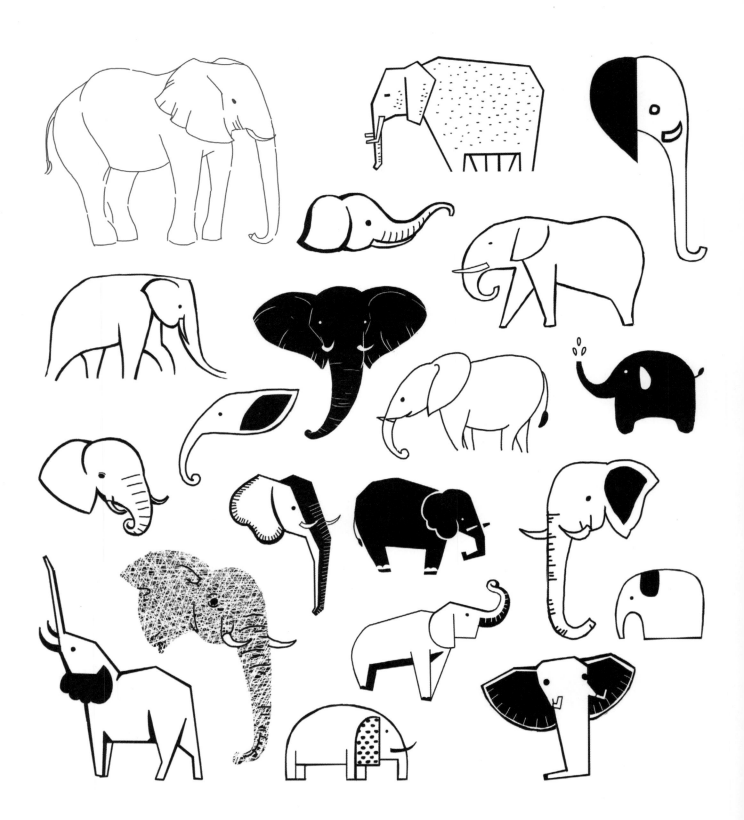

DRAW 20

elephants

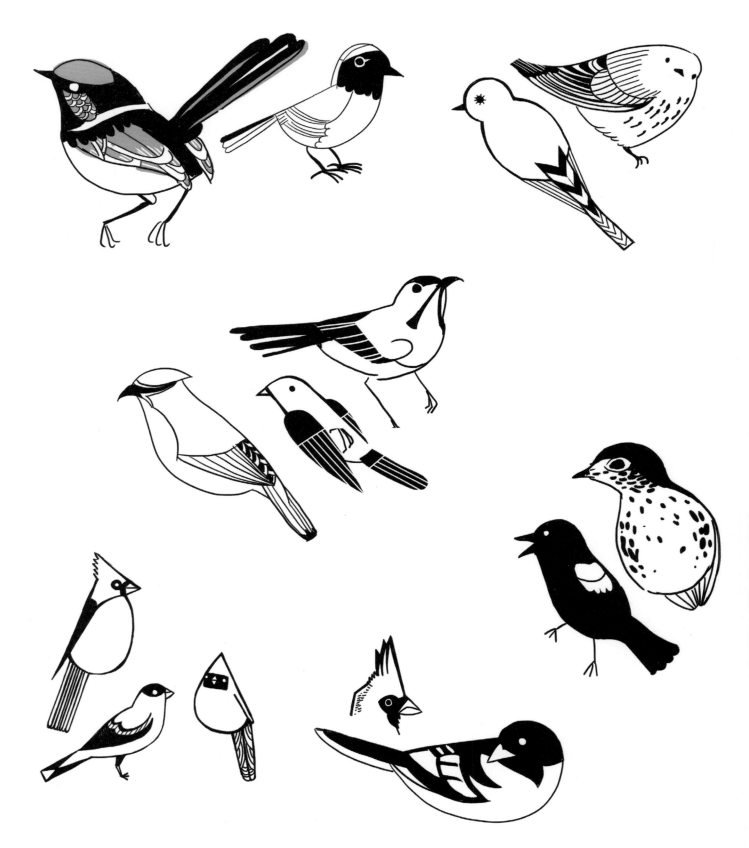

DRAW 20
Songbirds

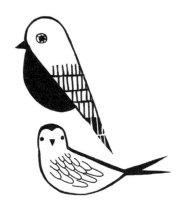

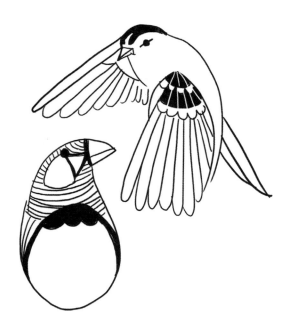

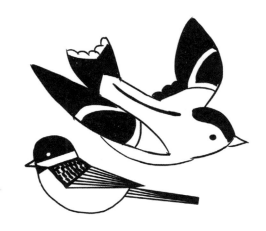

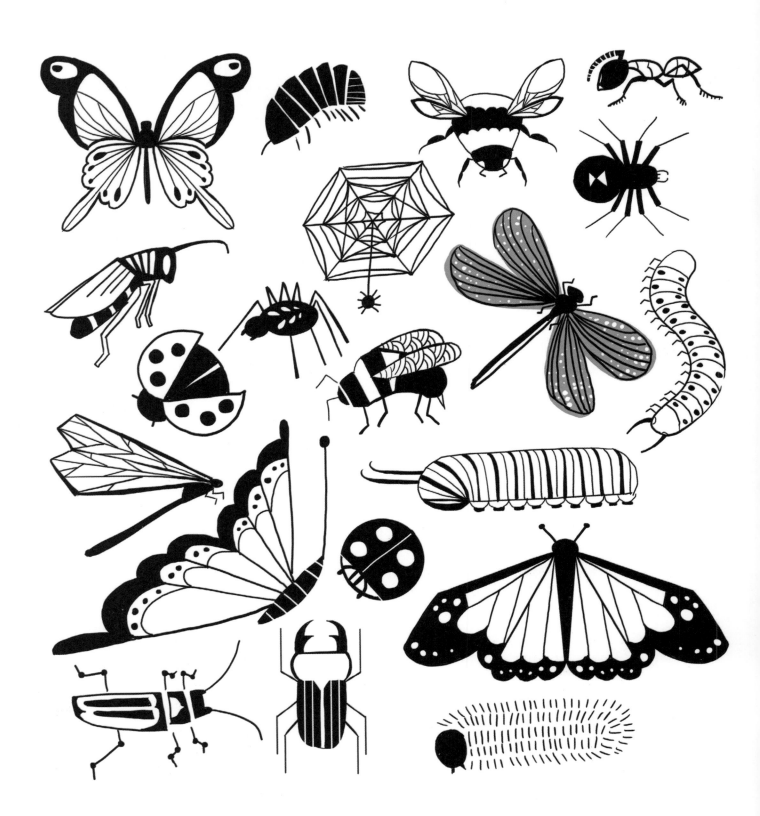

DRAW 20
BUGS

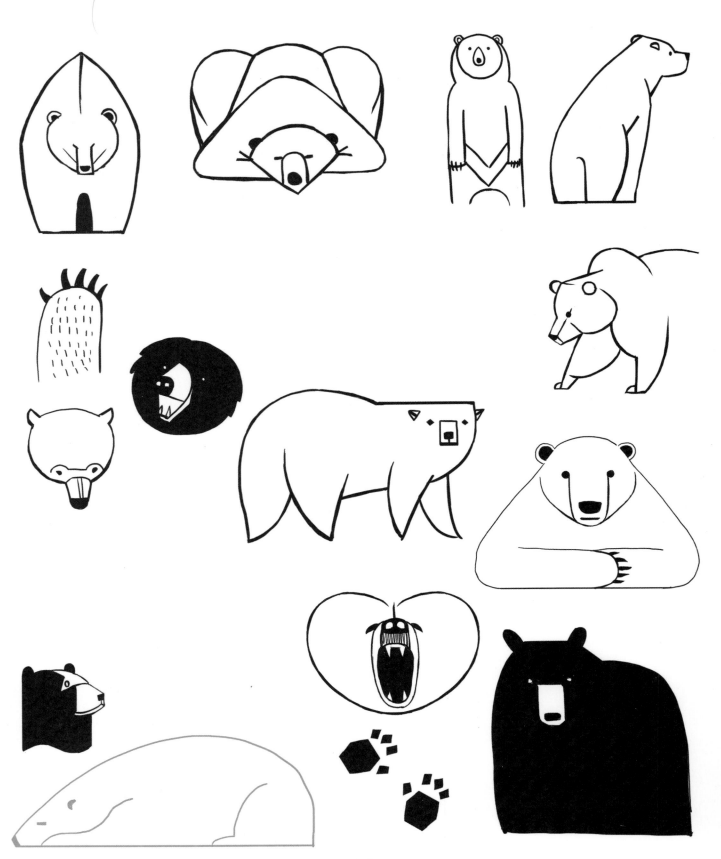

DRAW 20
BEARS

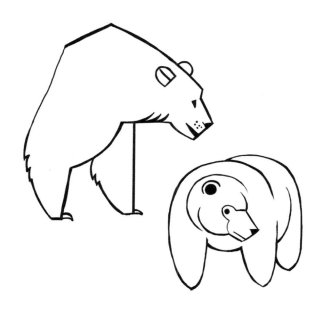

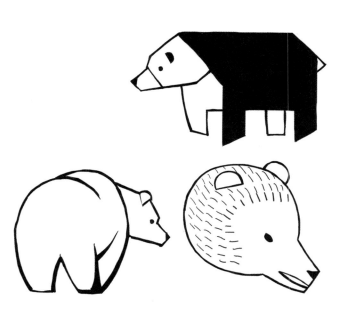

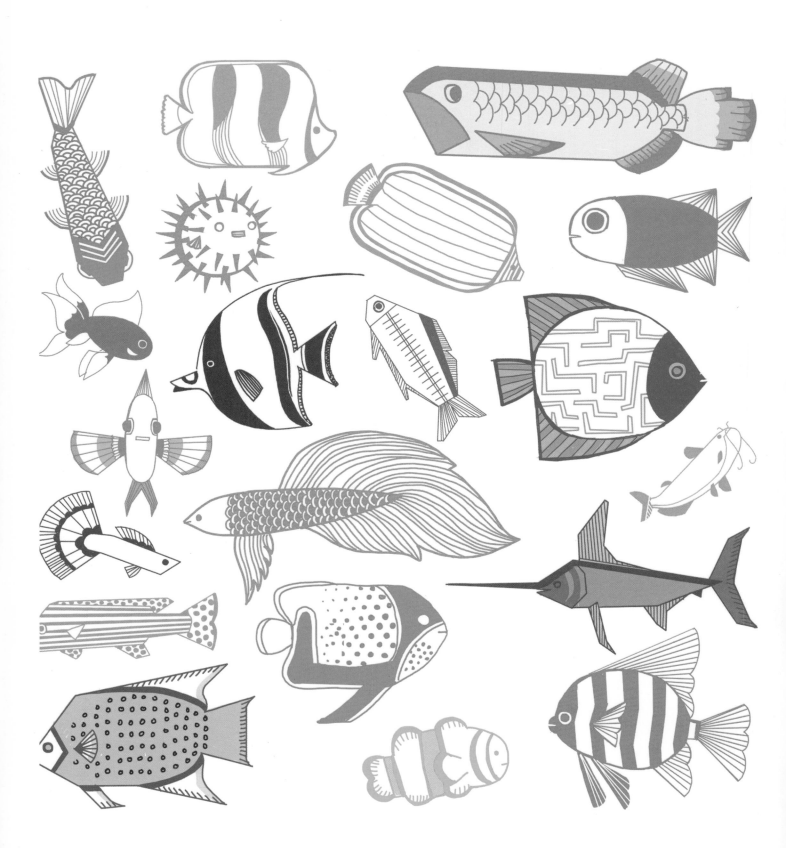

DRAW 20

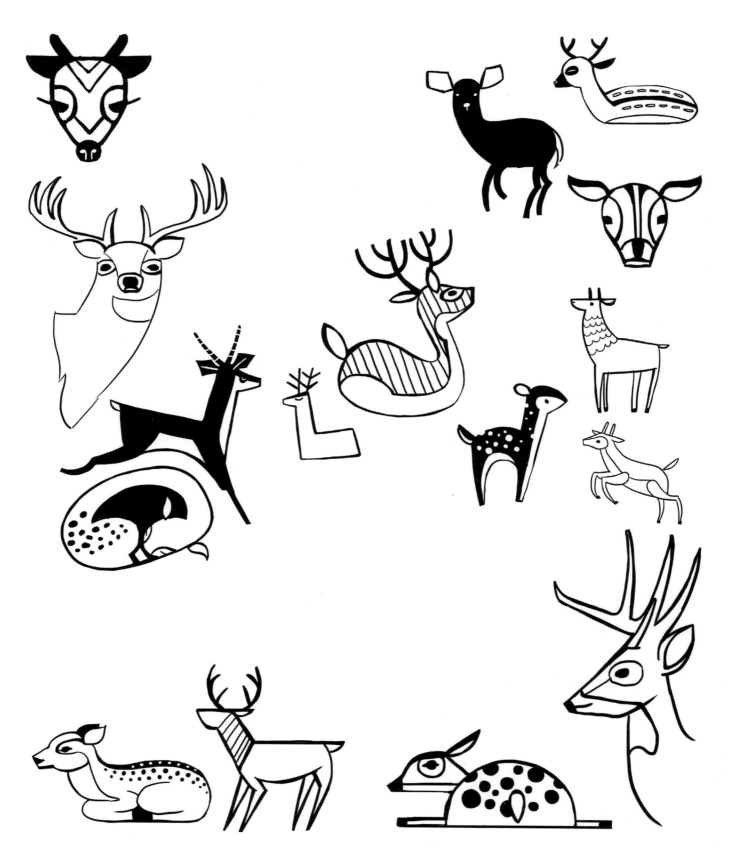

DRAW 20
DEER

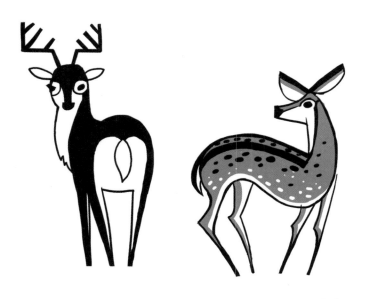

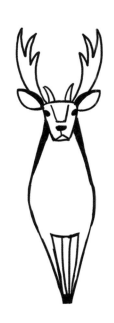

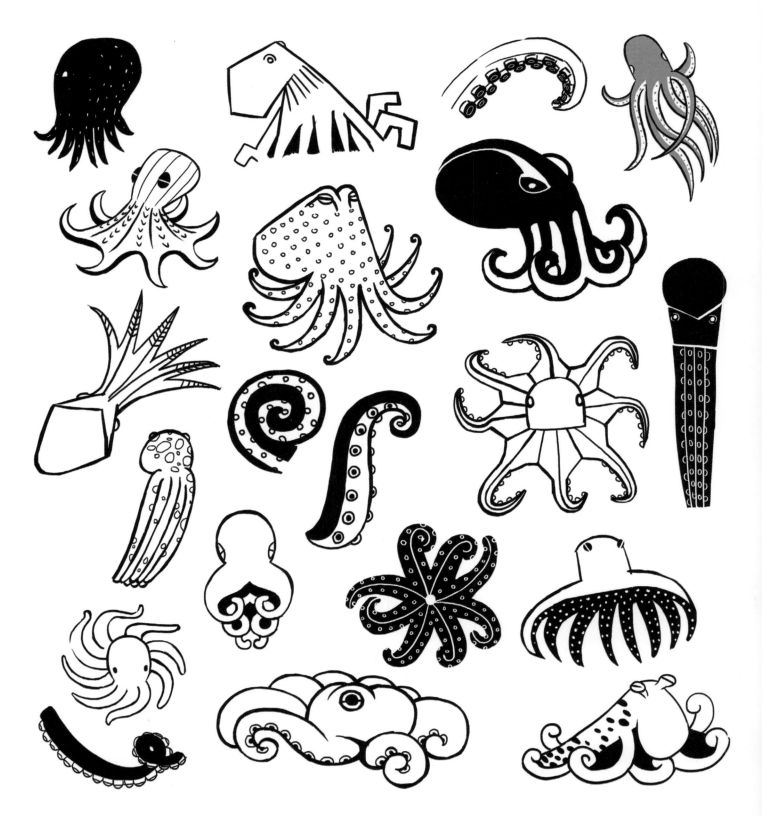

DRAW 20
octopi

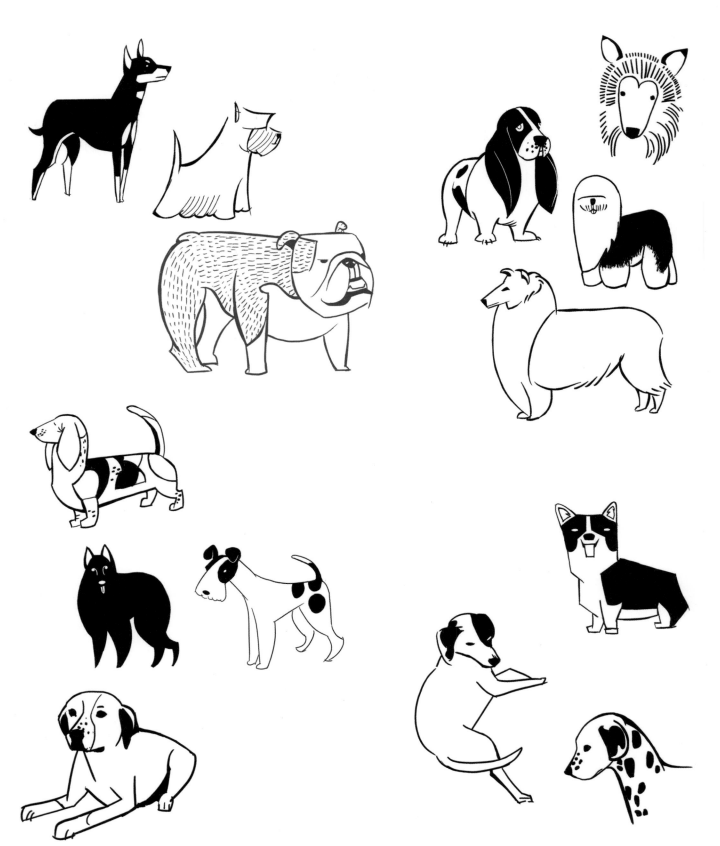

DRAW 20
DOGS

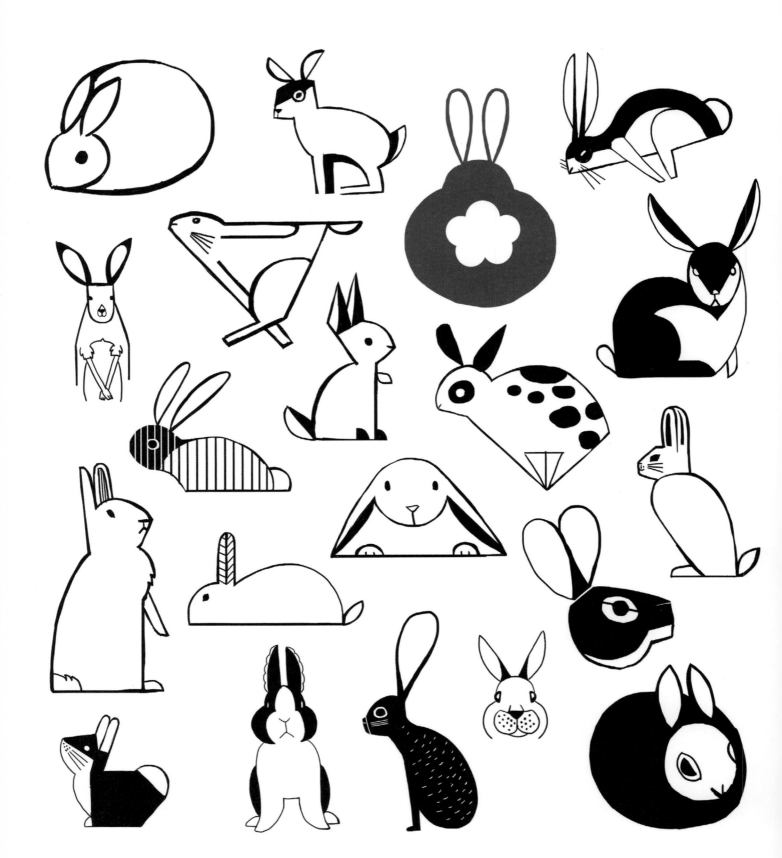

DRAW 20
rabbits

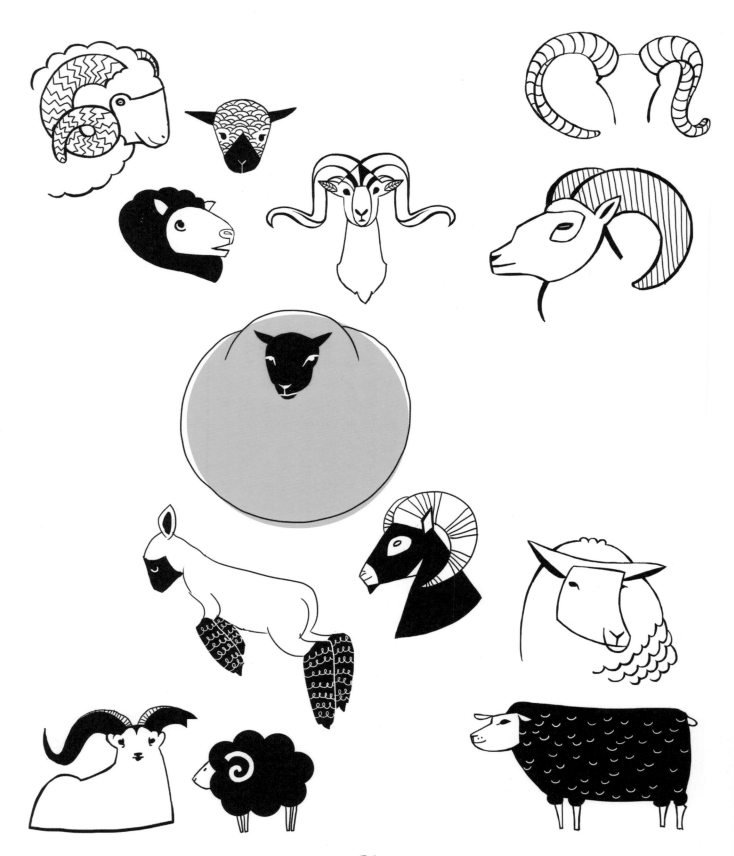

sheep

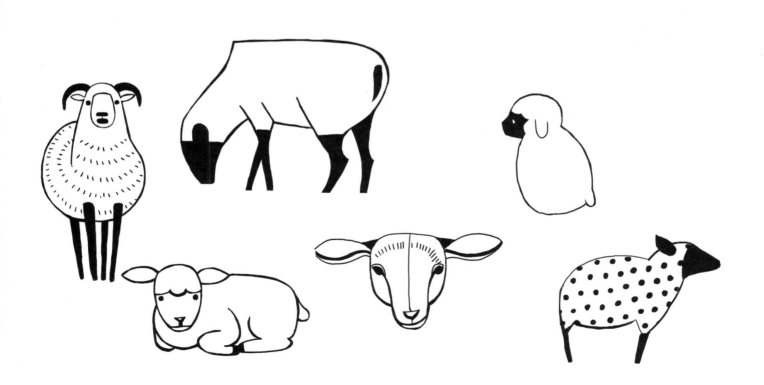

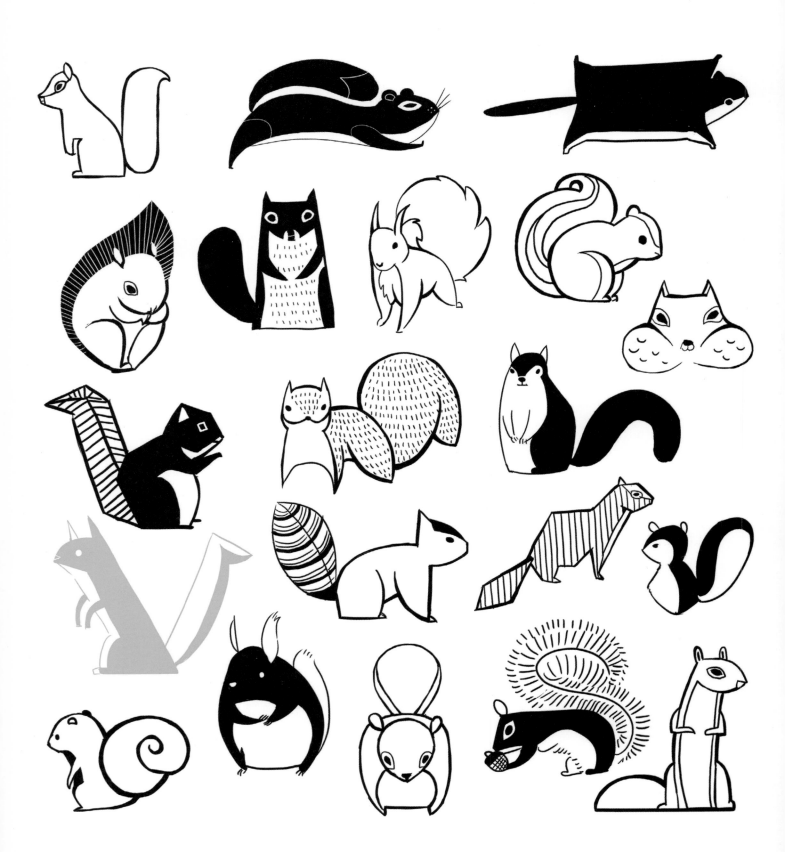

DRAW 20
SQUIRRELS

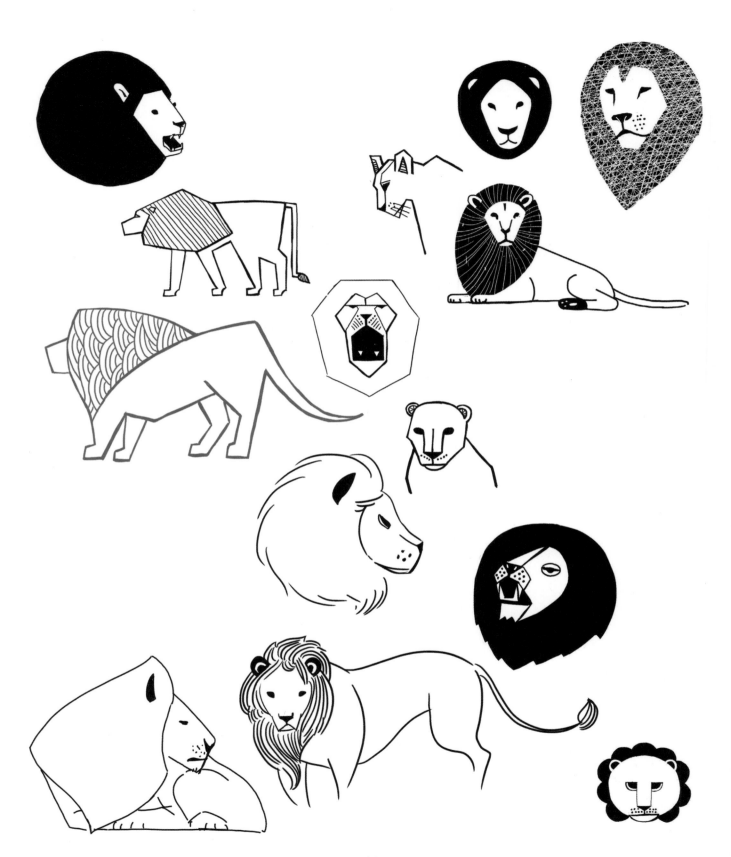

DRAW 20
LIONS

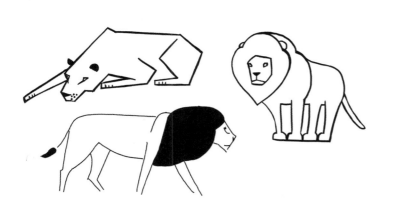

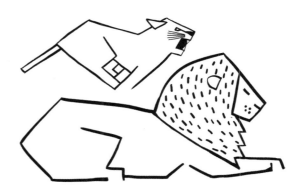

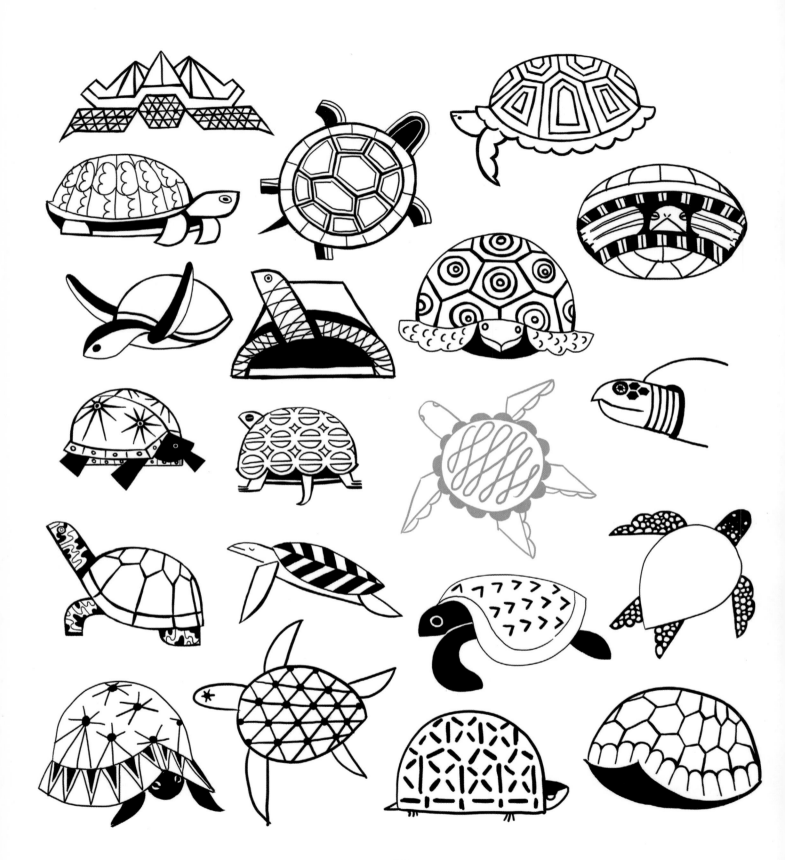

DRAW 20
TURTLES

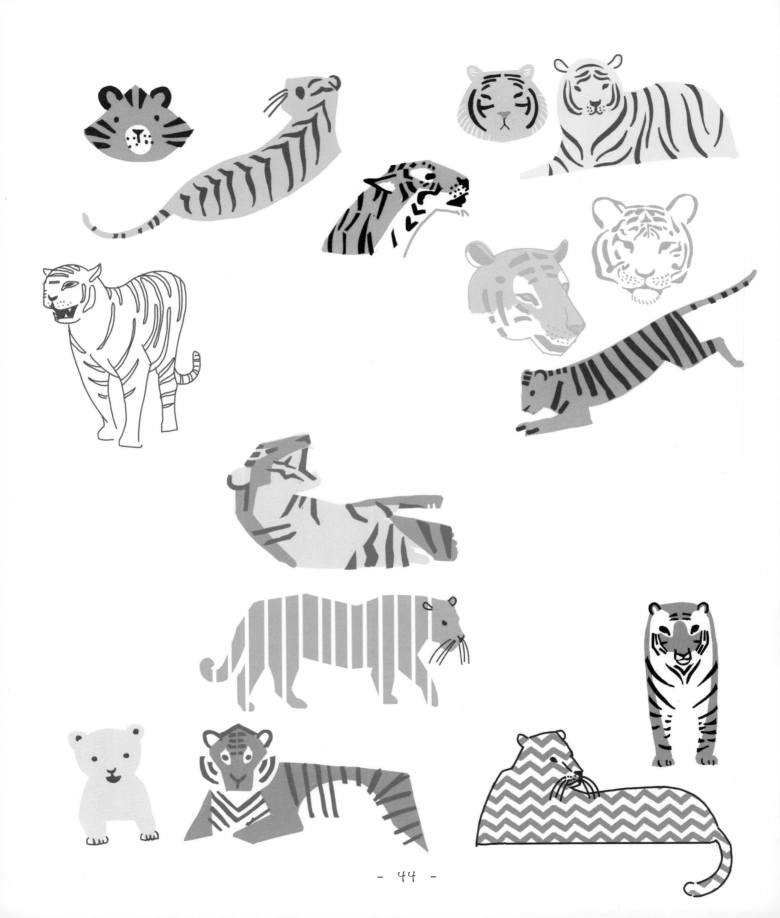

DRAW 20
tigers

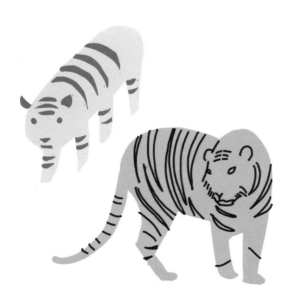

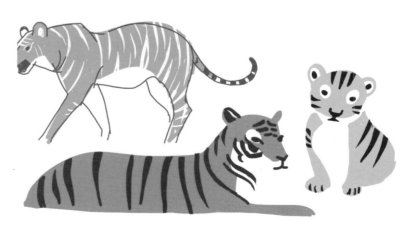

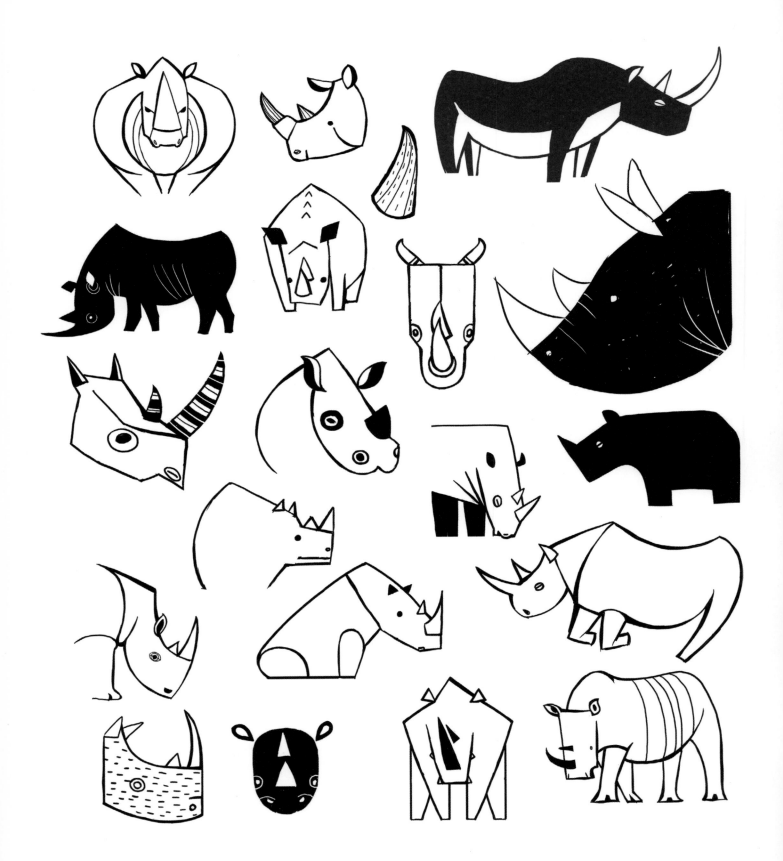

DRAW 20
RHINOCEROSES

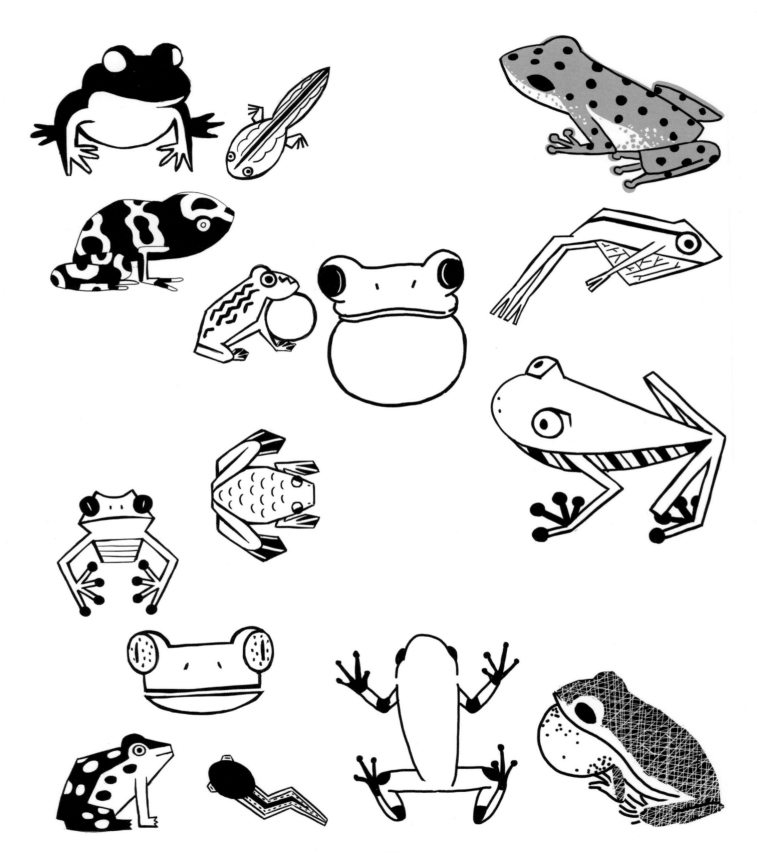

DRAW 20
frogs

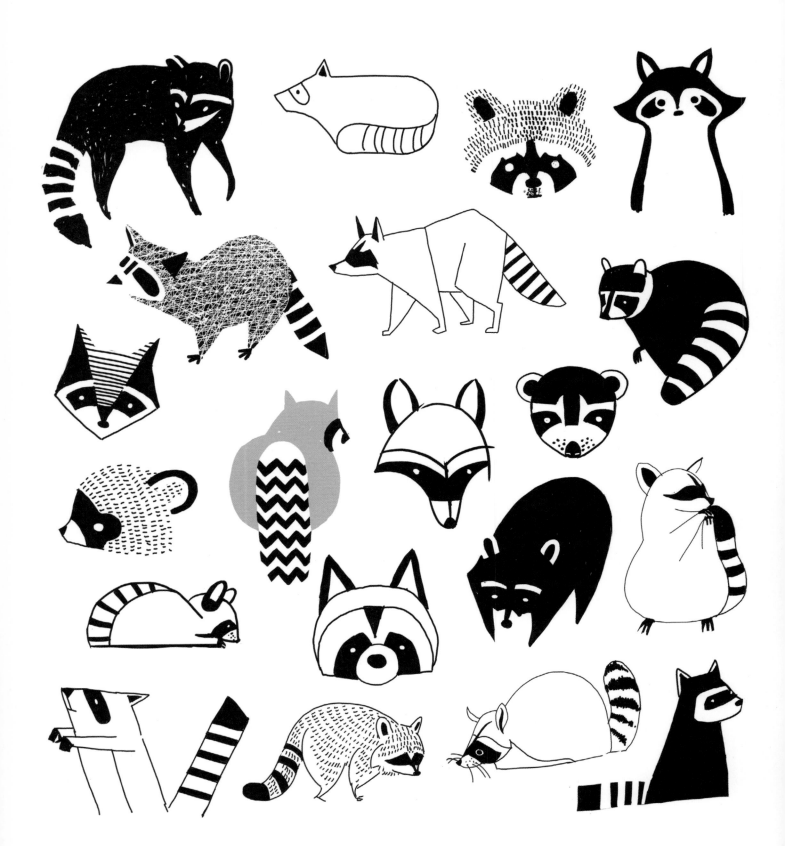

DRAW 20
Raccoons

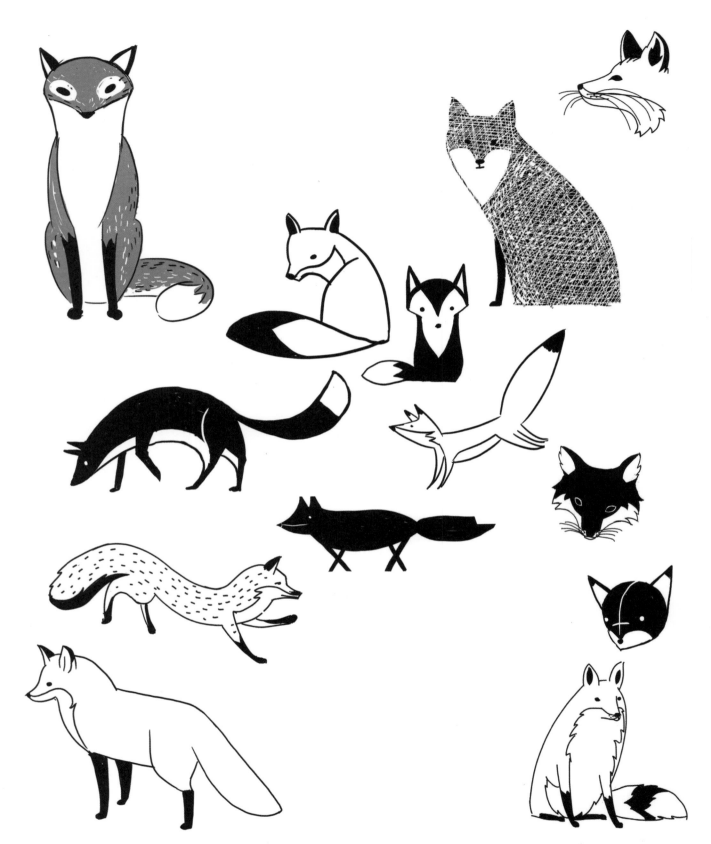

DRAW 20
FOXeS

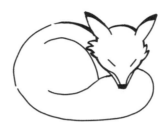

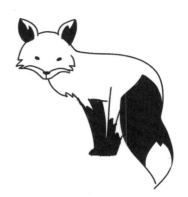

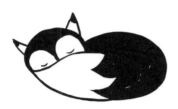

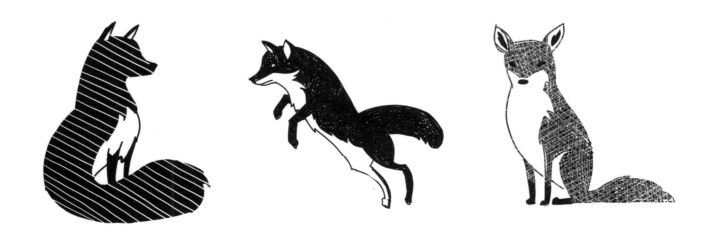

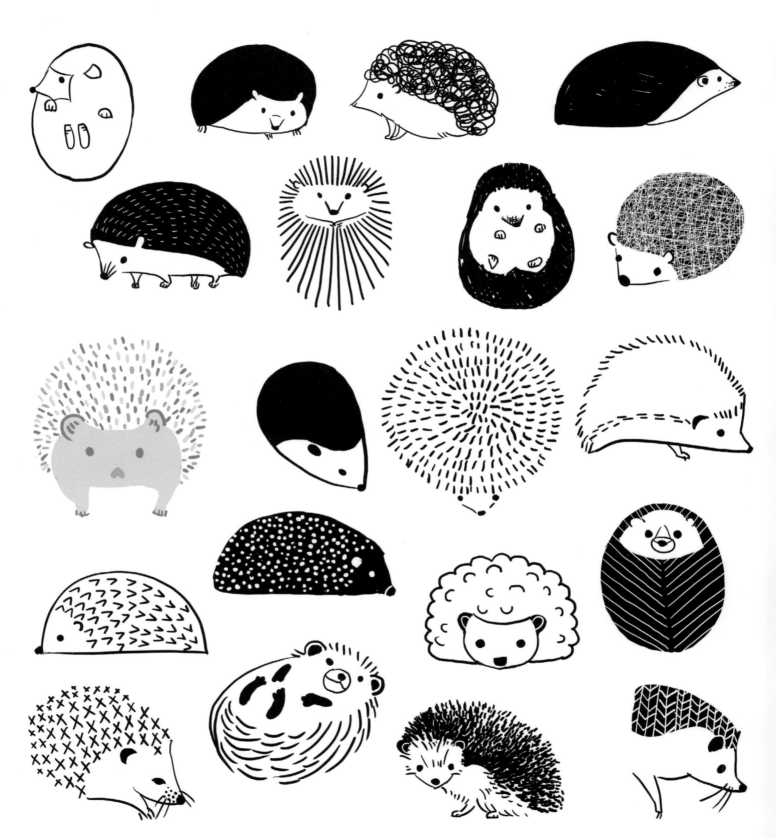

DRAW 20
hedgehogs

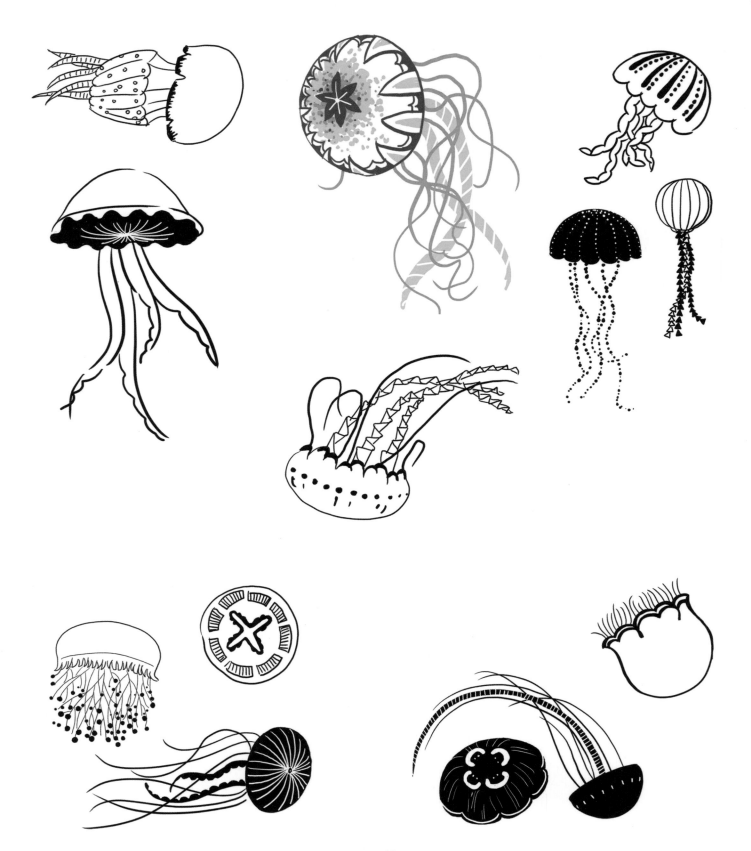

DRAW 20
jellyfish

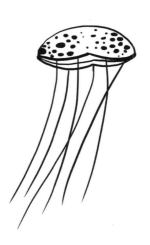

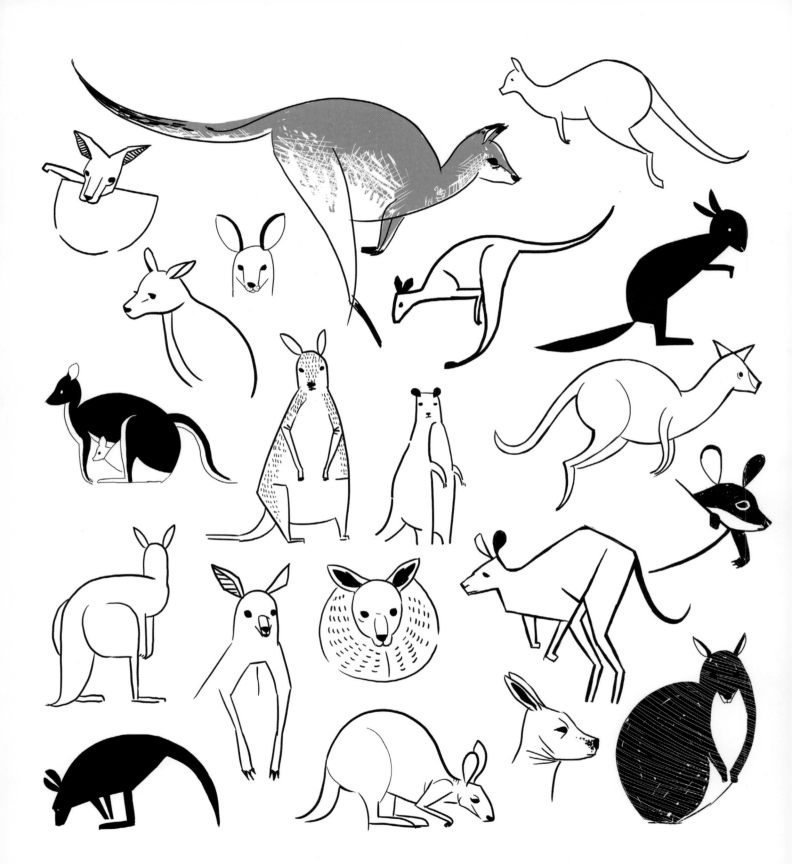

DRAW 20
Kangaroos

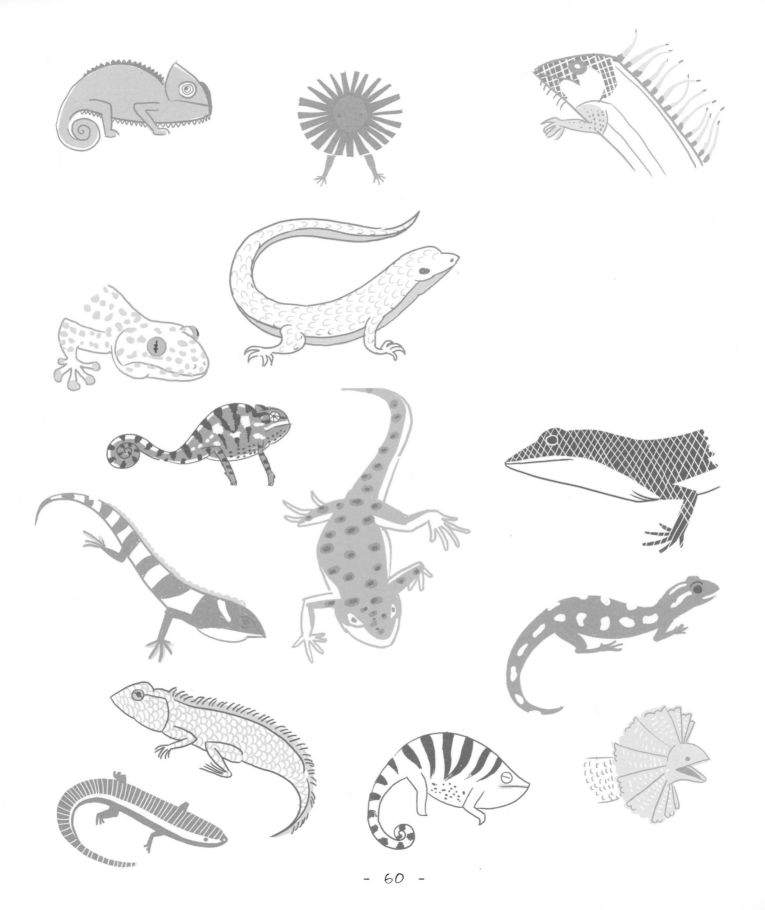

DRAW 20 *Lizards*

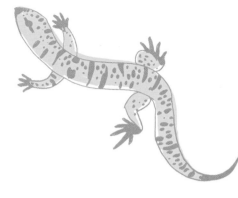

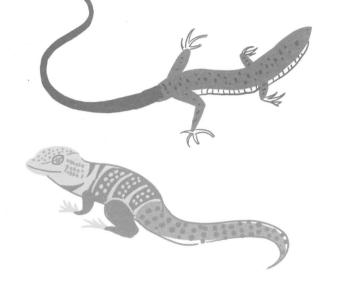

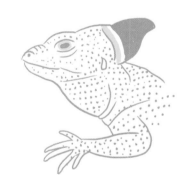

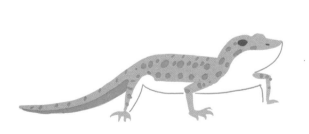

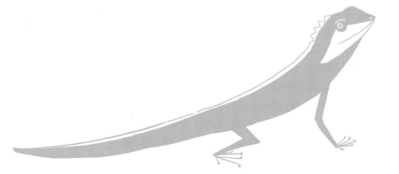

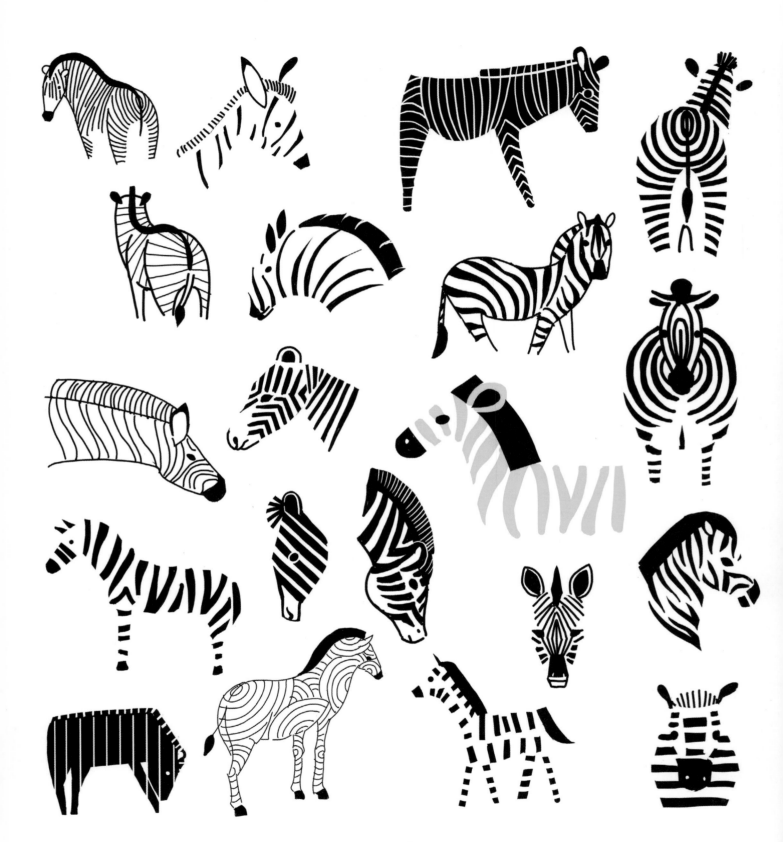

DRAW 20
ZEBRAS

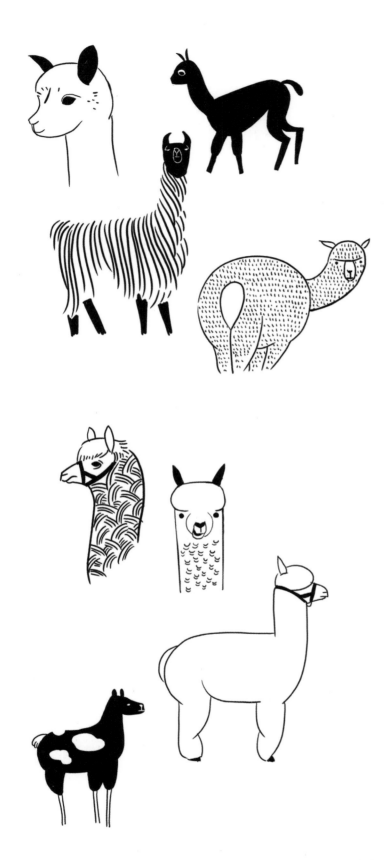
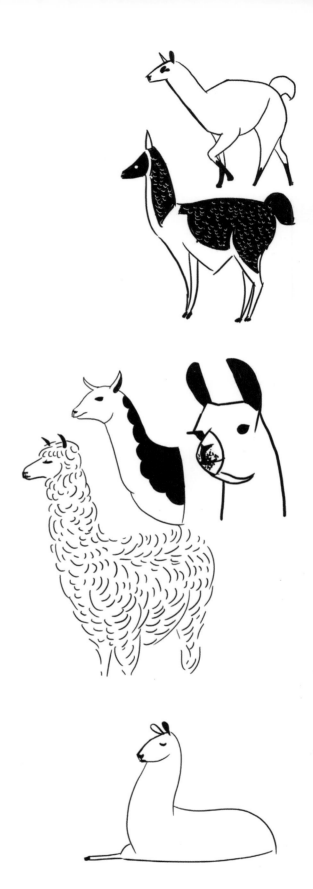

DRAW 20
llamas & alpacas

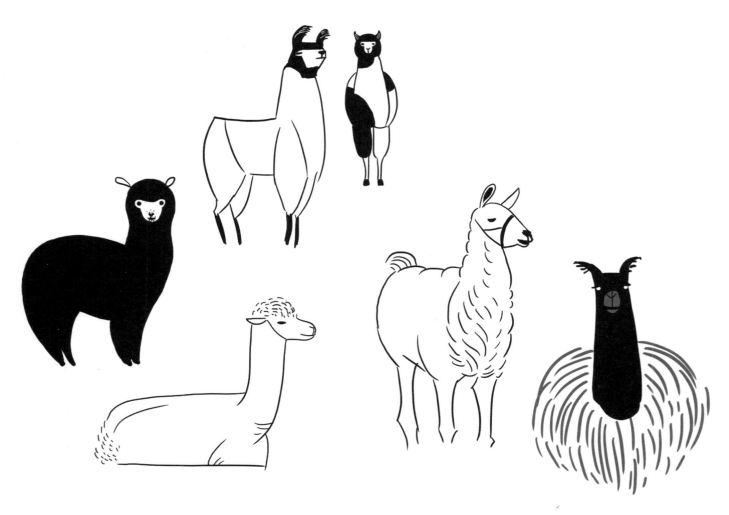

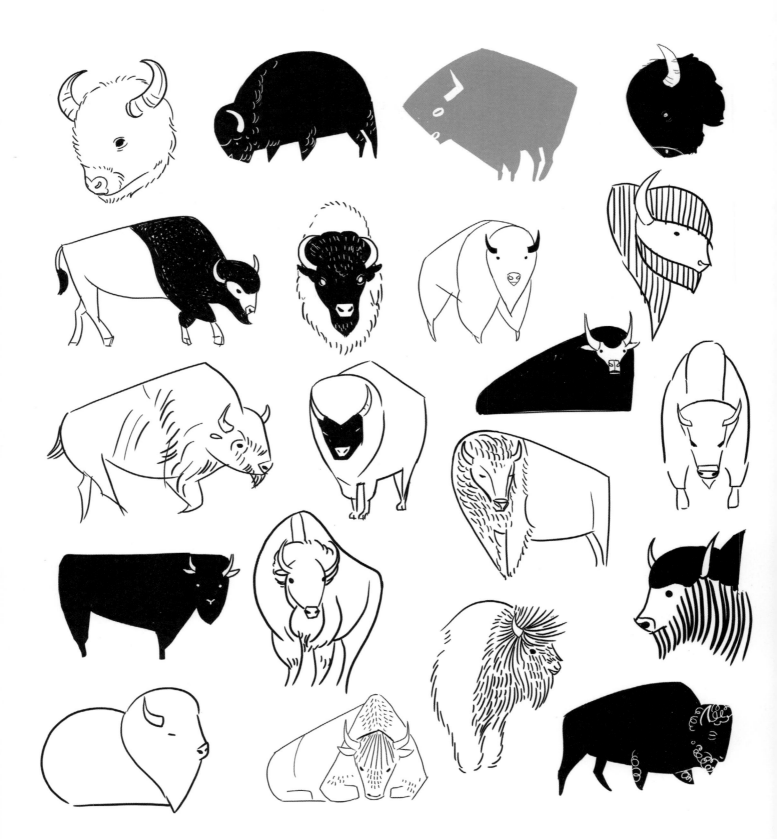

DRAW 20

BUFFALOES

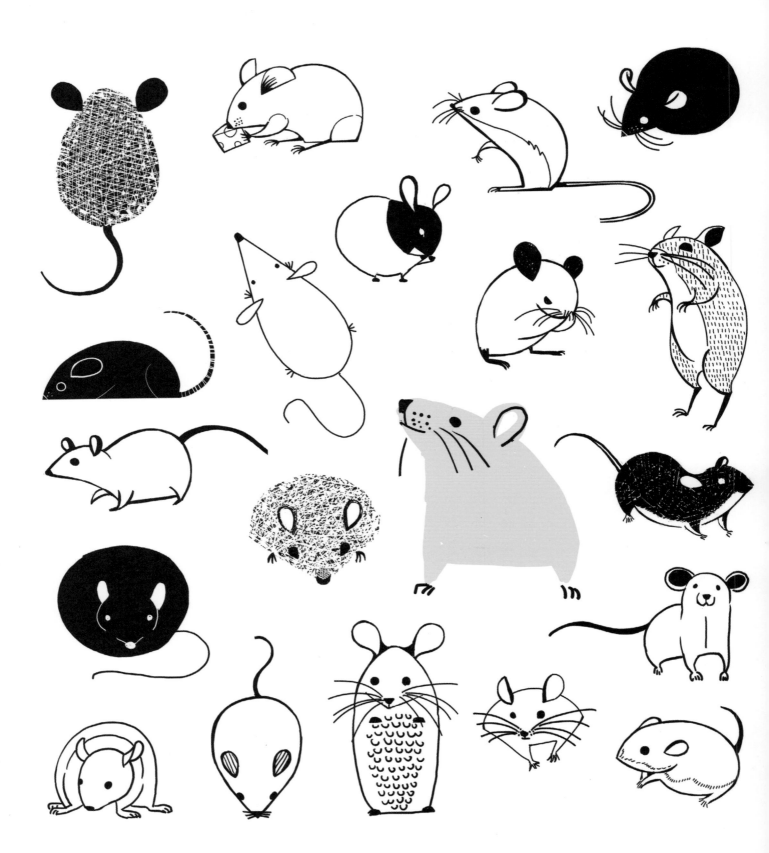

DRAW 20
mice

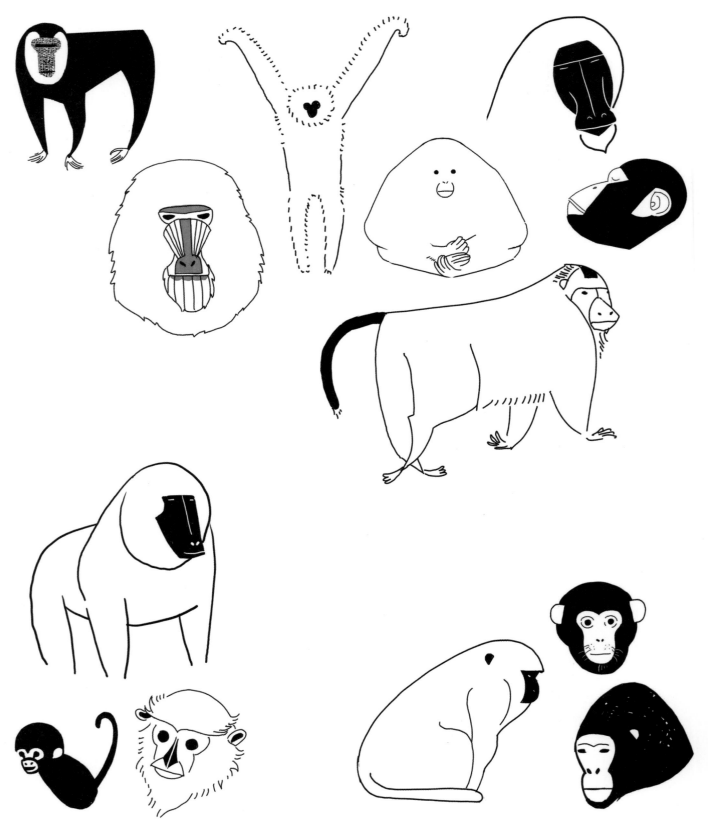

monkeys & apes

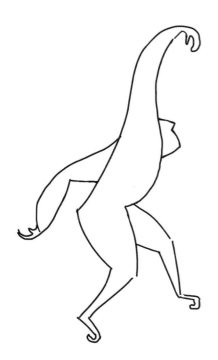

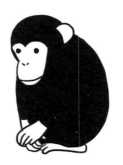

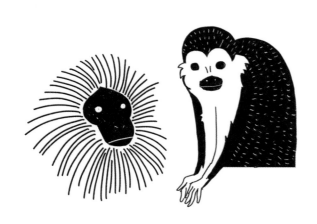

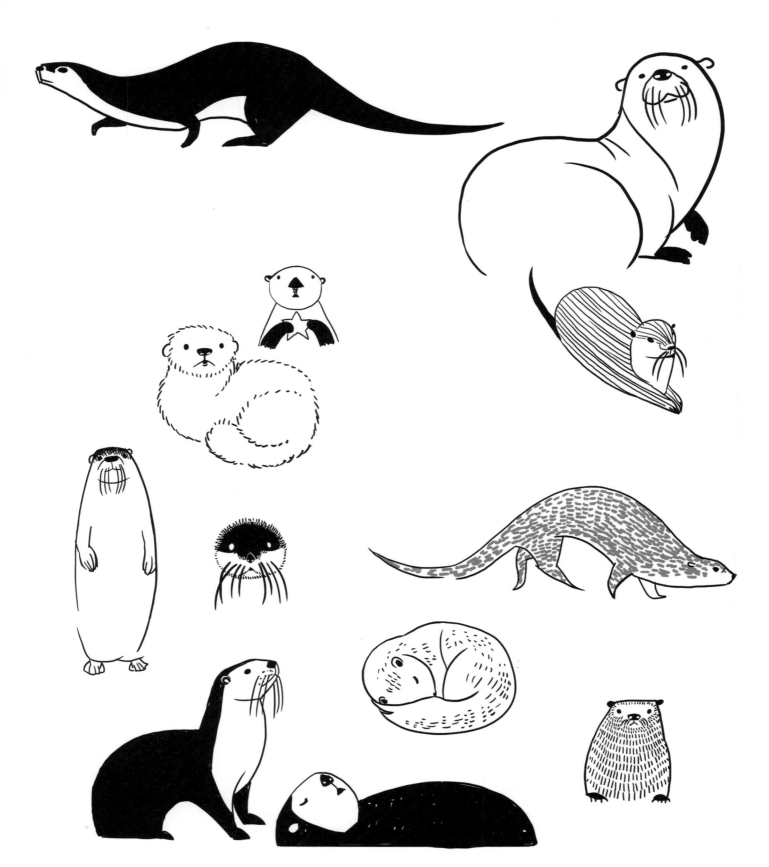

DRAW 20
OTTERS

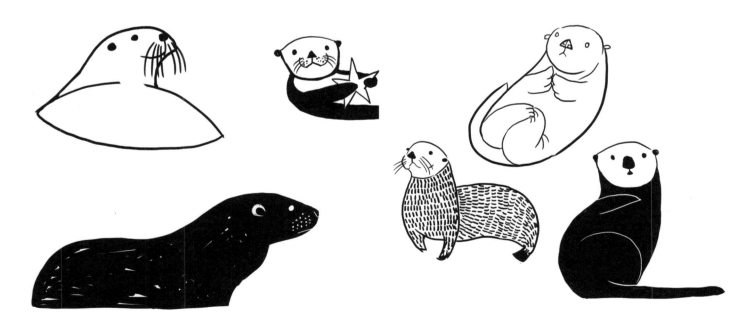

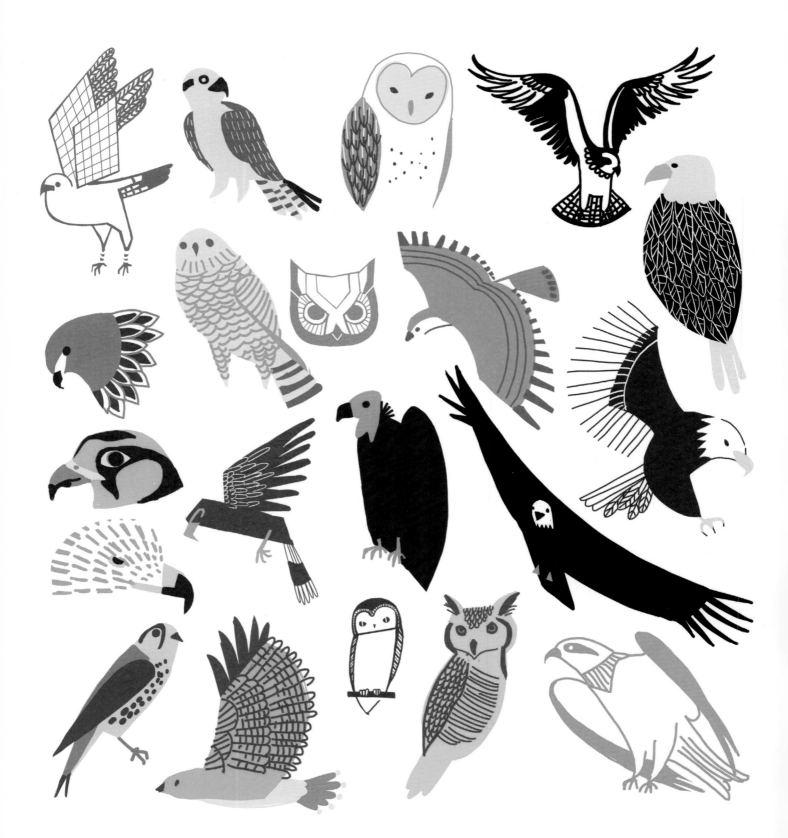

DRAW 20
Birds of Prey

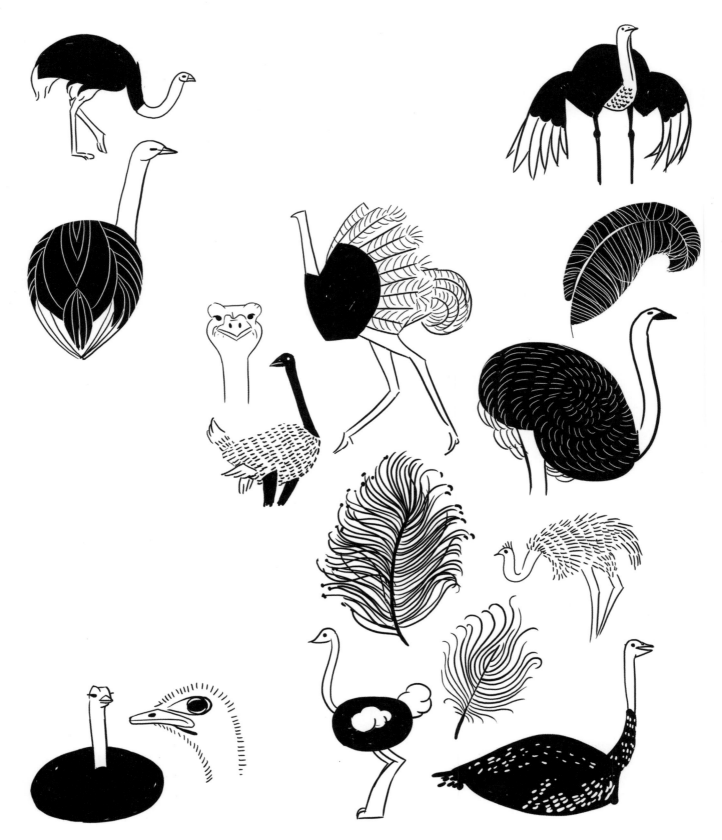

DRAW 20
OSTRICHES

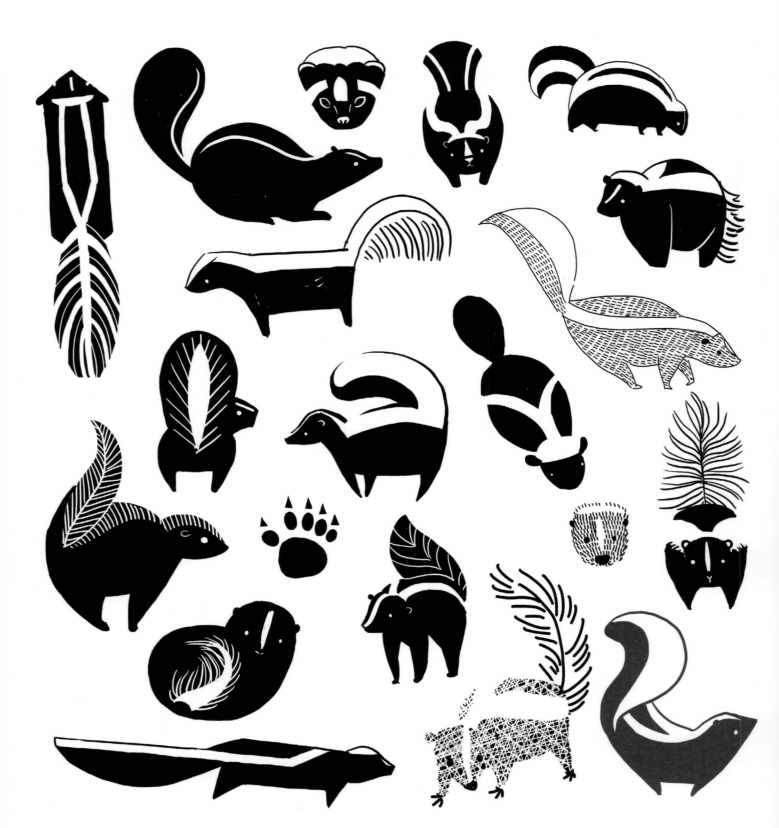

DRAW 20
Skunks

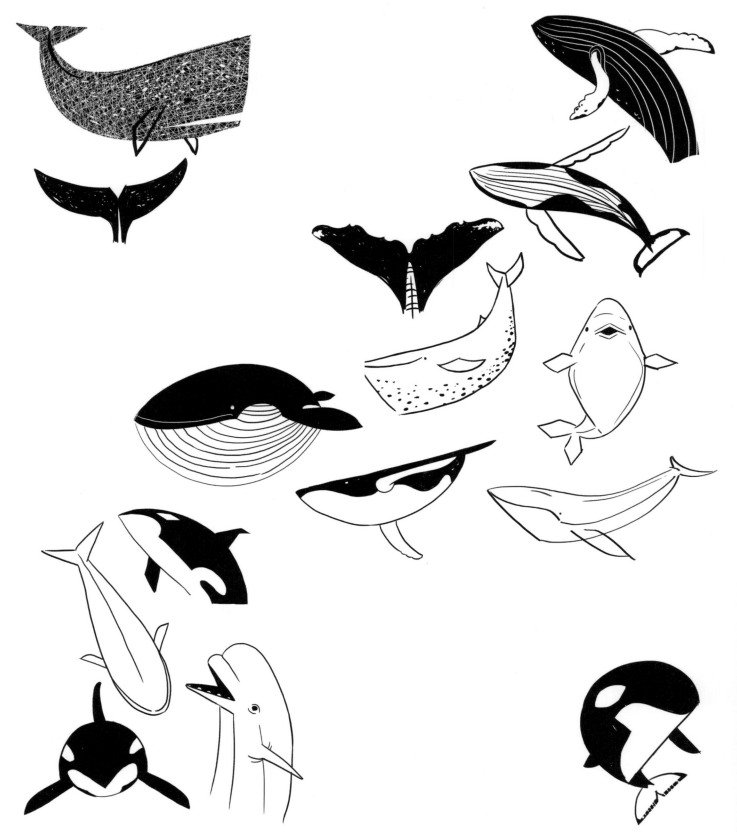

DRAW 20
WHALES

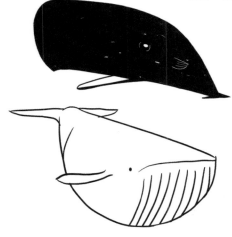

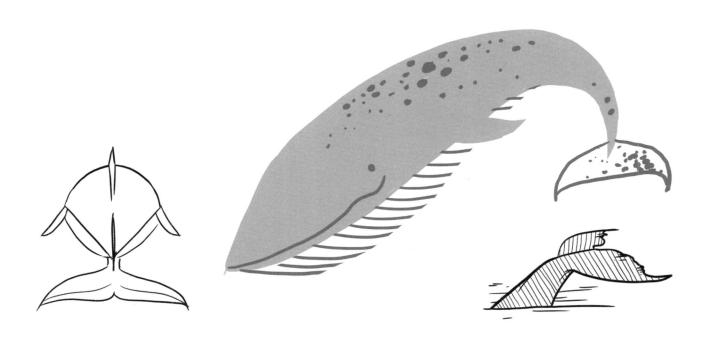

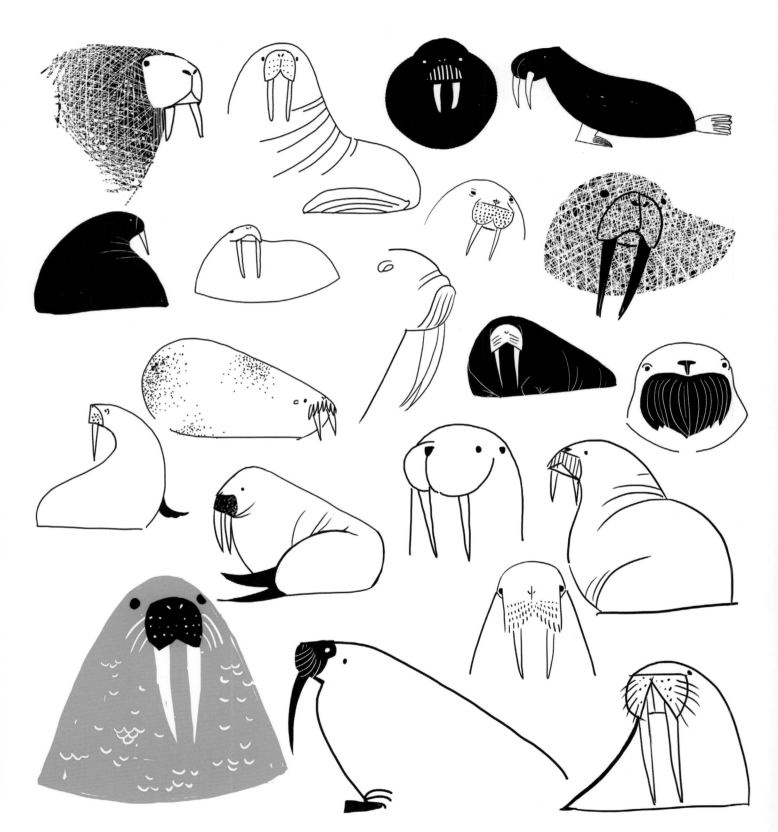

DRAW 20
walruses

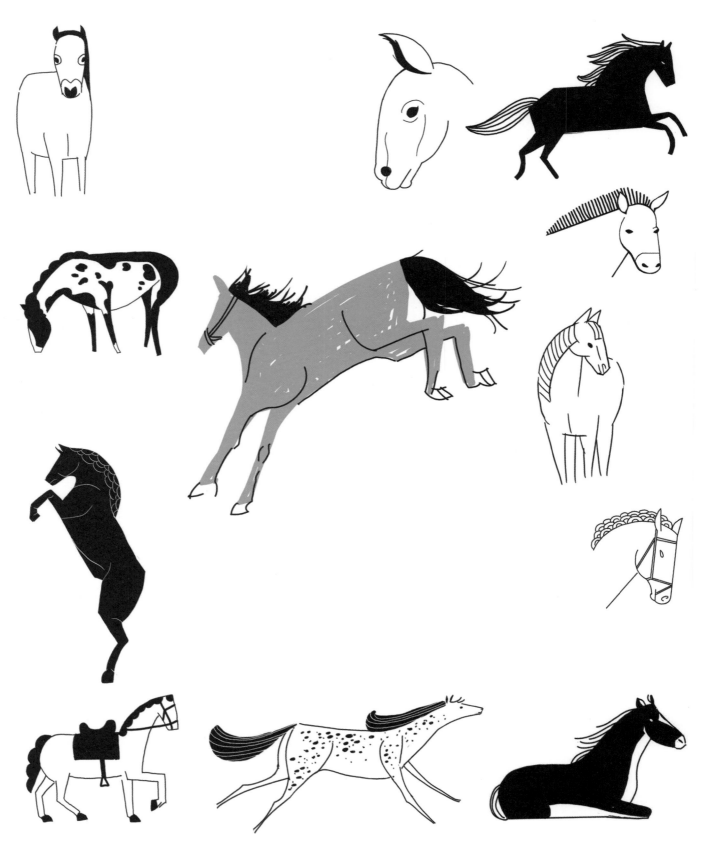

DRAW 20
HORSES

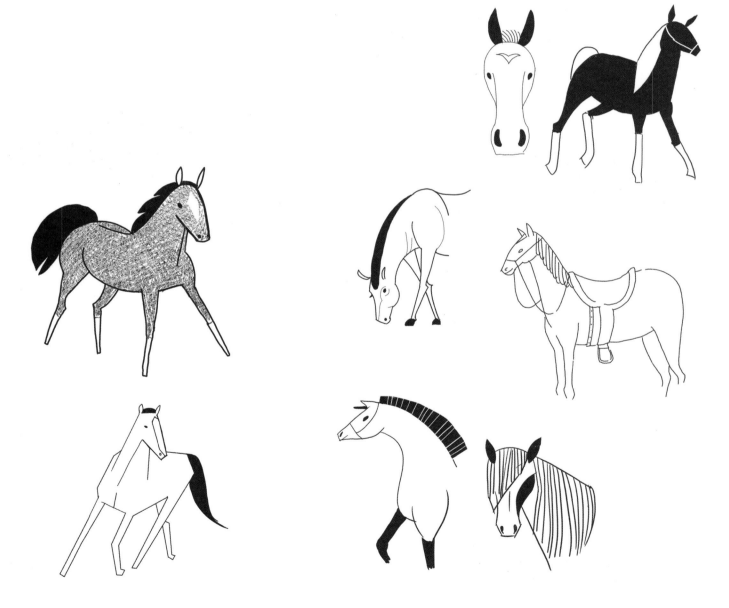

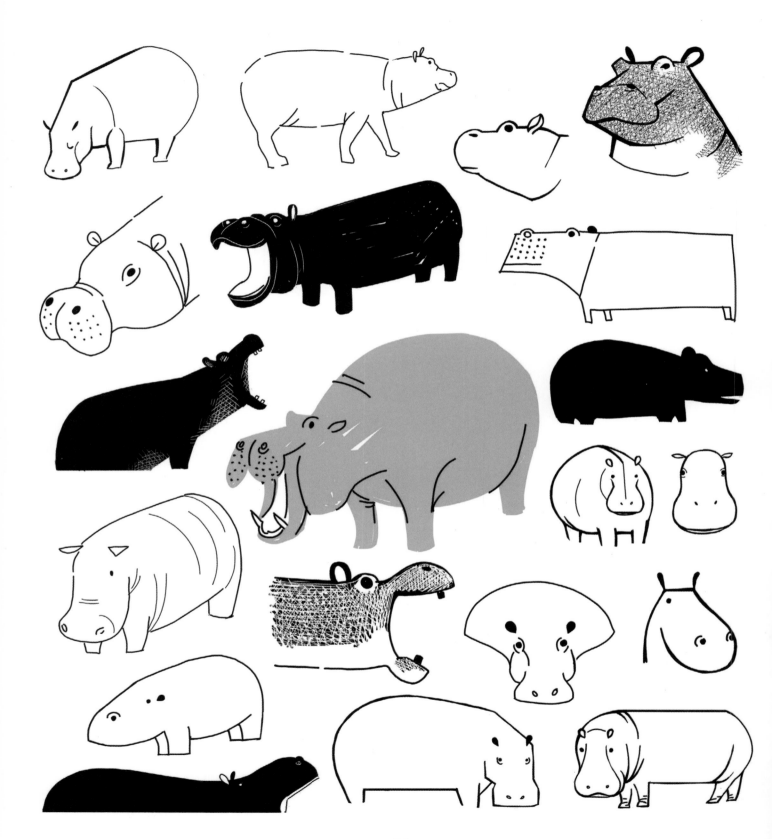

DRAW 20
hippopotamuses

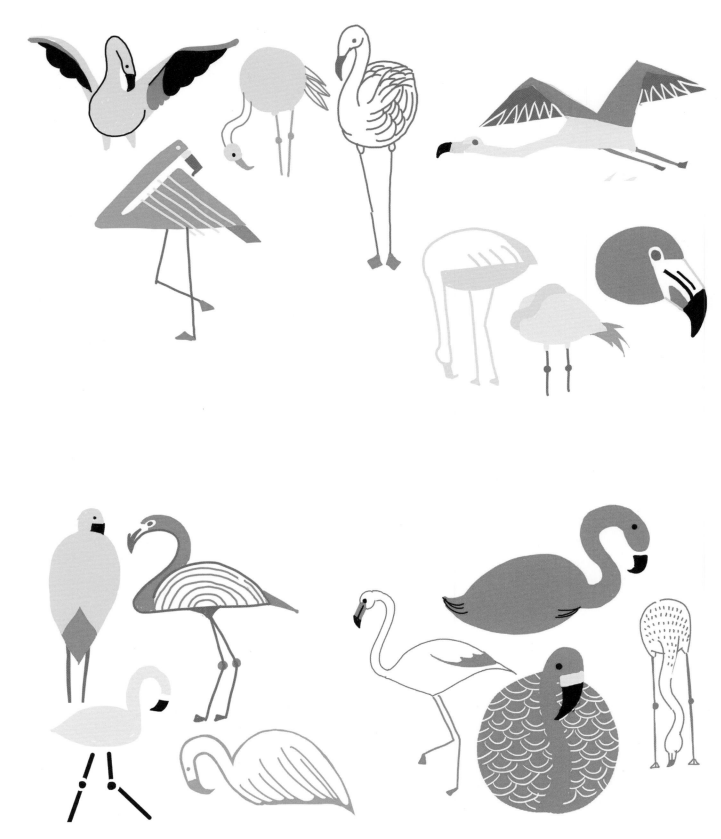

DRAW 20
FLAMINGOS

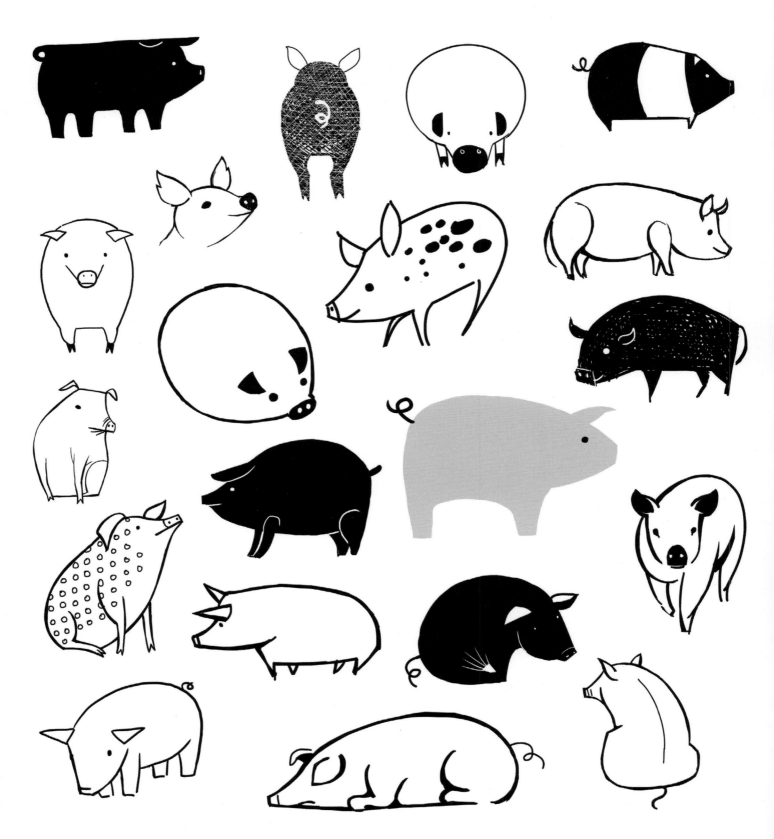

DRAW 20
PIGS

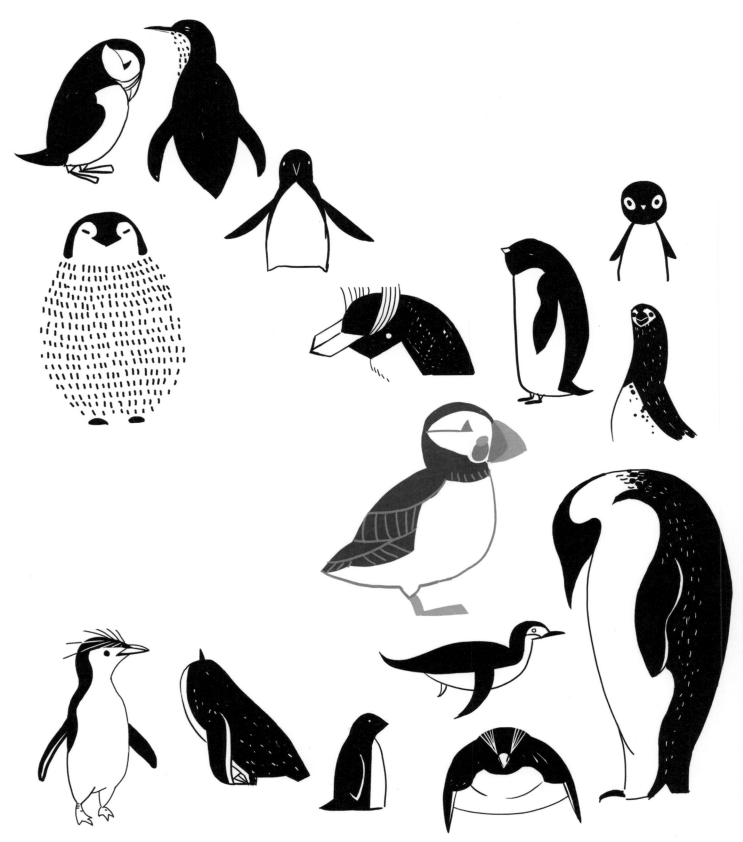

DRAW 20
penguins & puffins

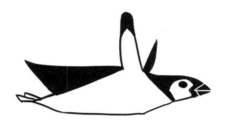

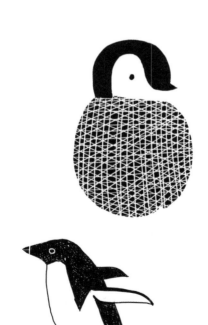

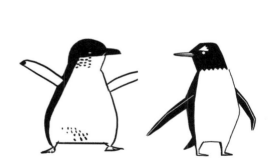

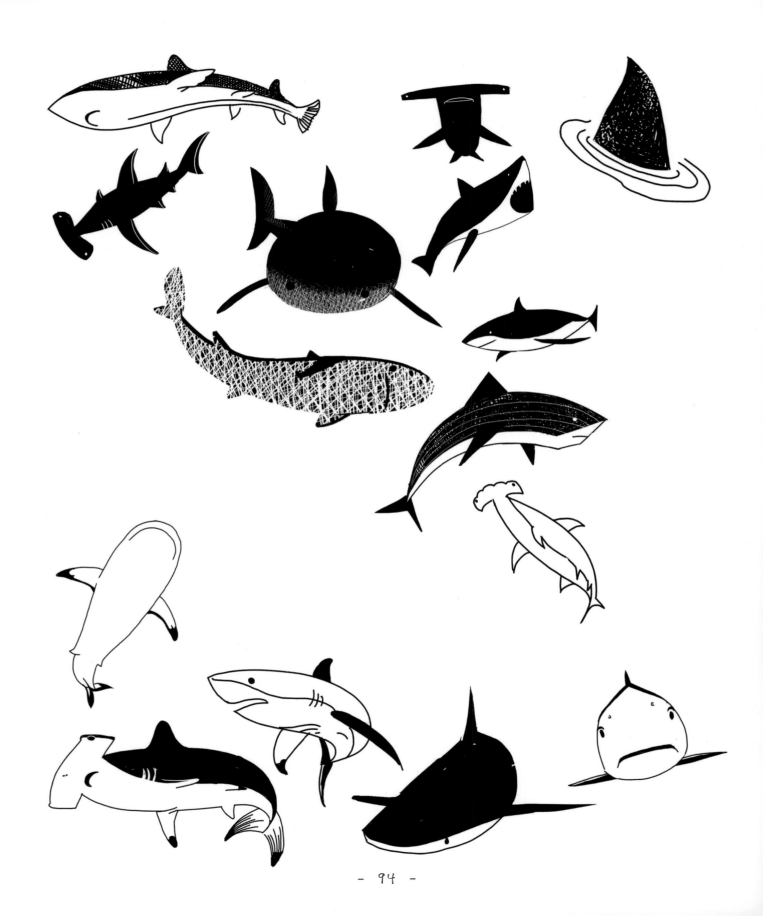

SHARKS

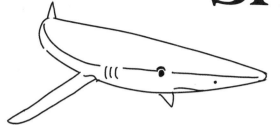

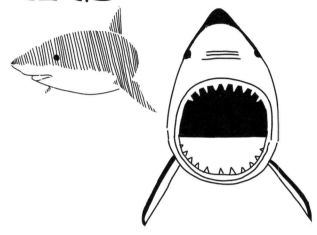

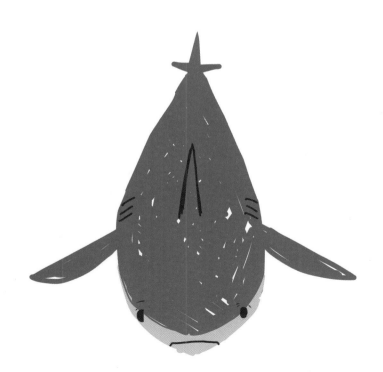

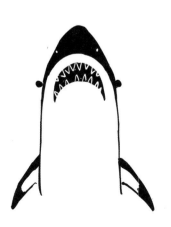

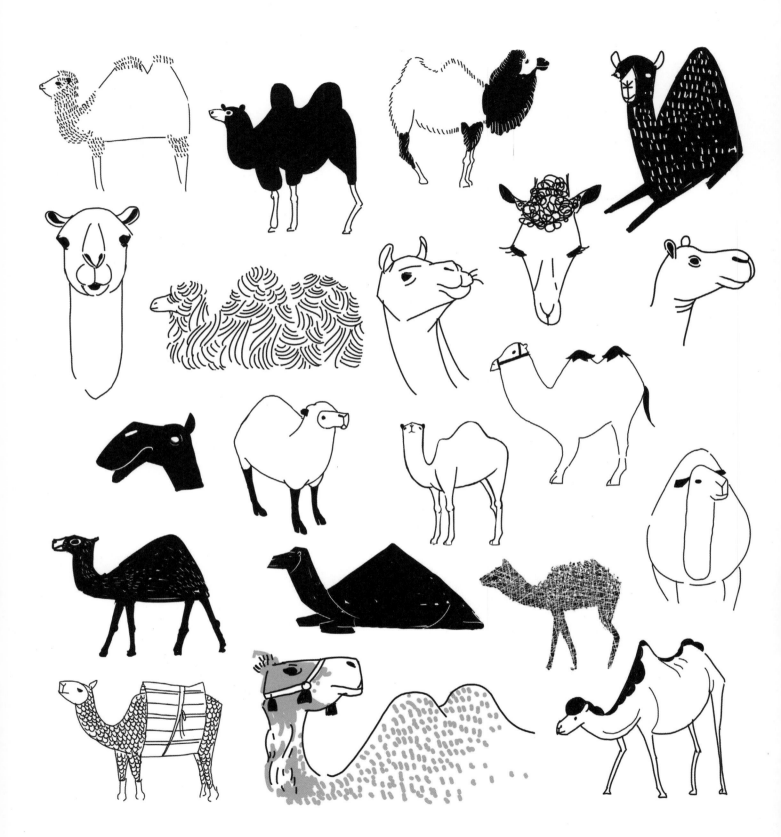

DRAW 20
camels

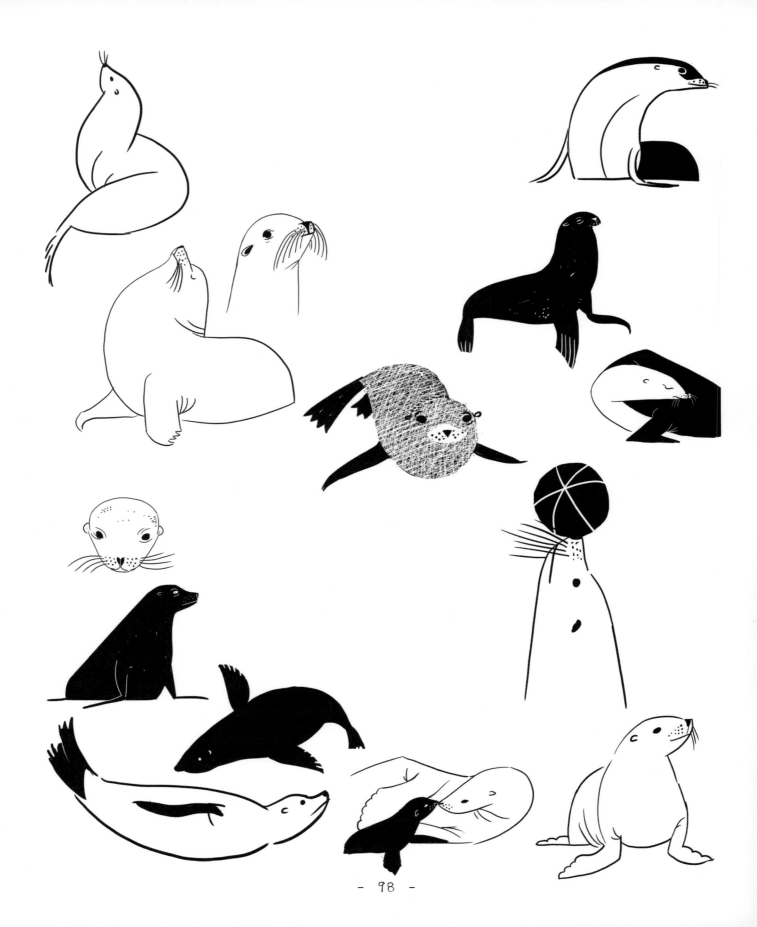

DRAW 20
sea lions

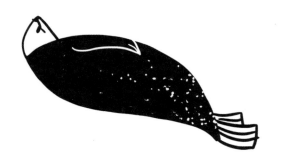

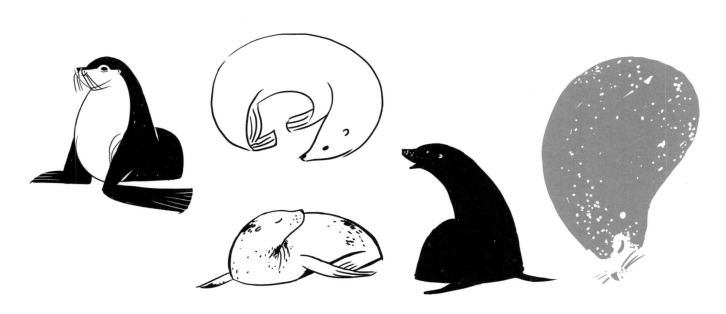

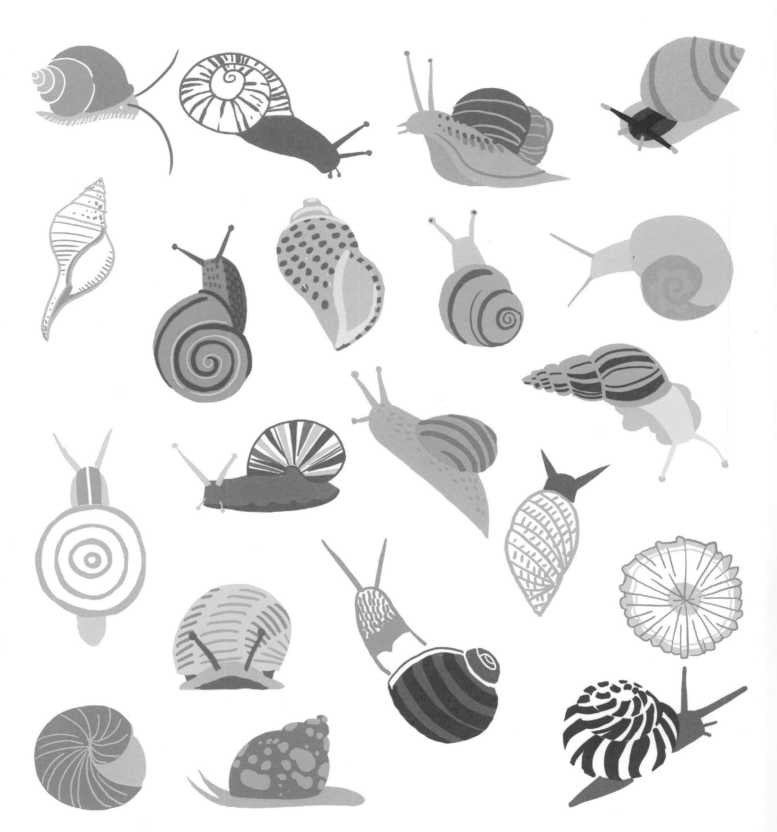

DRAW 20
snails

SECTION 2

NATURE

Illustrations by Eloise Renouf

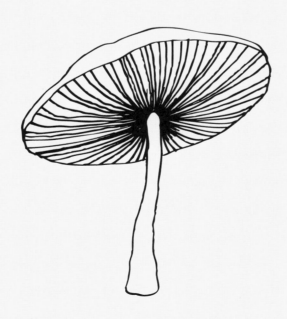

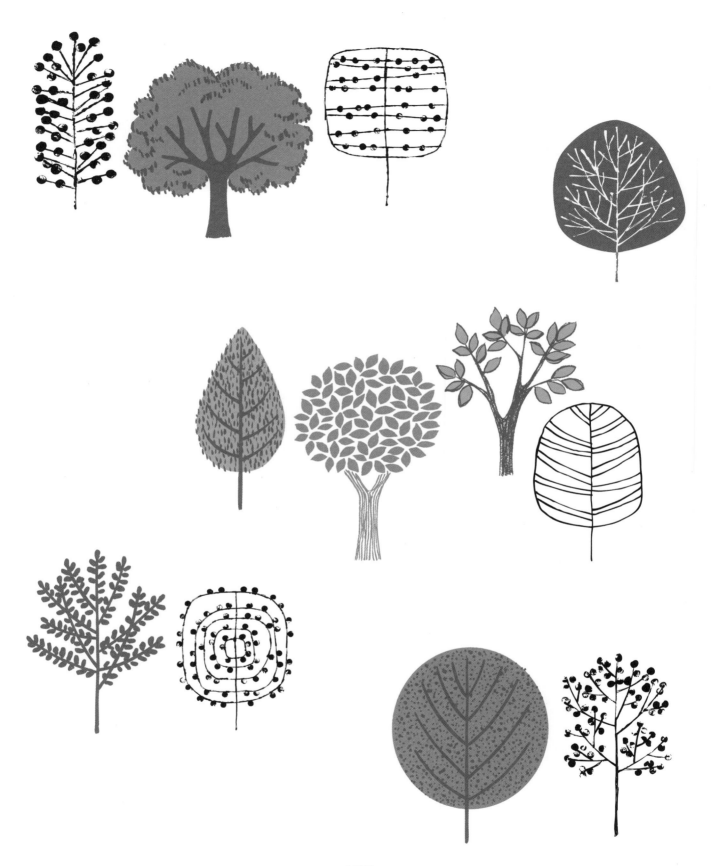

DRAW 20
TREES

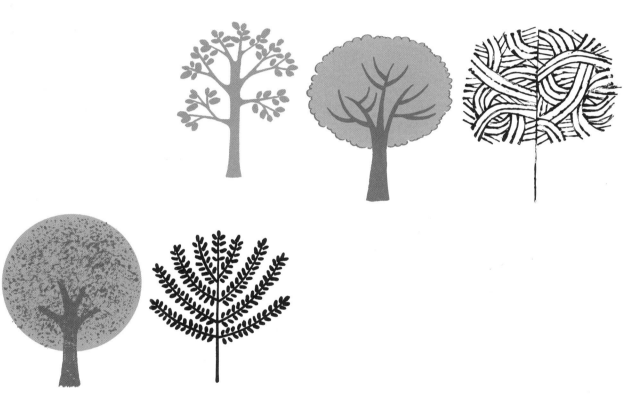

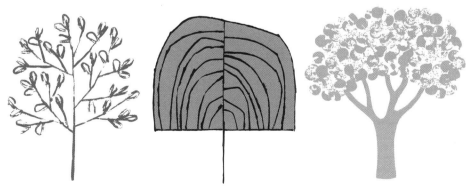

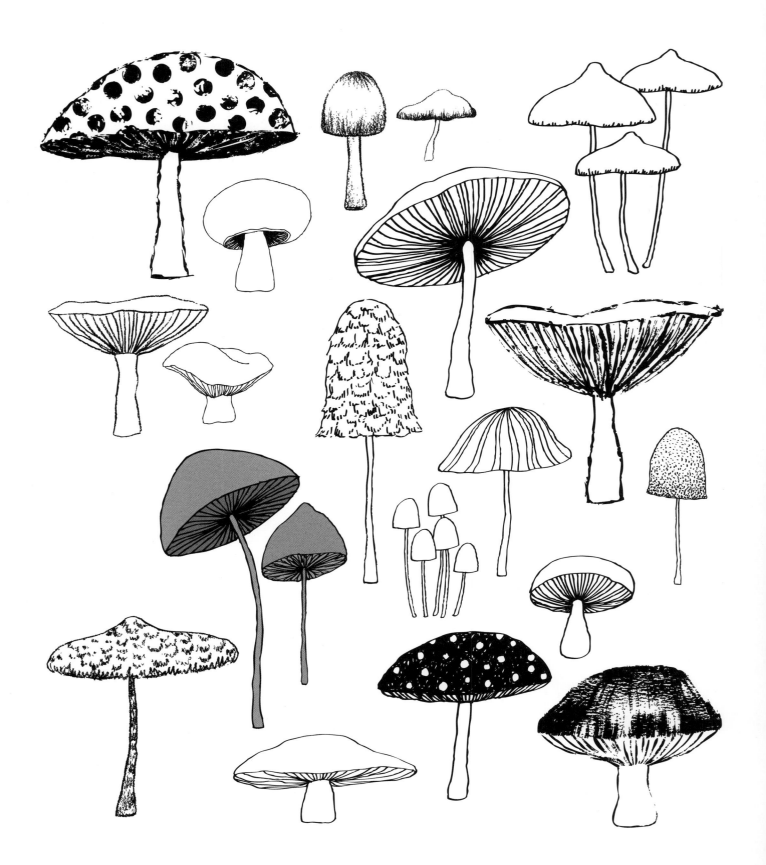

DRAW 20
mushrooms

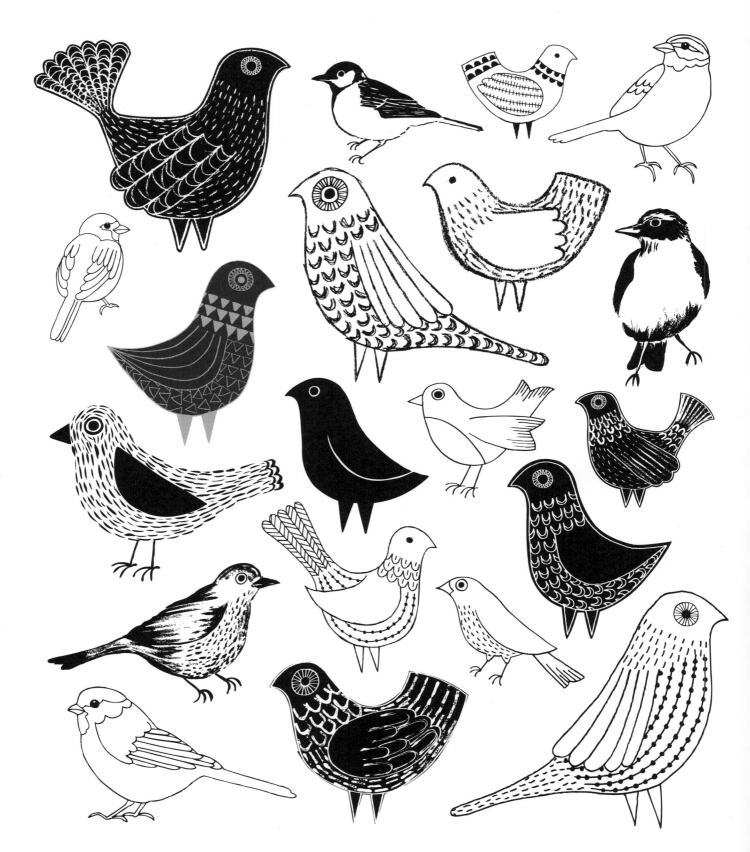

DRAW 20
Birds

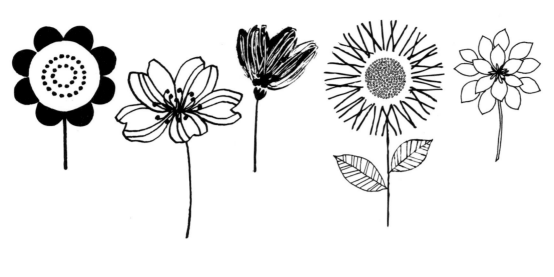

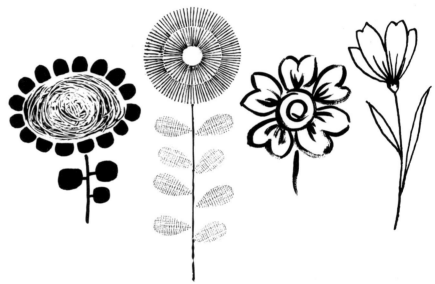

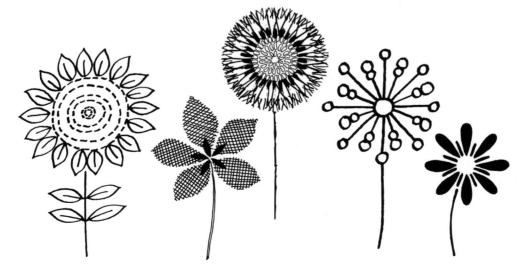

DRAW 20
stemmed flowers

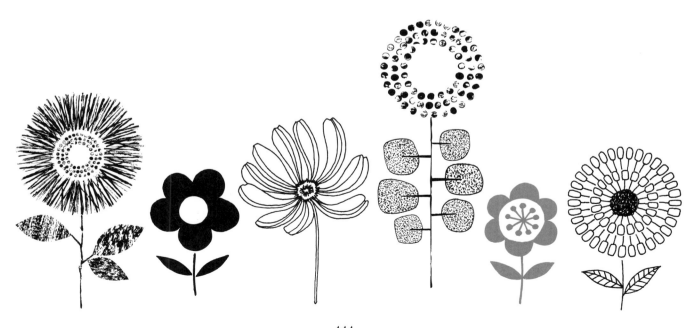

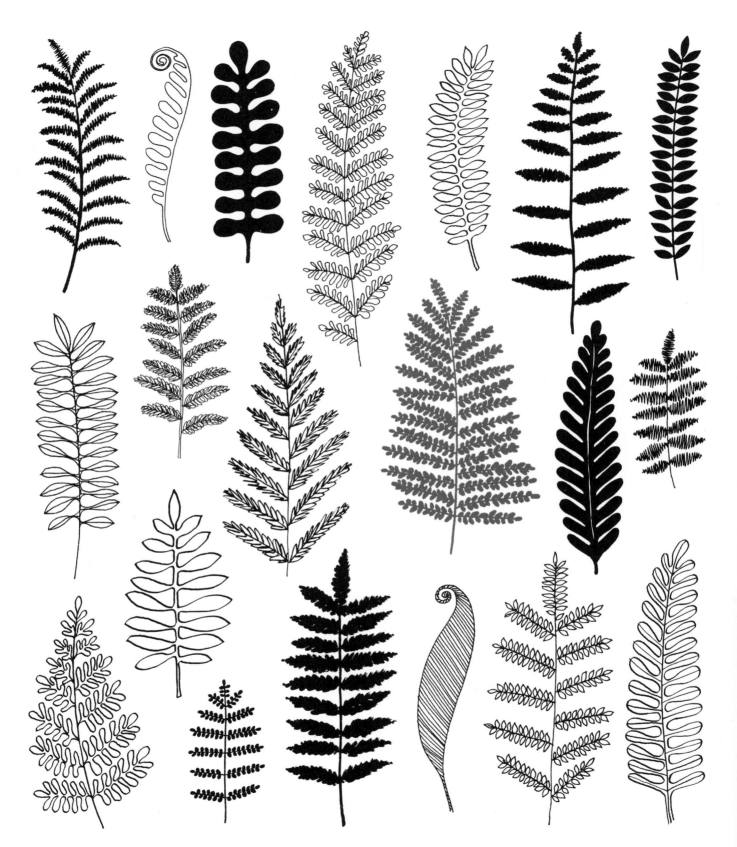

DRAW 20
Ferns

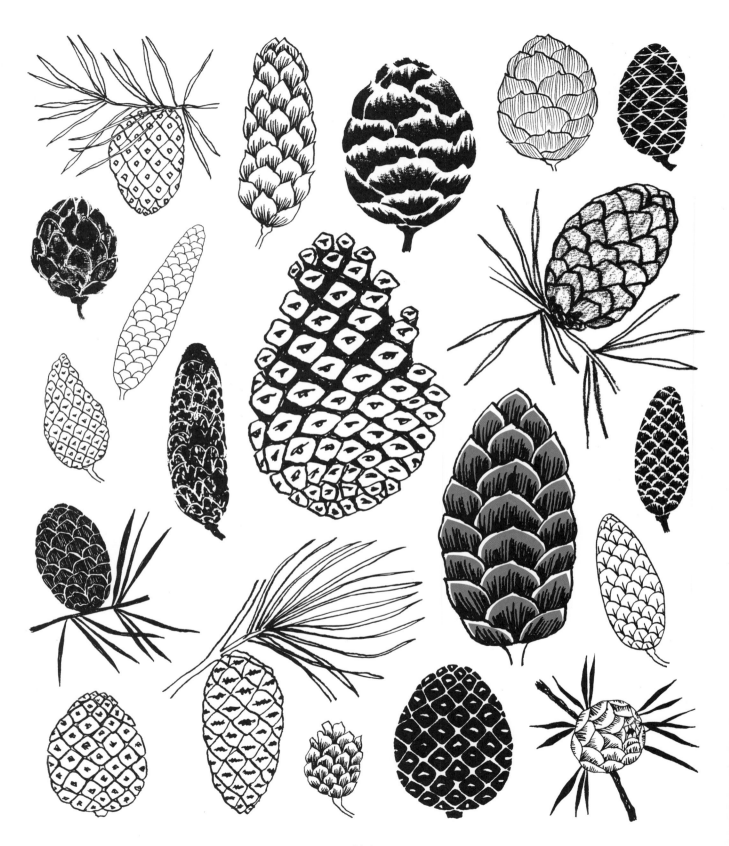

DRAW 20
PINECONES

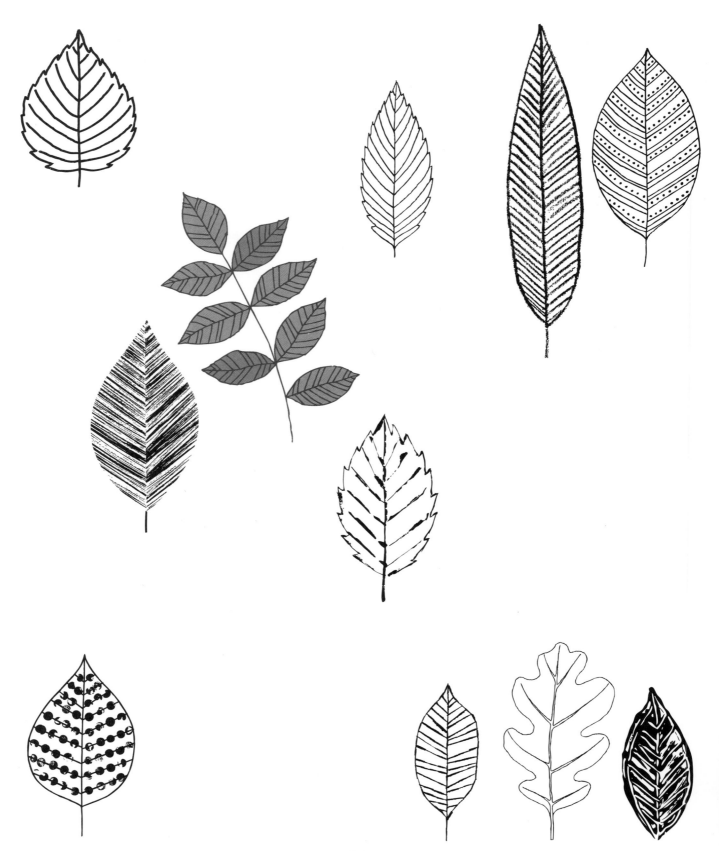

DRAW 20
LEAVES

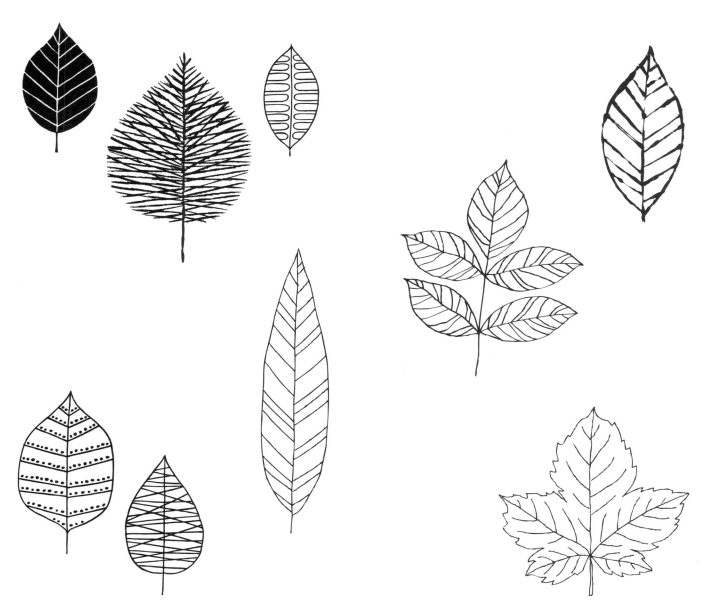

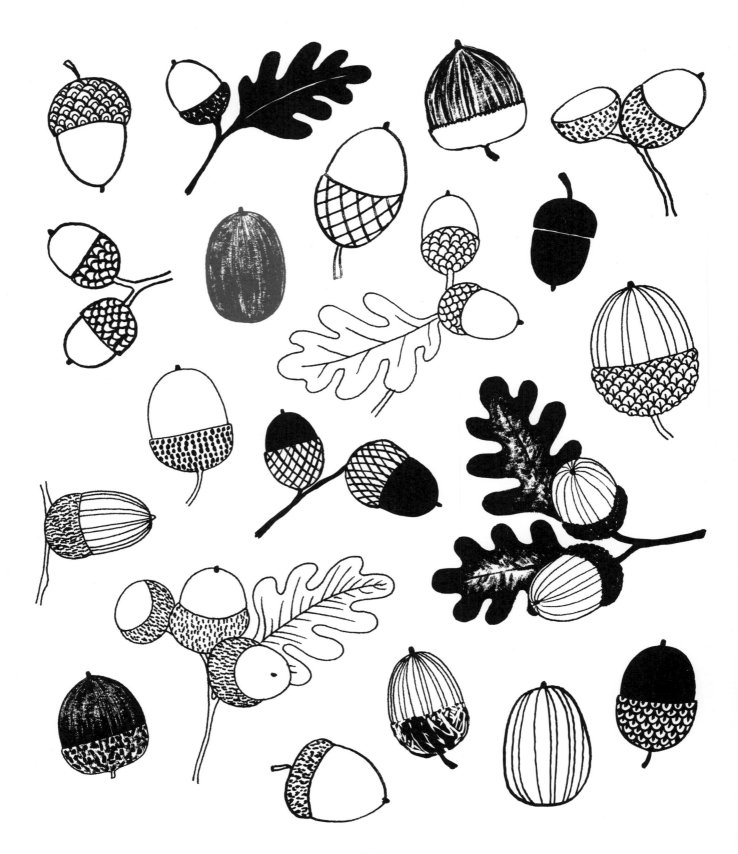

DRAW 20
acorns

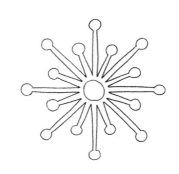

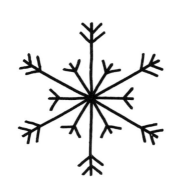

DRAW 20
SNOWFLAKES

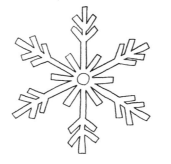

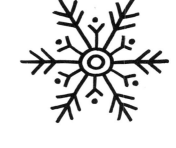

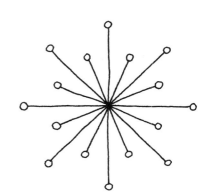

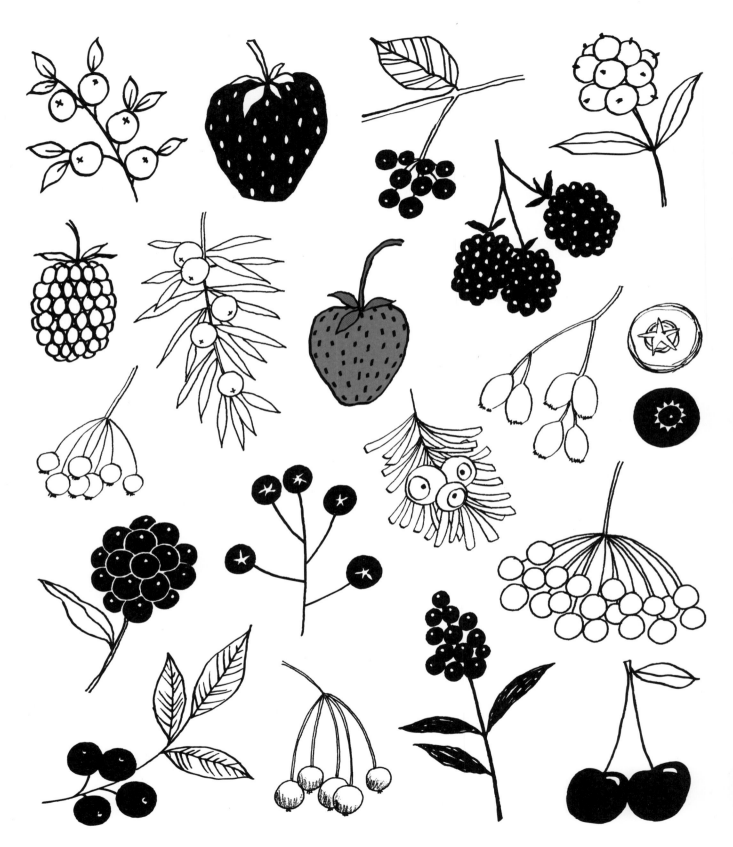

DRAW 20
berries

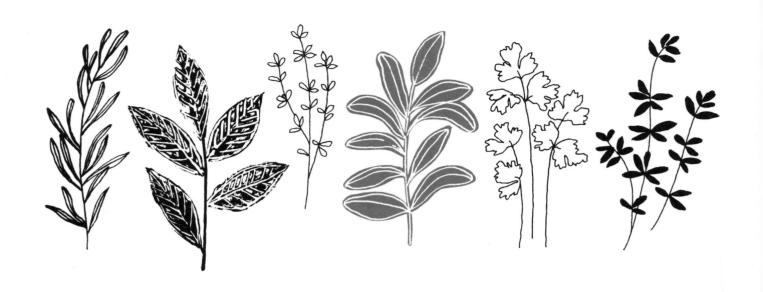

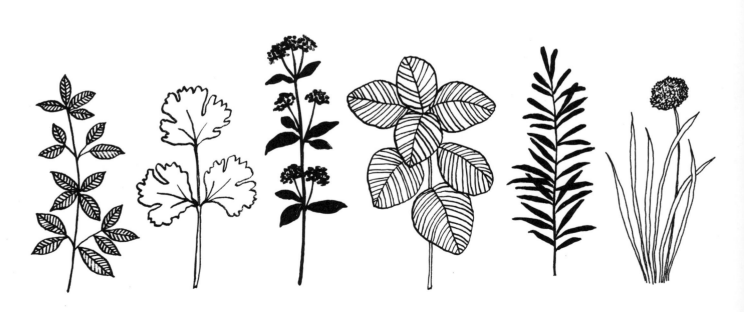

DRAW 20
Herbs

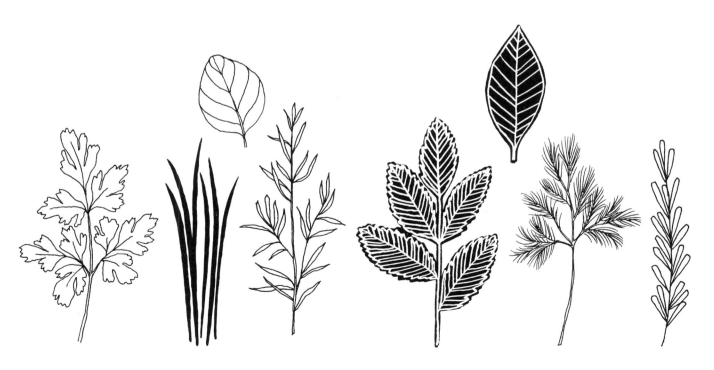

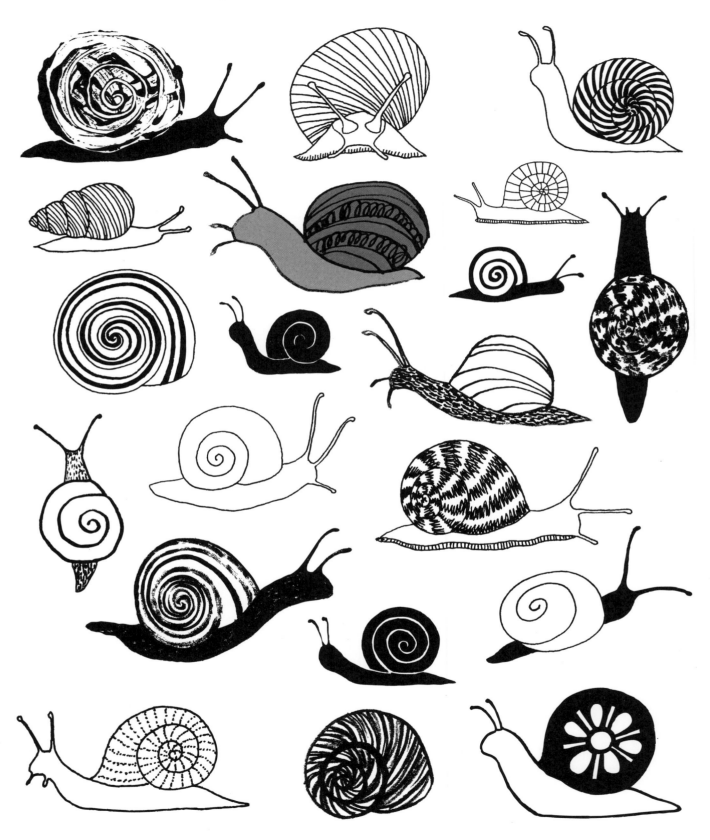

DRAW 20
snails

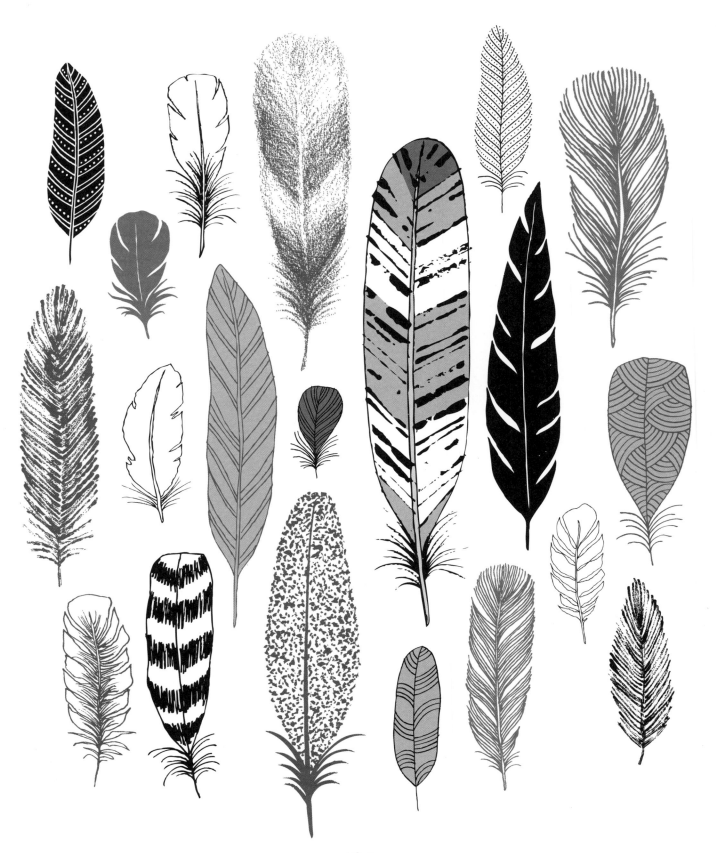

DRAW 20
FEATHERS

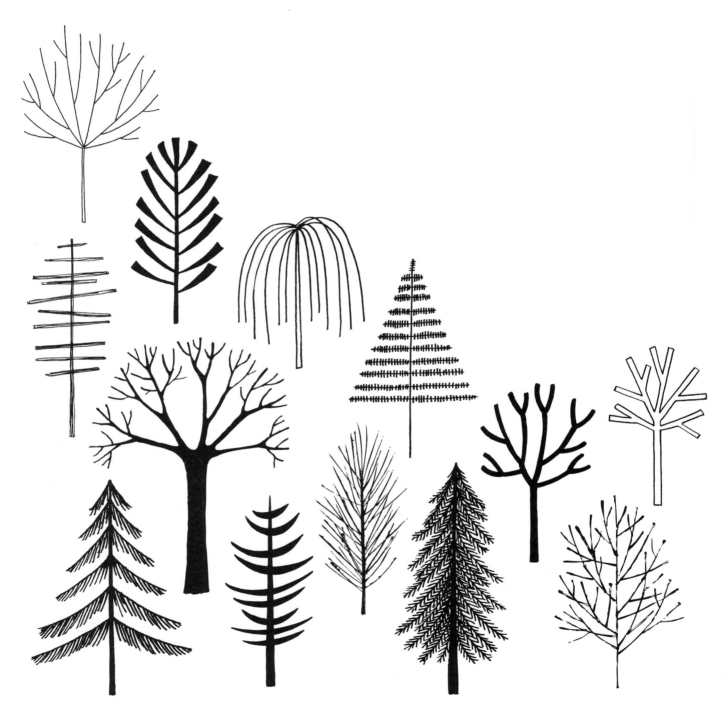

DRAW 20
Winter Trees

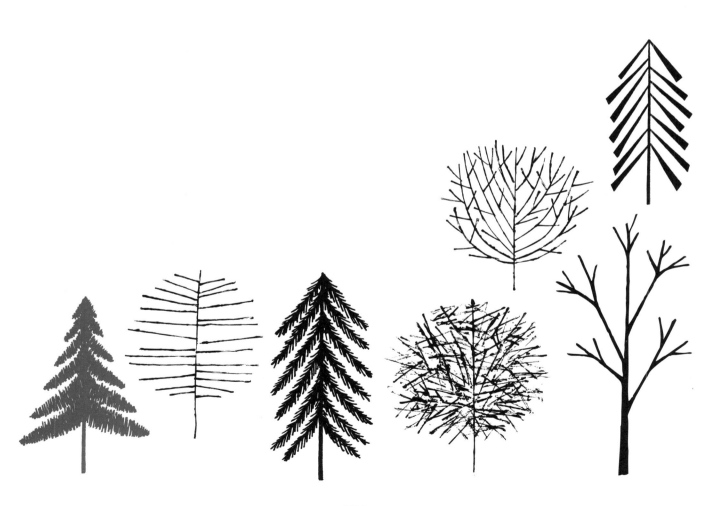

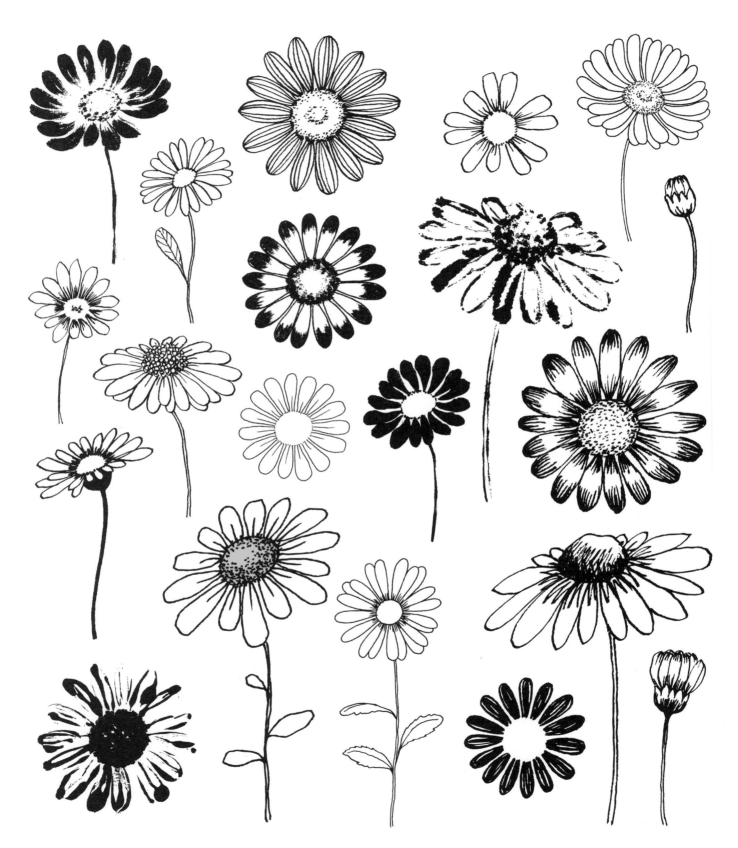

DRAW 20
daisies

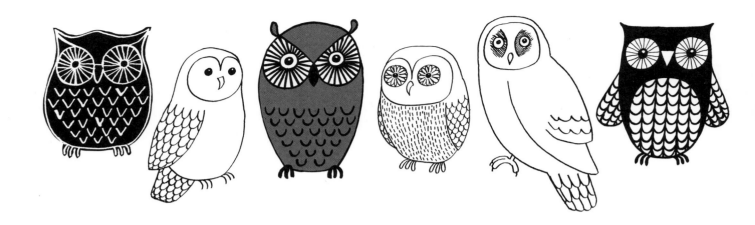

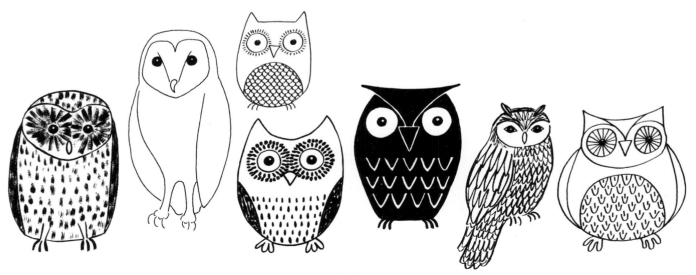

DRAW 20
Owls

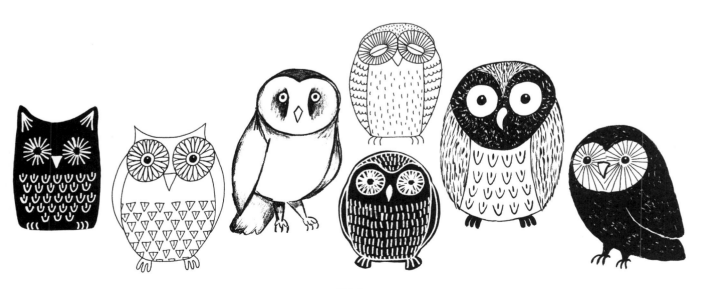

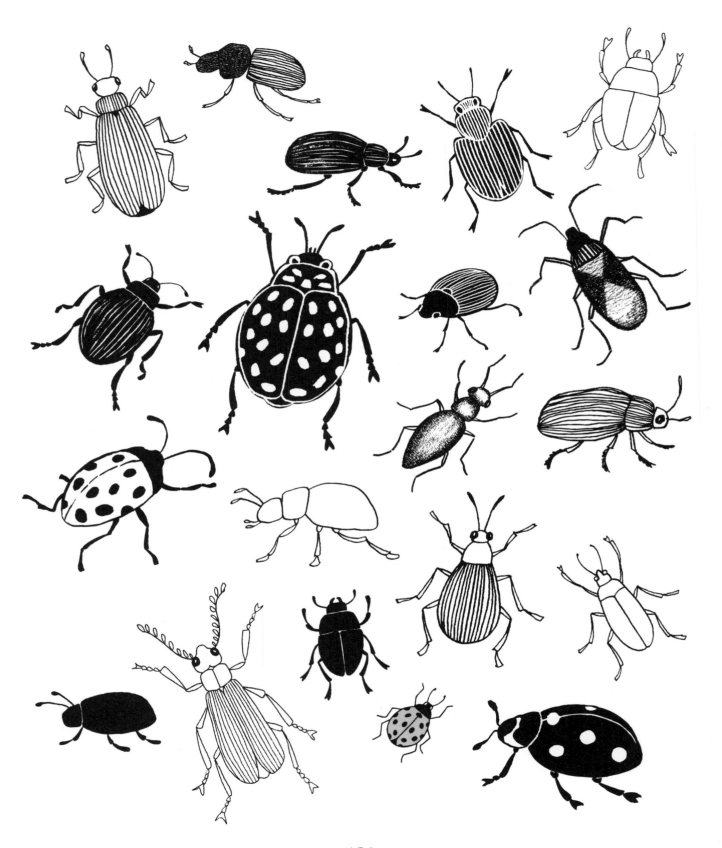

DRAW 20
Beetles

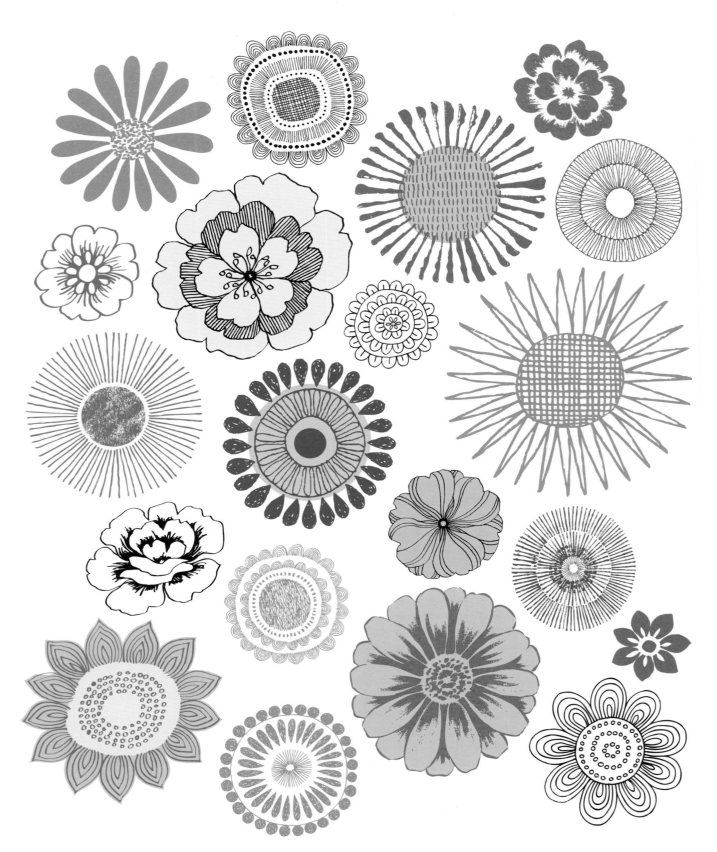

DRAW 20
flowers

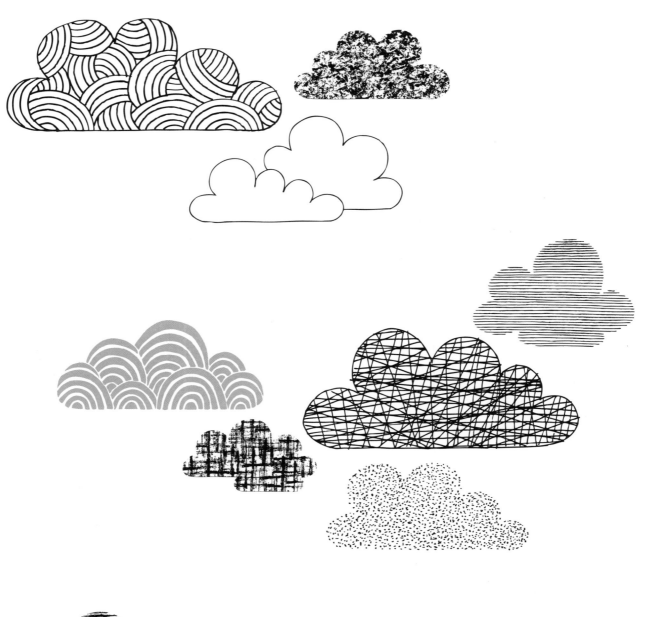

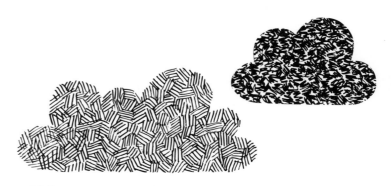

DRAW 20
CLOUDS

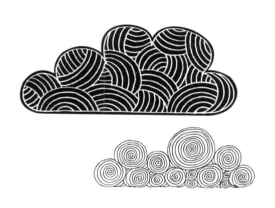

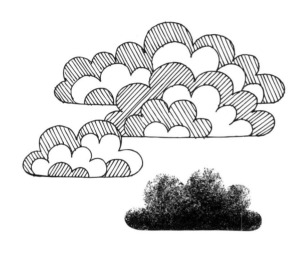

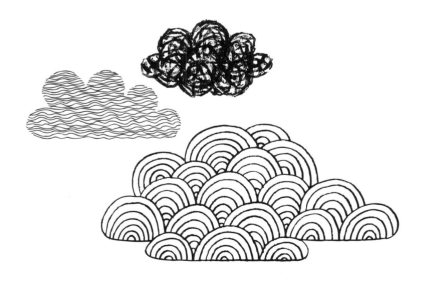

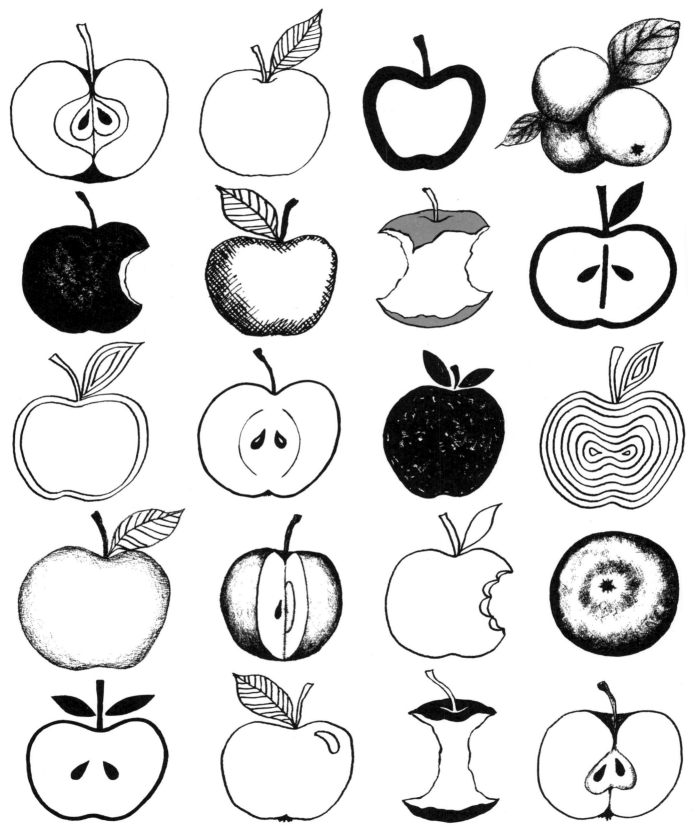

DRAW 20
apples

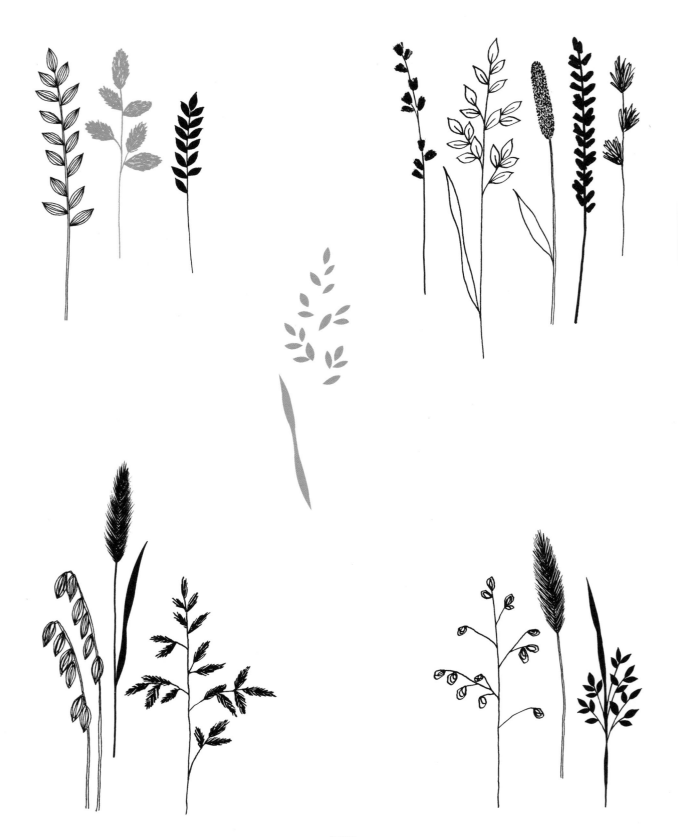

DRAW 20
GRASSES

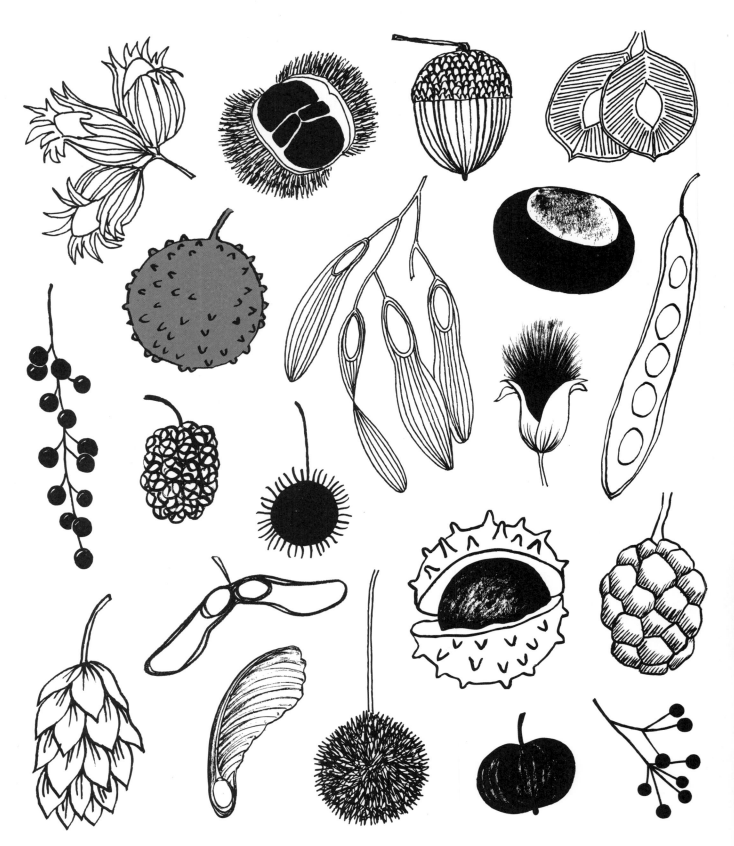

DRAW 20
tree seeds

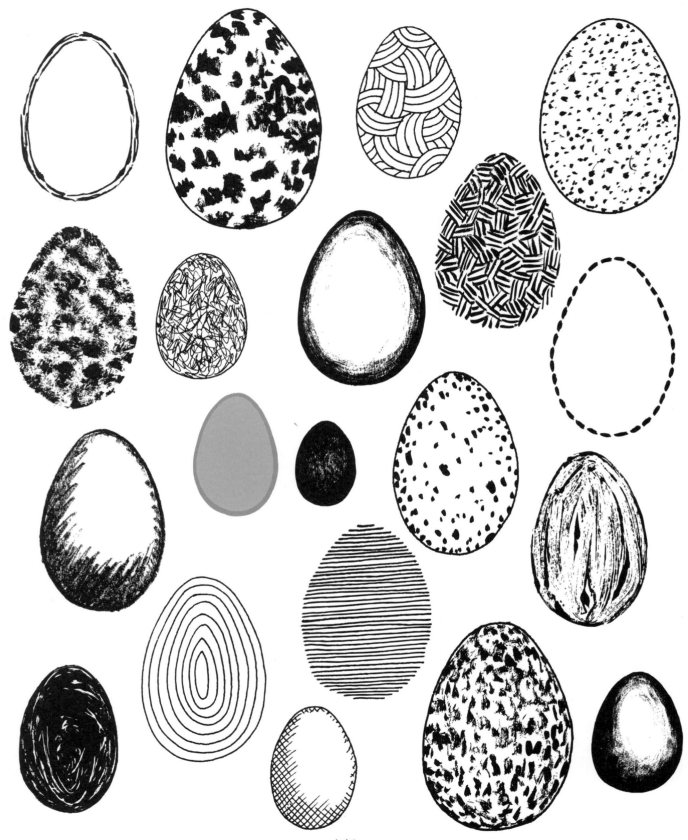

DRAW 20
eggs

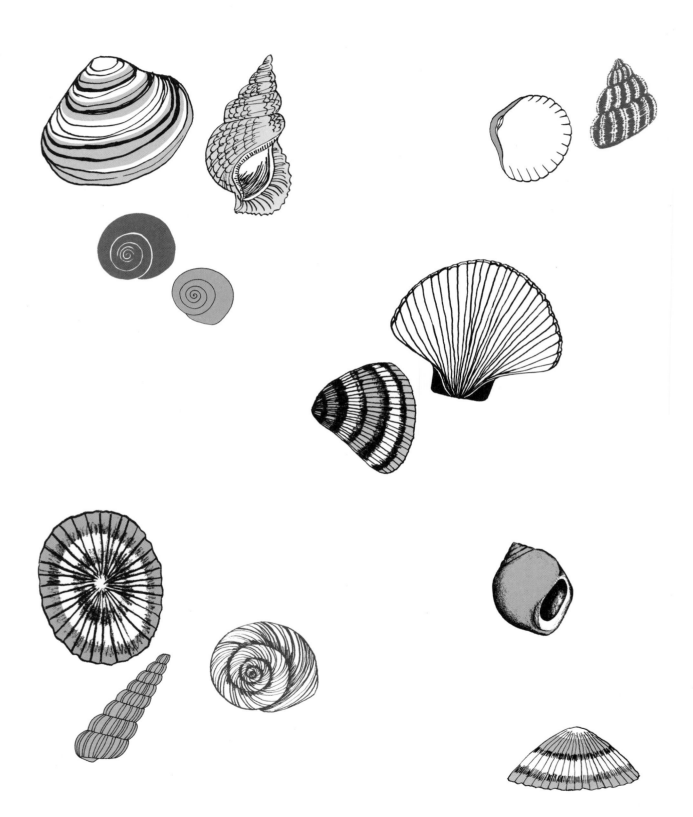

DRAW 20
shells

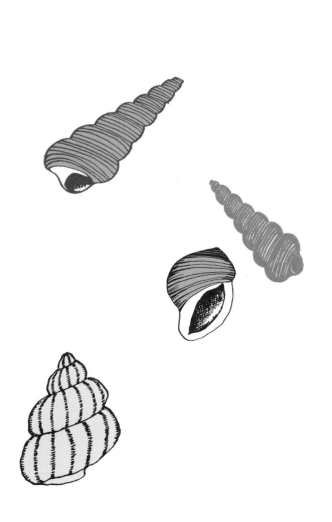

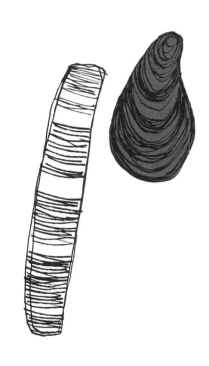

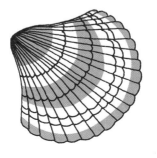

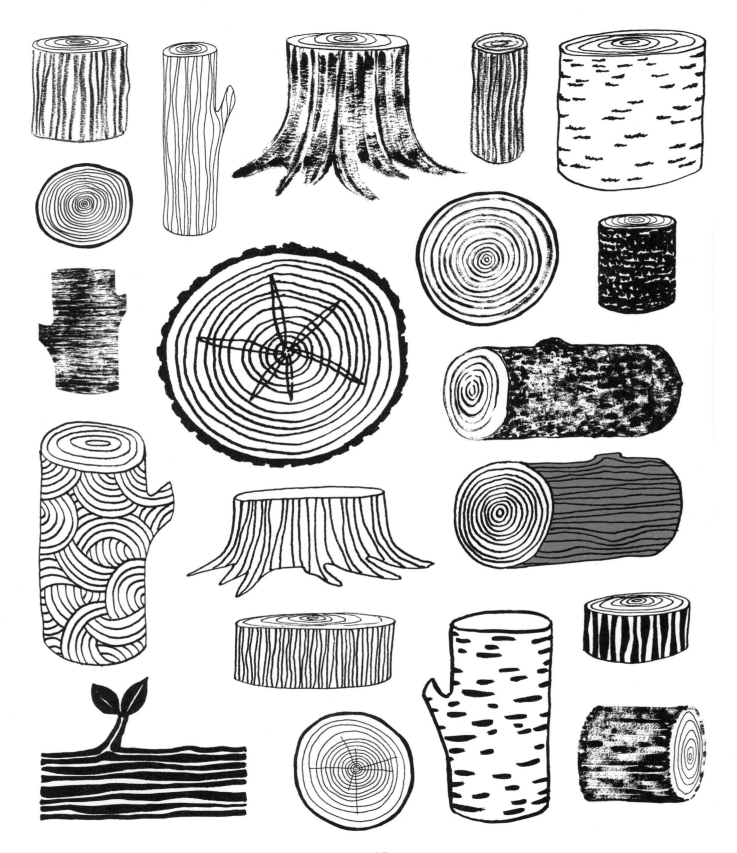

DRAW 20

logs

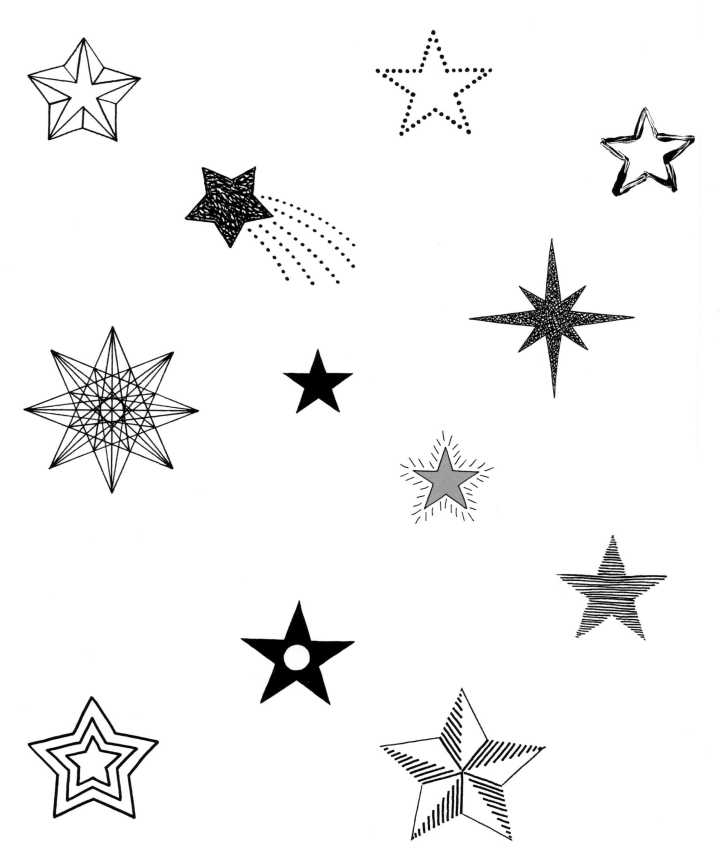

DRAW 20
STARS

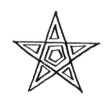

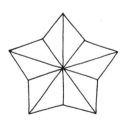

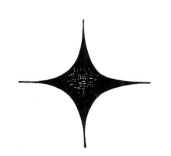
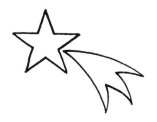

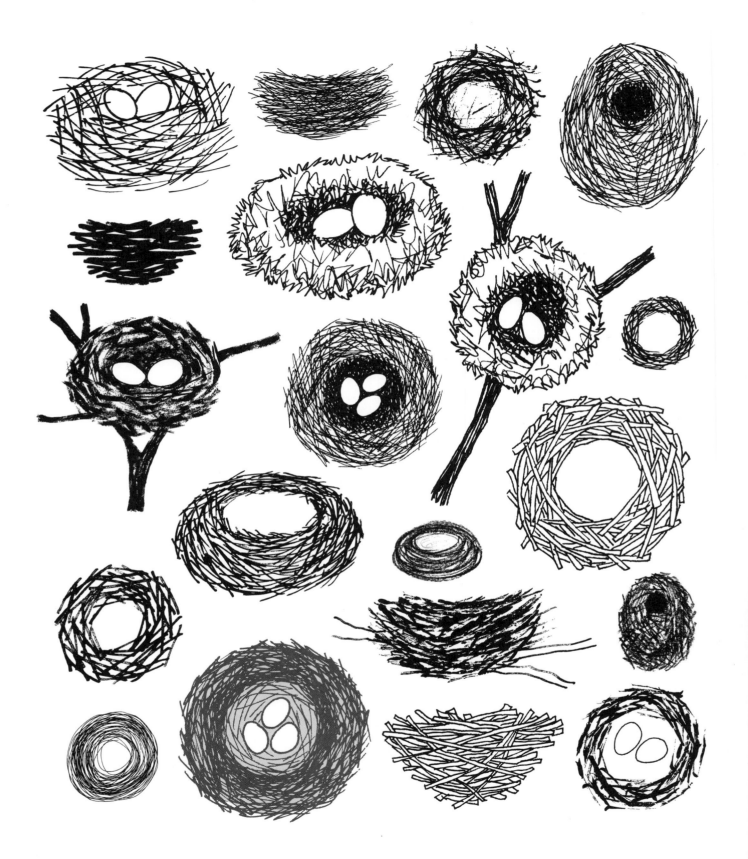

DRAW 20
nests

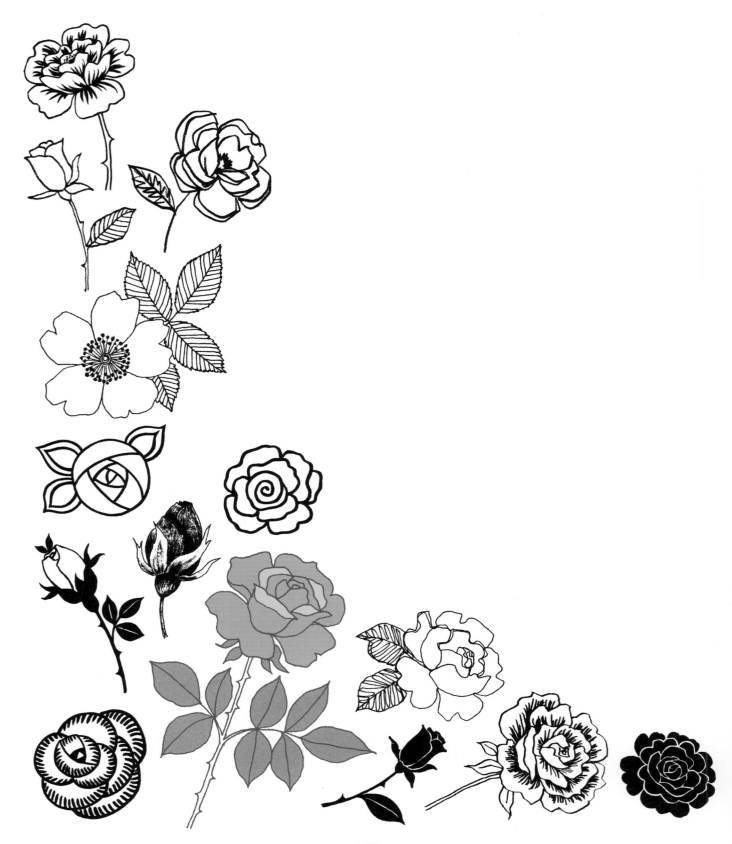

DRAW 20
roses

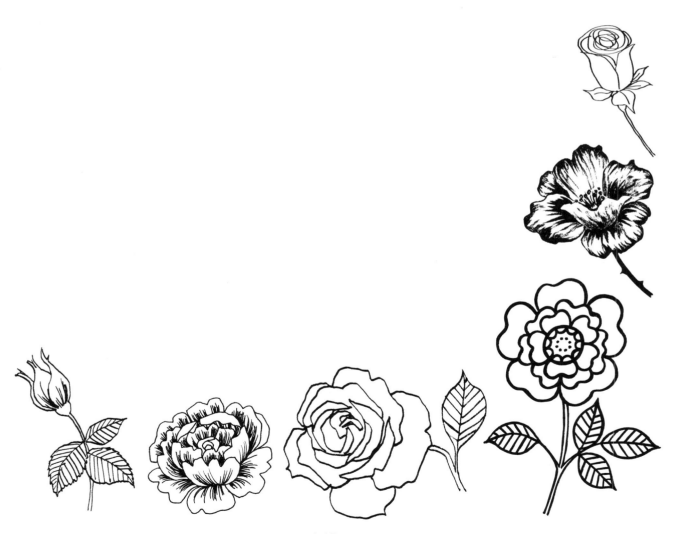

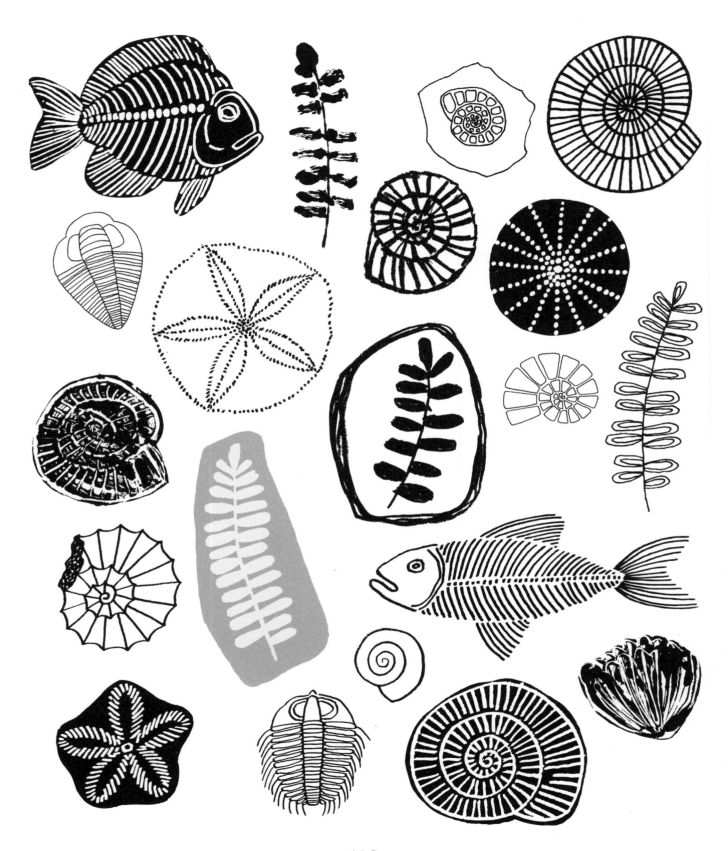

DRAW 20
FOSSILS

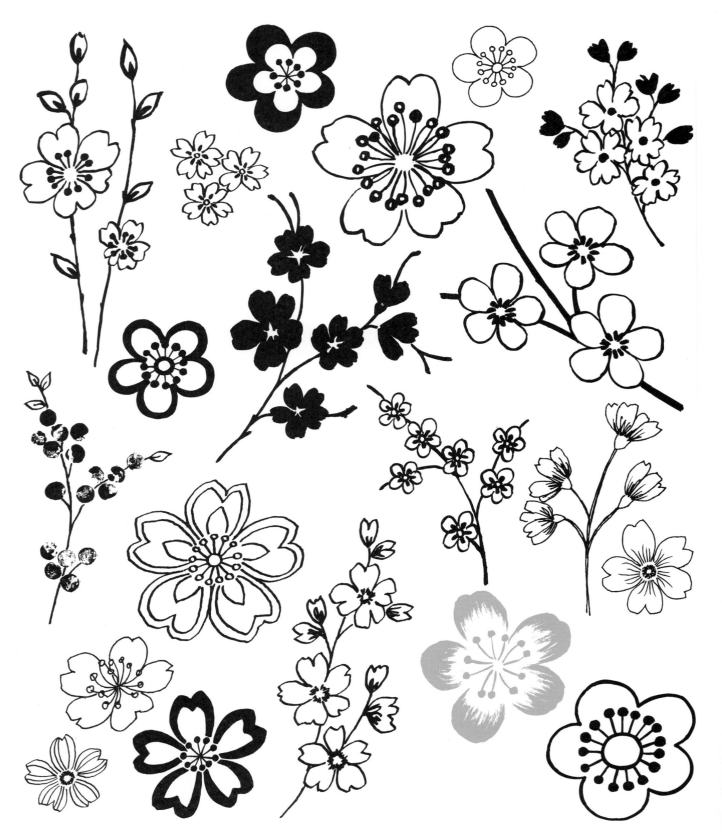

DRAW 20

blossoms

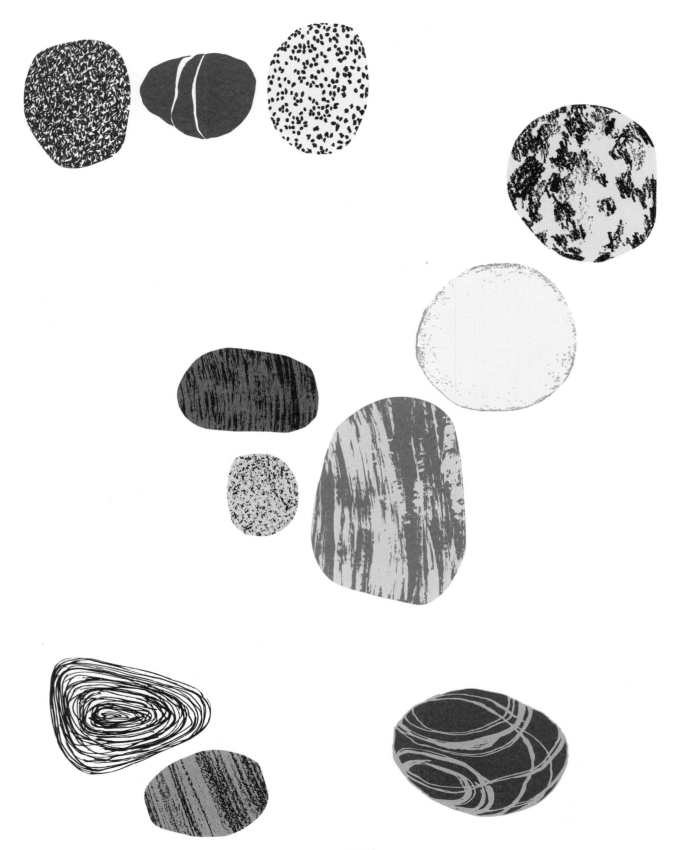

DRAW 20
STONES

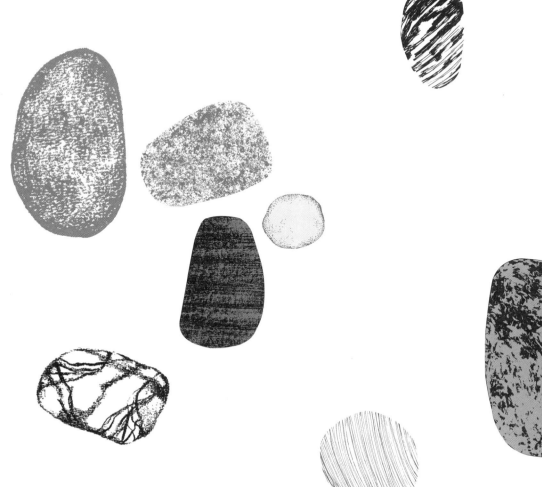

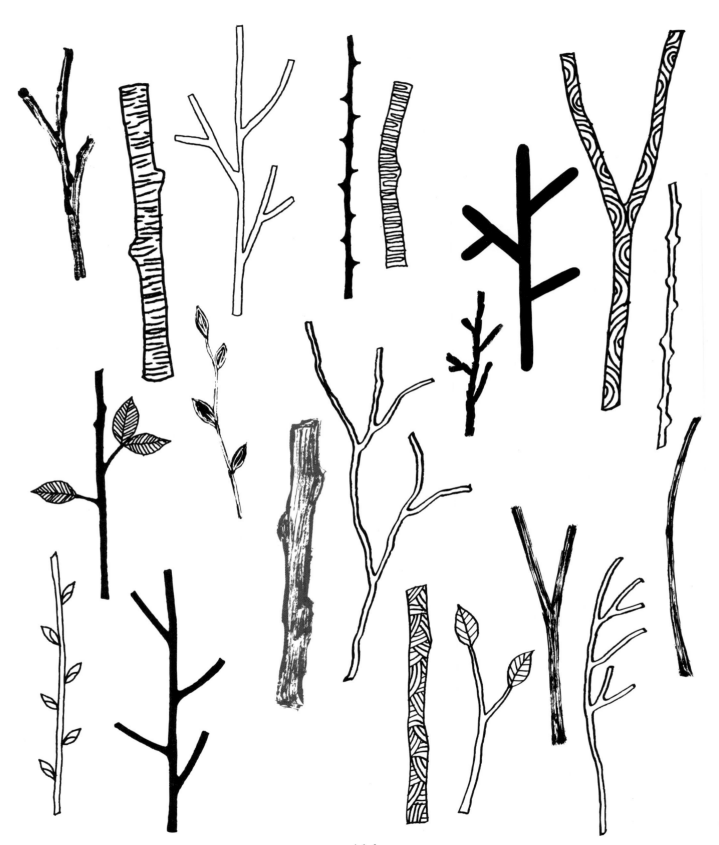

DRAW 20
TWIGS

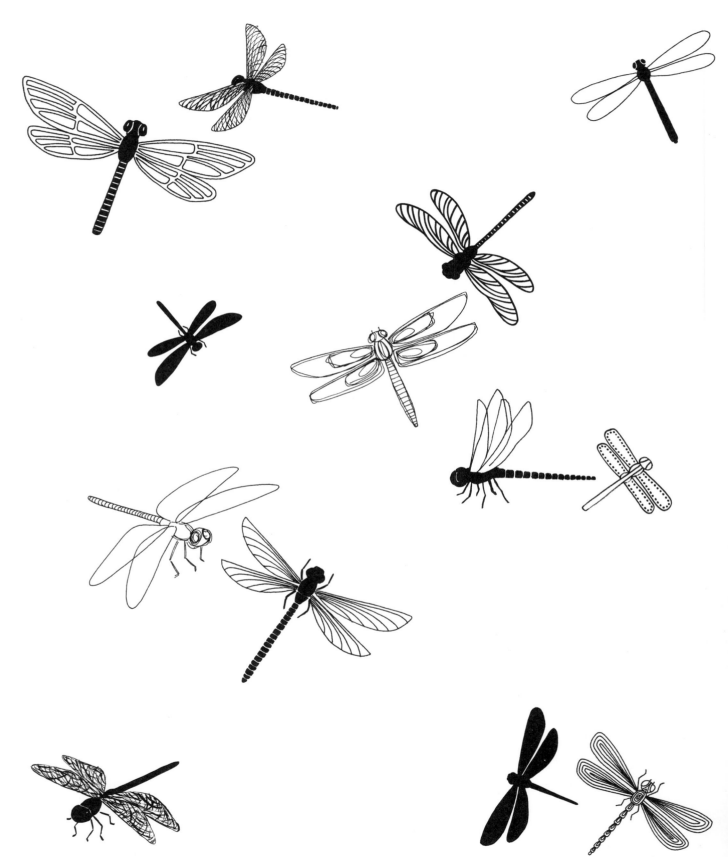

DRAW 20
Dragonflies

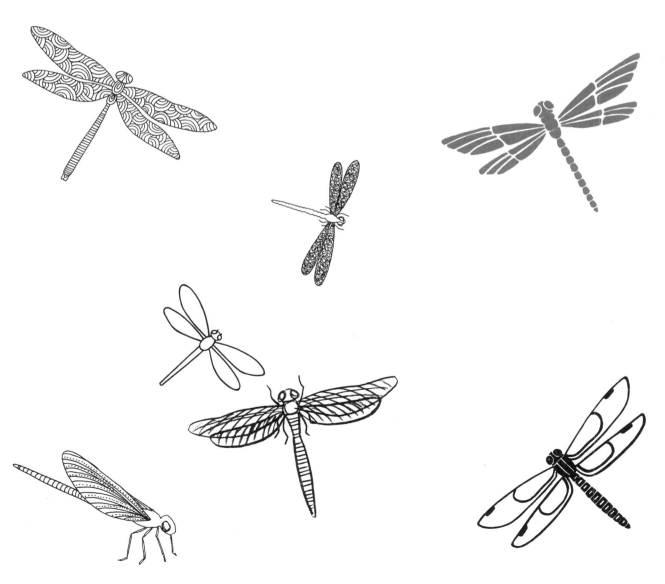

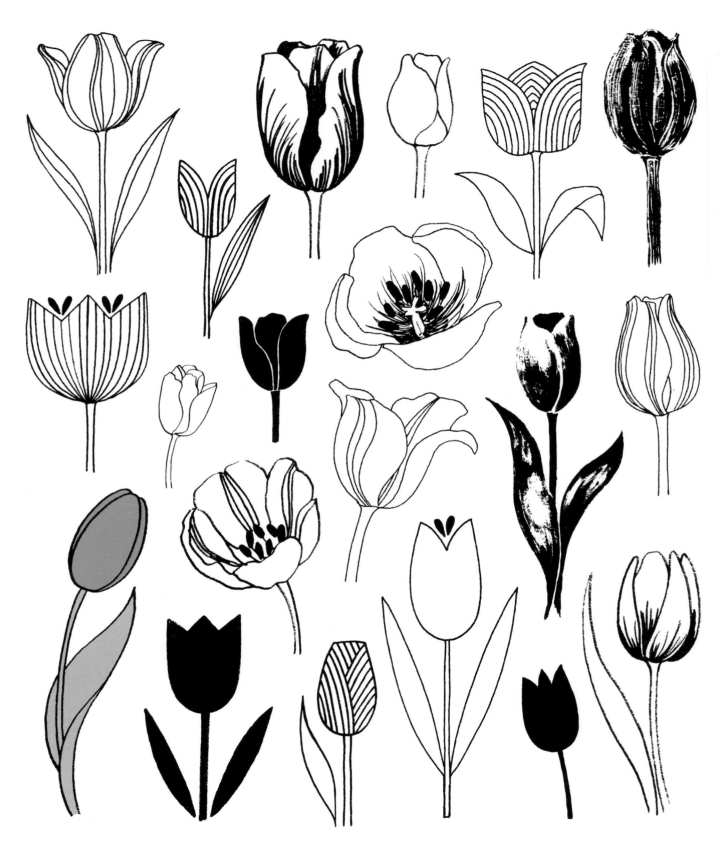

DRAW 20
Tulips

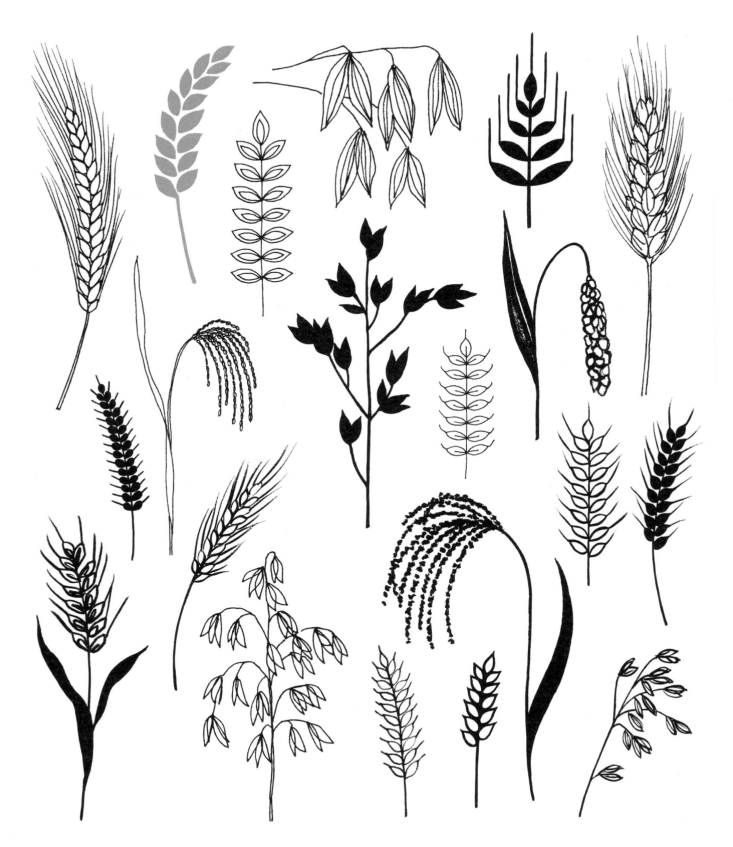

DRAW 20
GRAINS

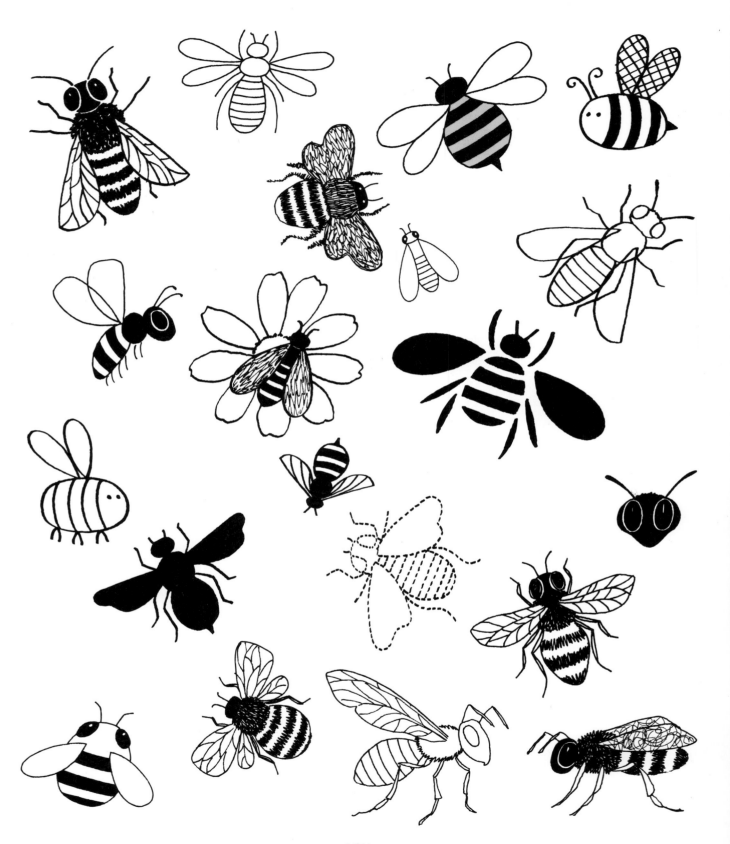

DRAW 20
BEES

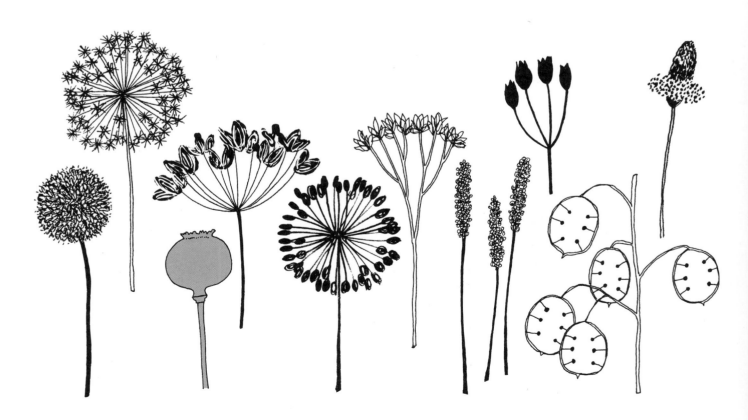

DRAW 20
seed heads

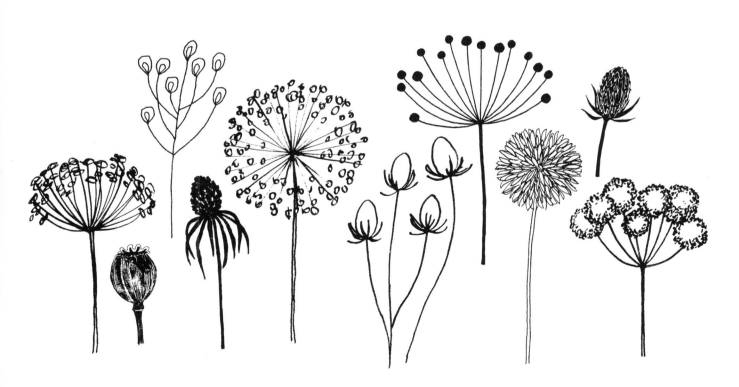

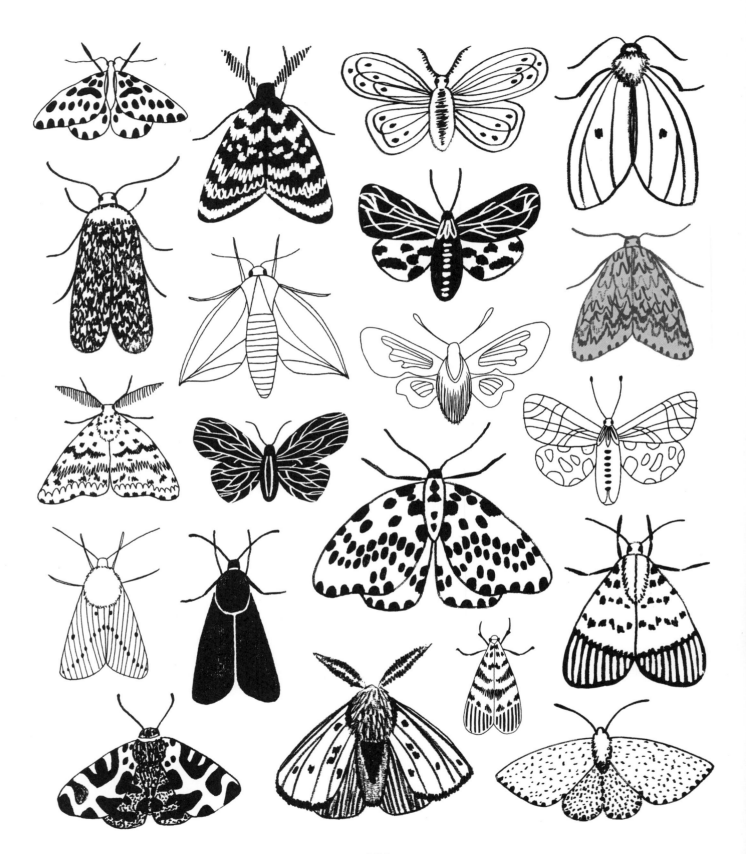

DRAW 20
MOTHS

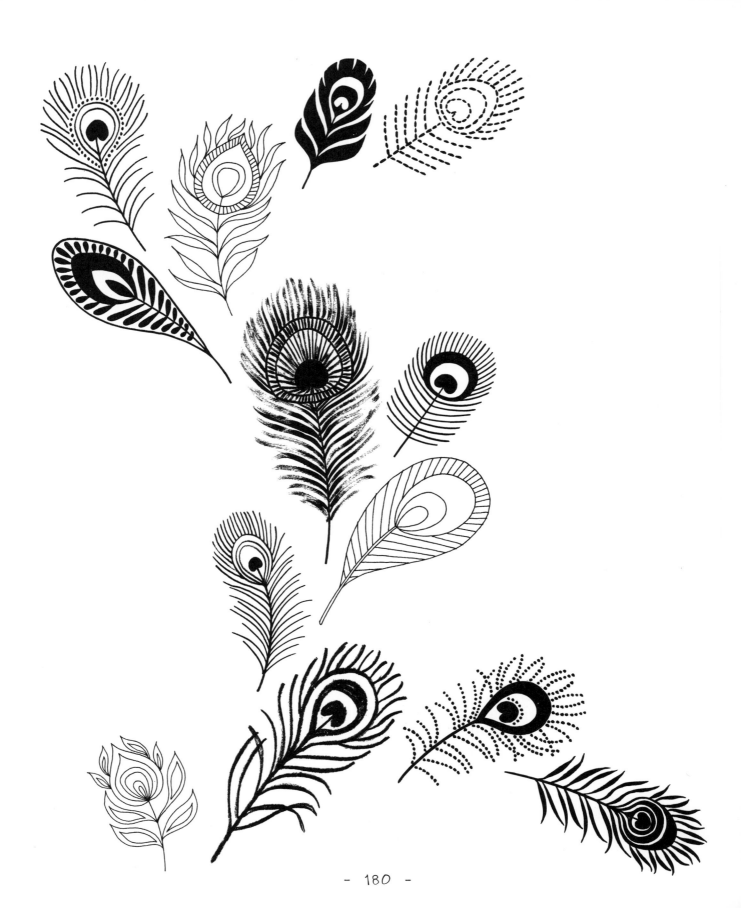

DRAW 20
PEACOCK FEATHERS

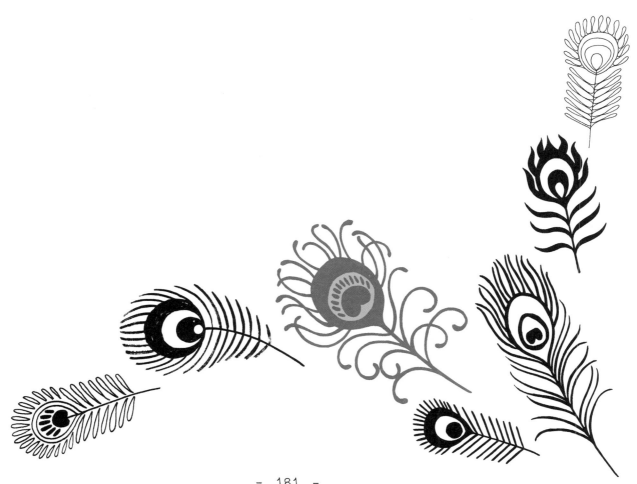

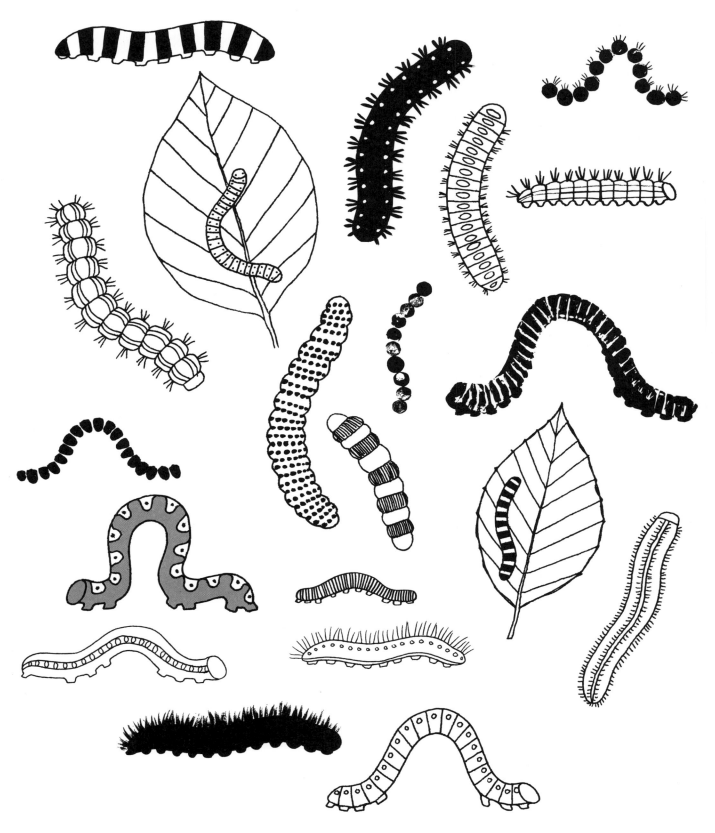

DRAW 20
caterpillars

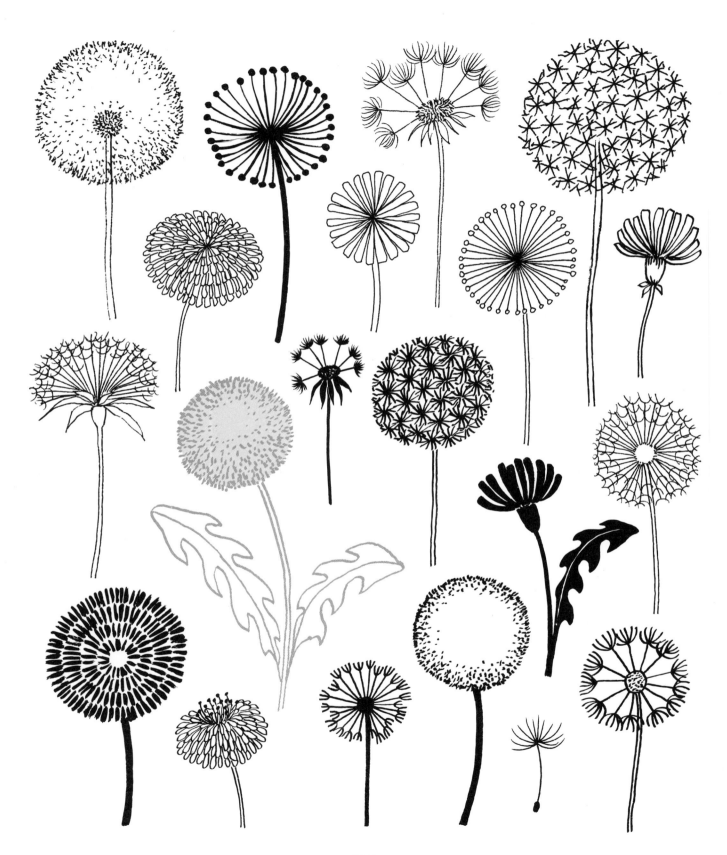

DRAW 20
DANDELIONS



DRAW 20
DANDELIONS

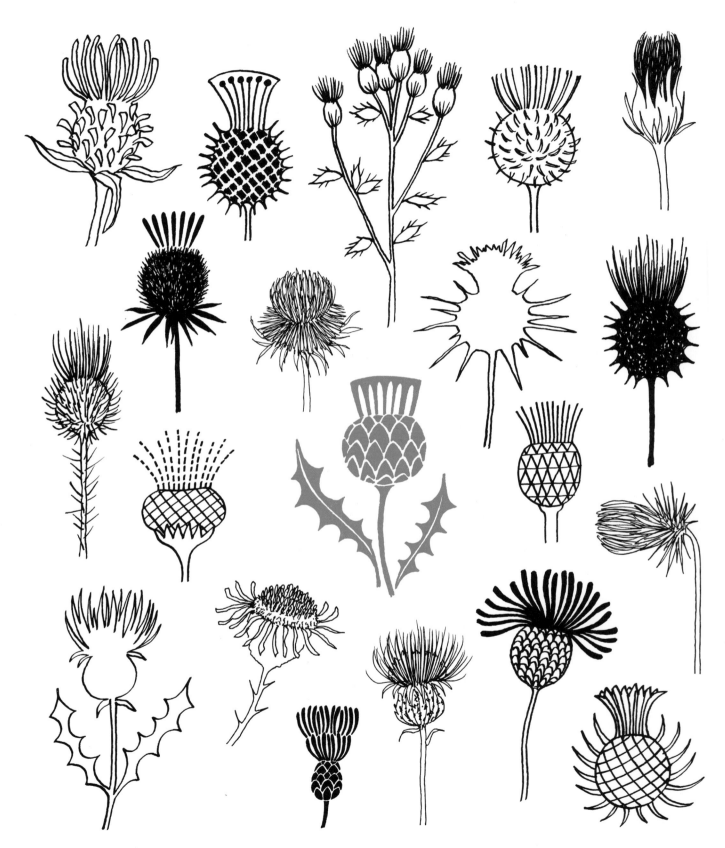

DRAW 20
thistles

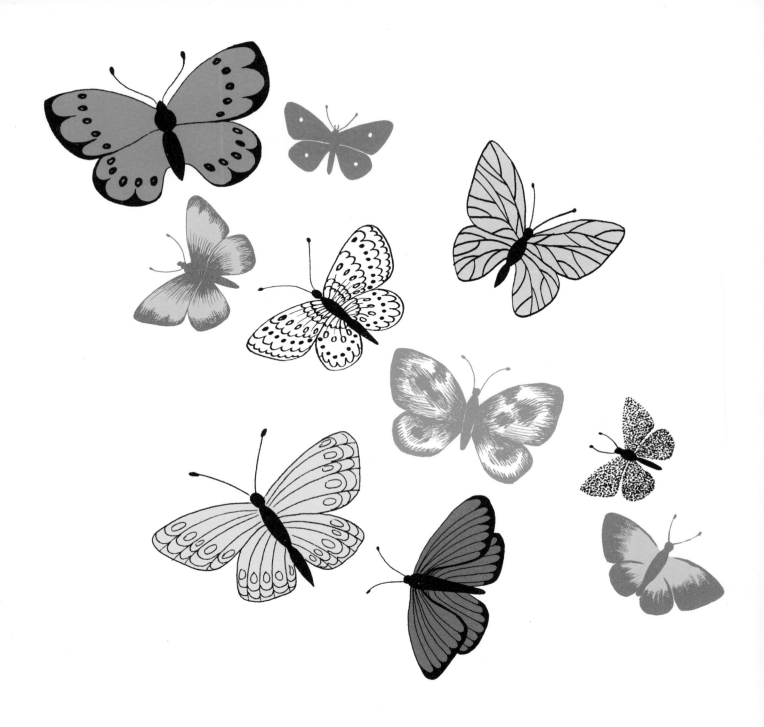

DRAW 20
butterflies

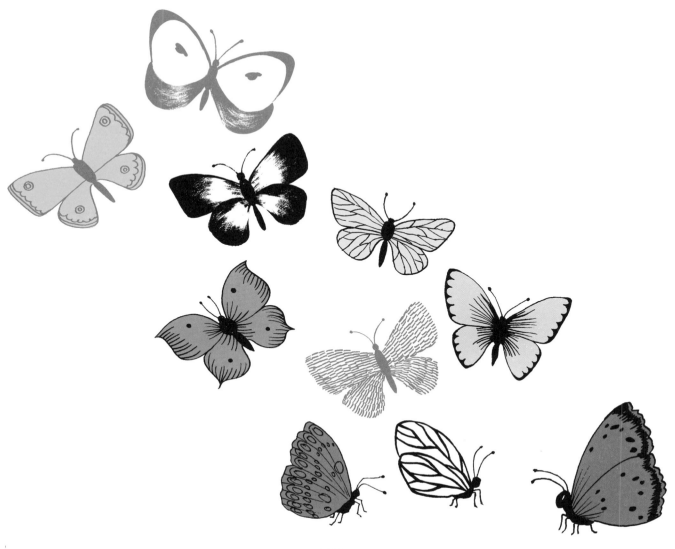

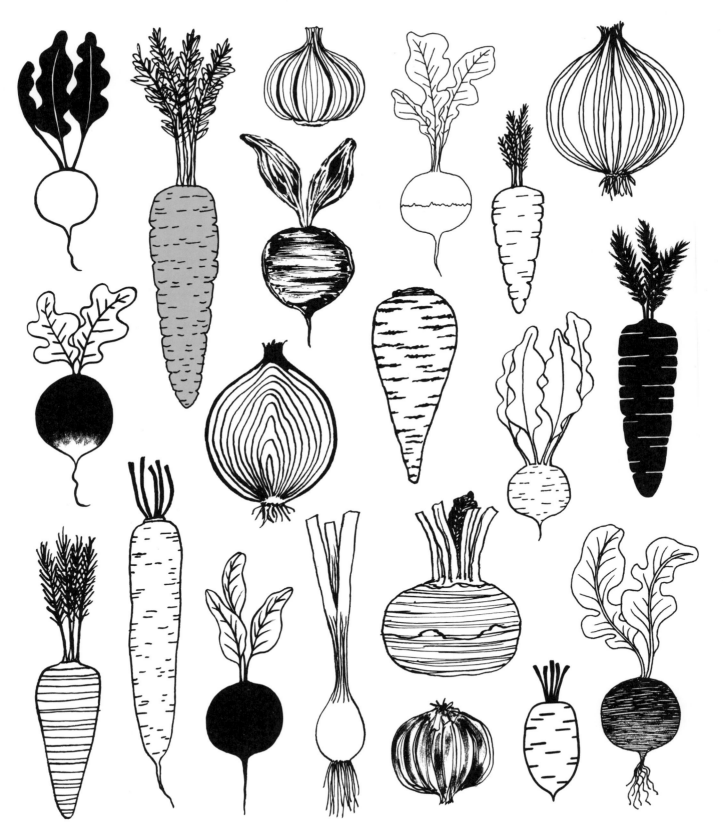

DRAW 20
root vegetables

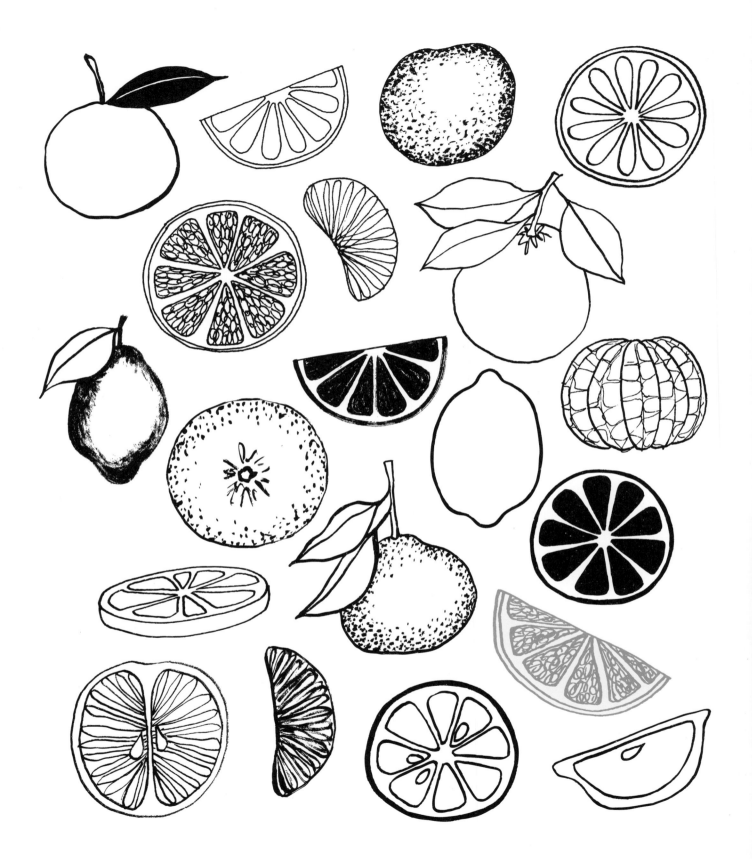

DRAW 20
citrus fruits

SECTION 3
FLOWERS

Illustrations by Lisa Congdon

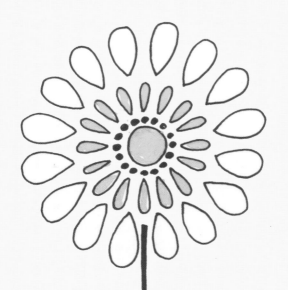

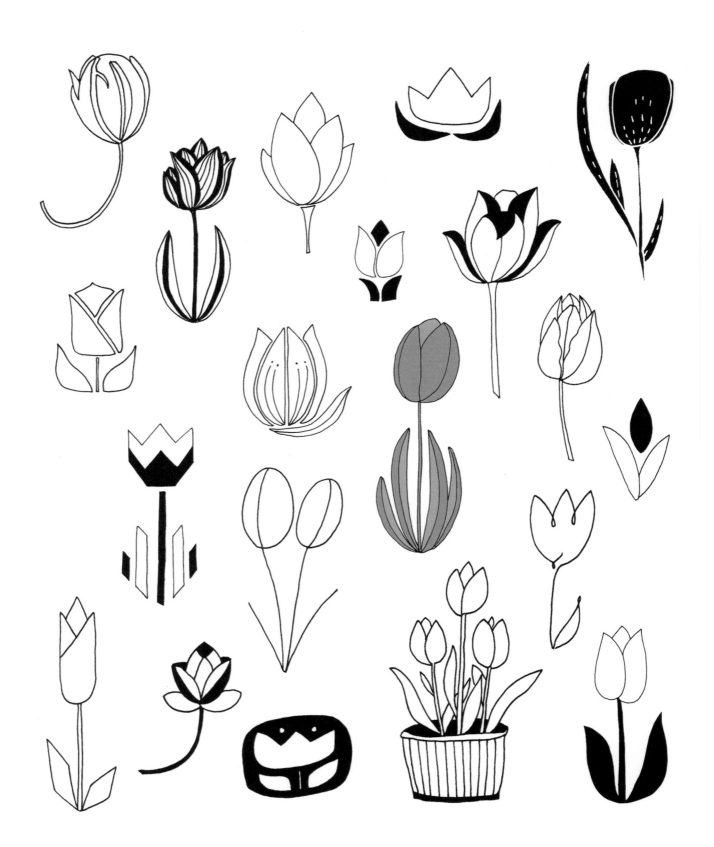

DRAW 20
Tulips

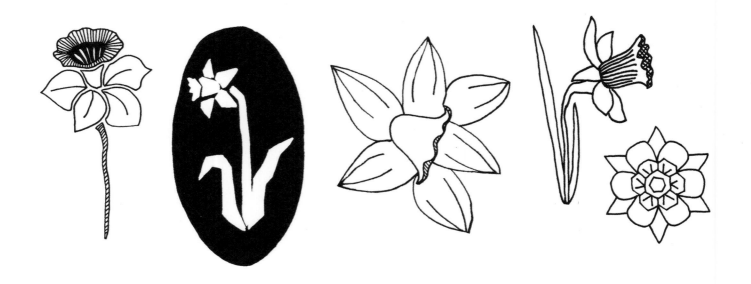

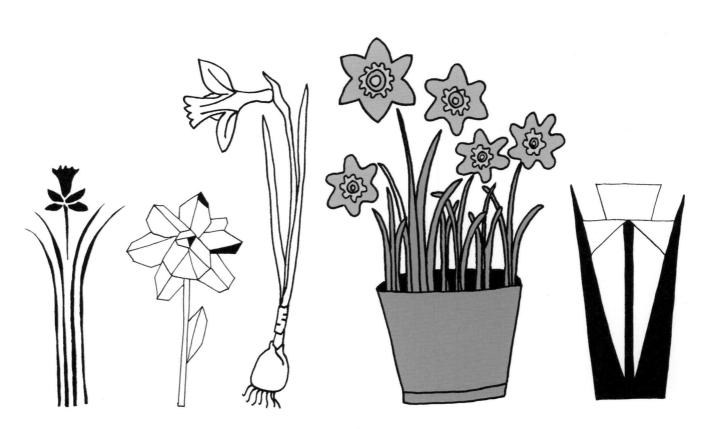

DRAW 20
DAFFODILS

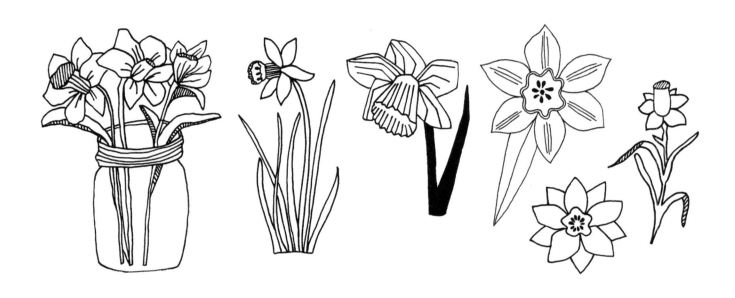

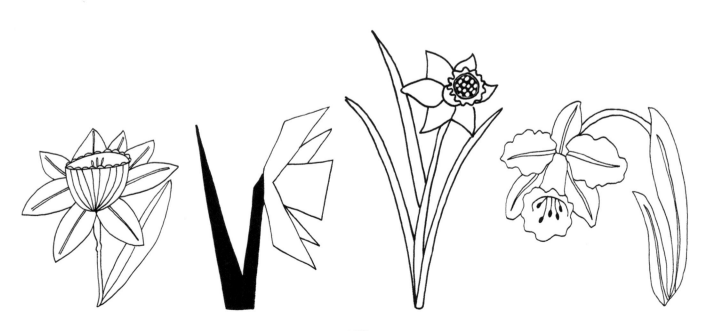

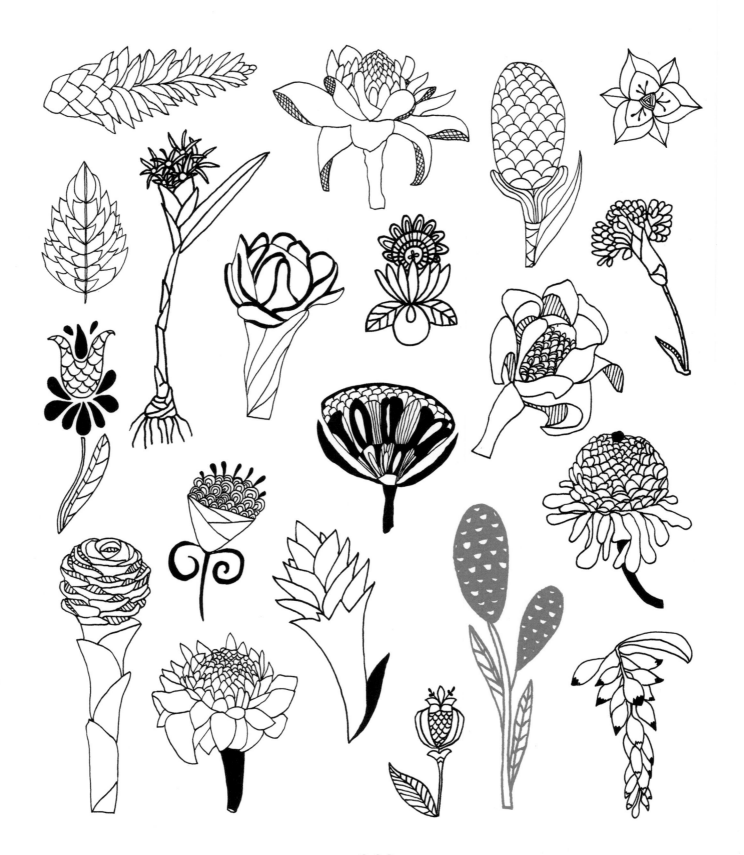

Ginger Blossoms

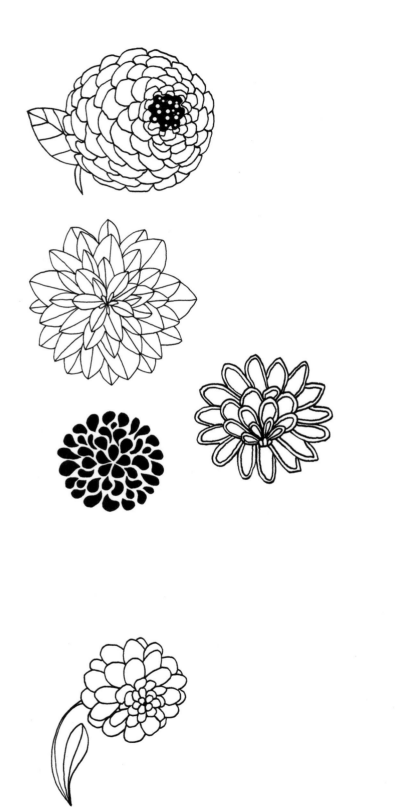

DRAW 20
Dahlias

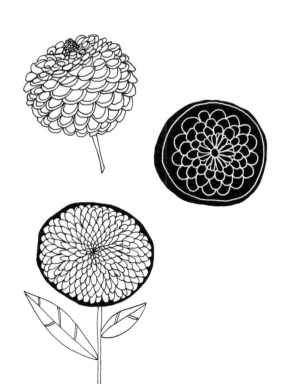

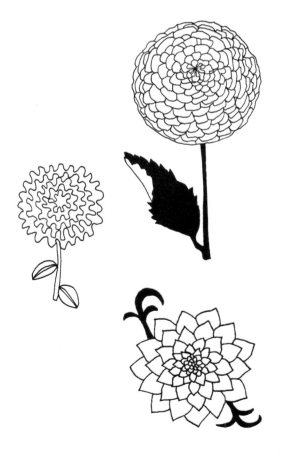

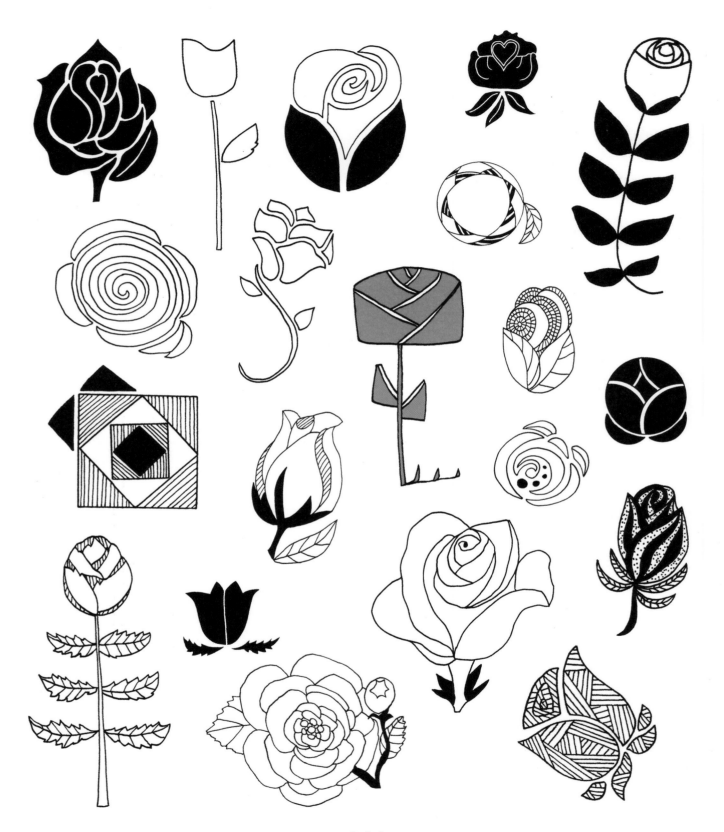

DRAW 20

Roses

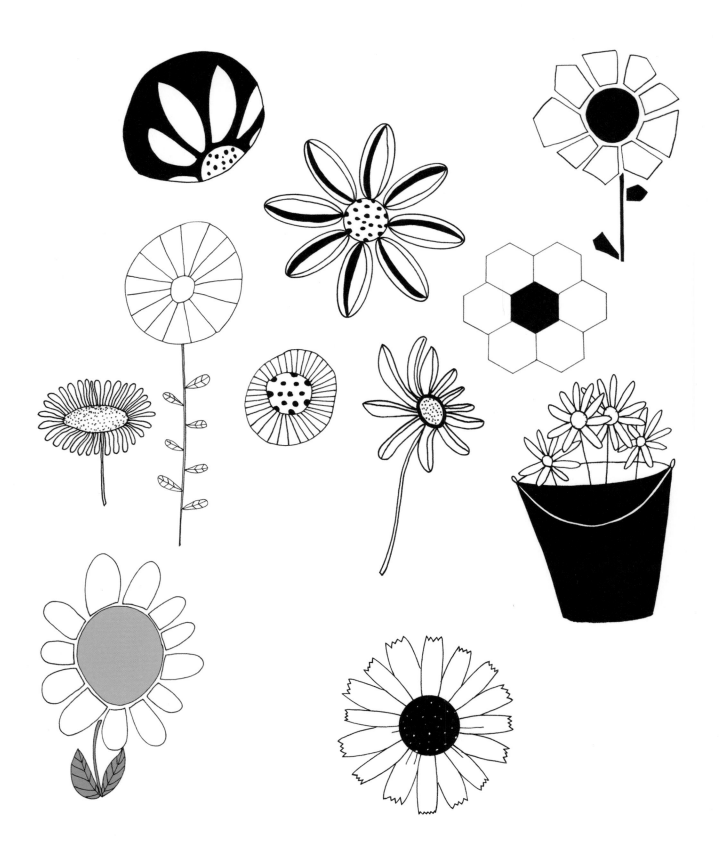

DRAW 20
DAISIES

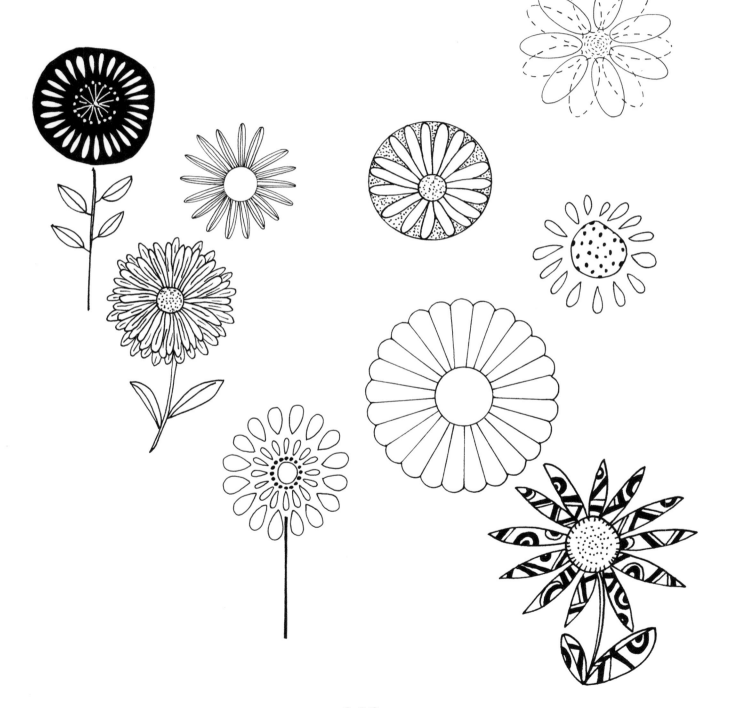

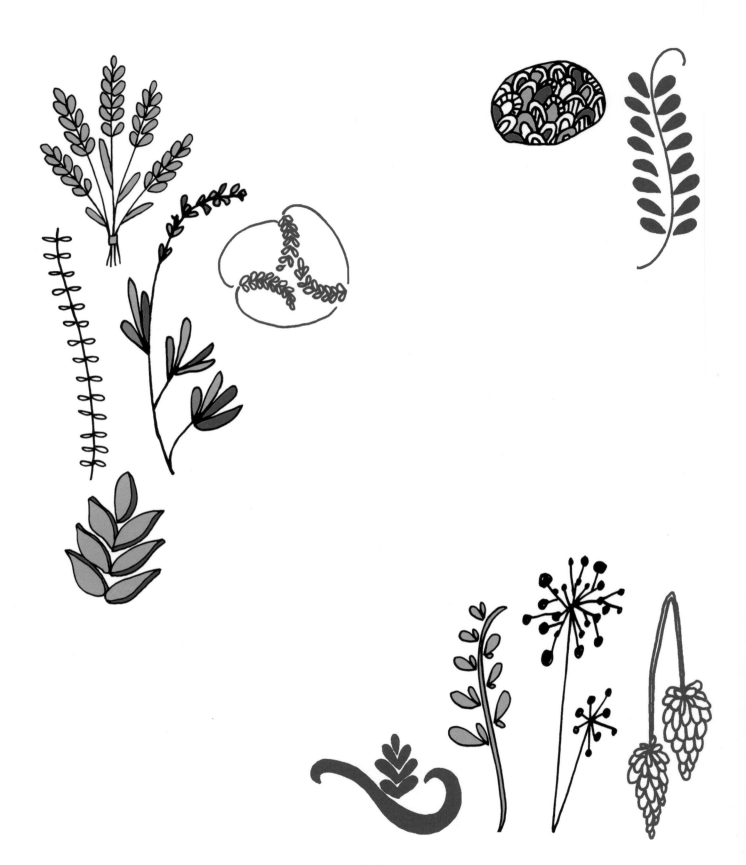

DRAW 20
Lavender Plants

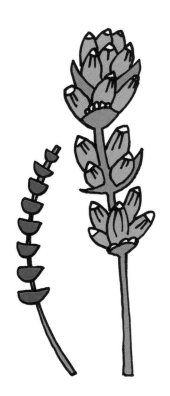

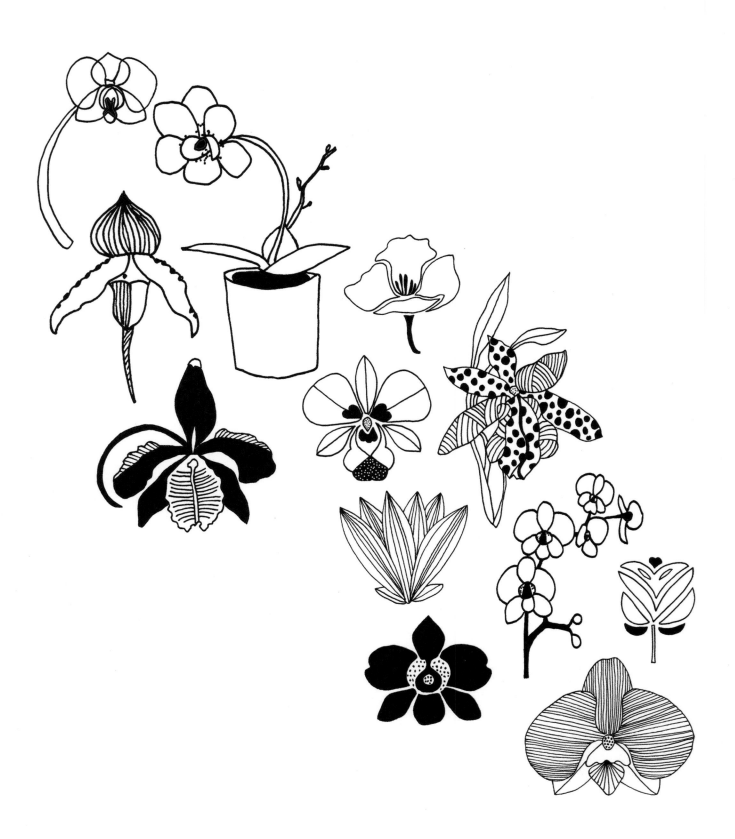

DRAW 20
Orchids

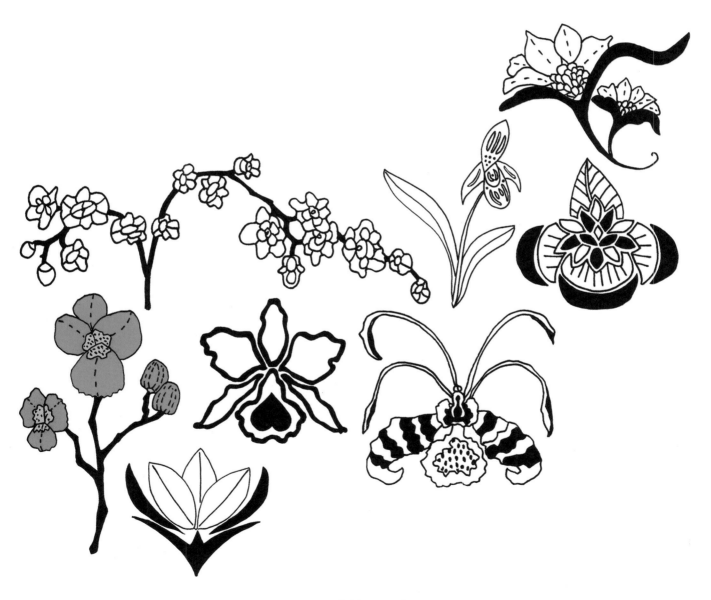

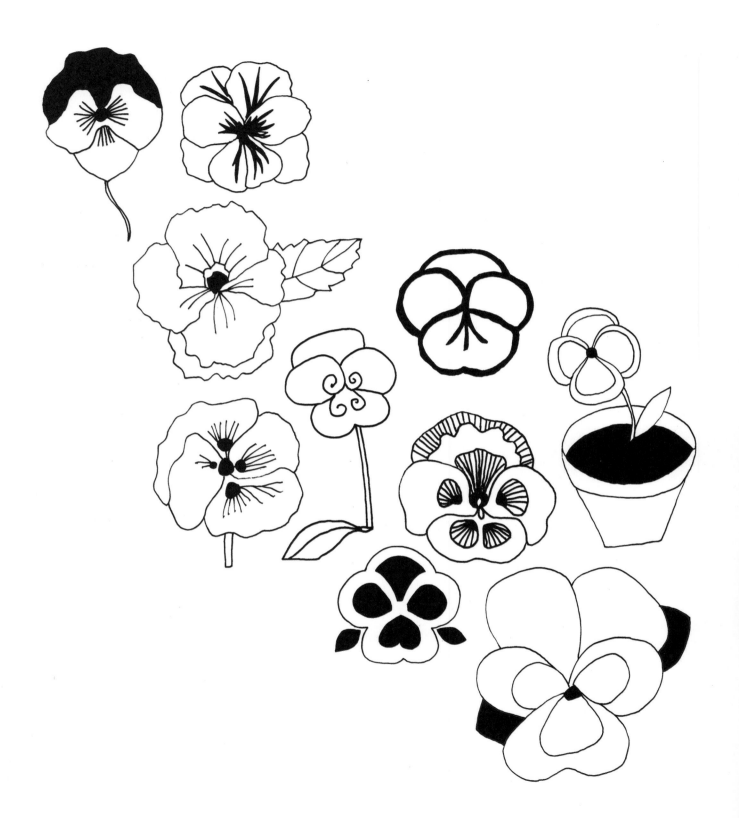

DRAW 20
Pansies

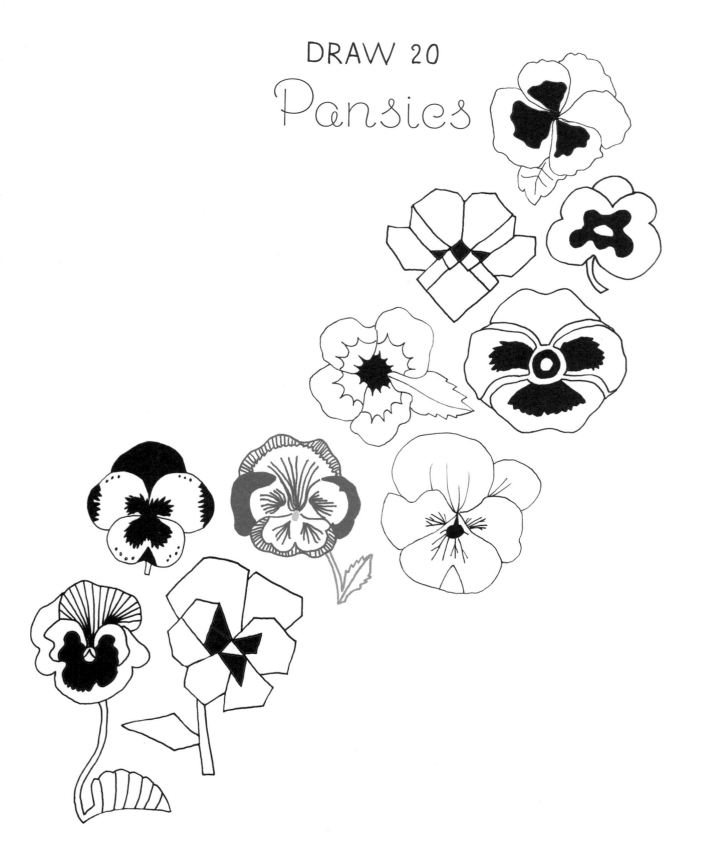

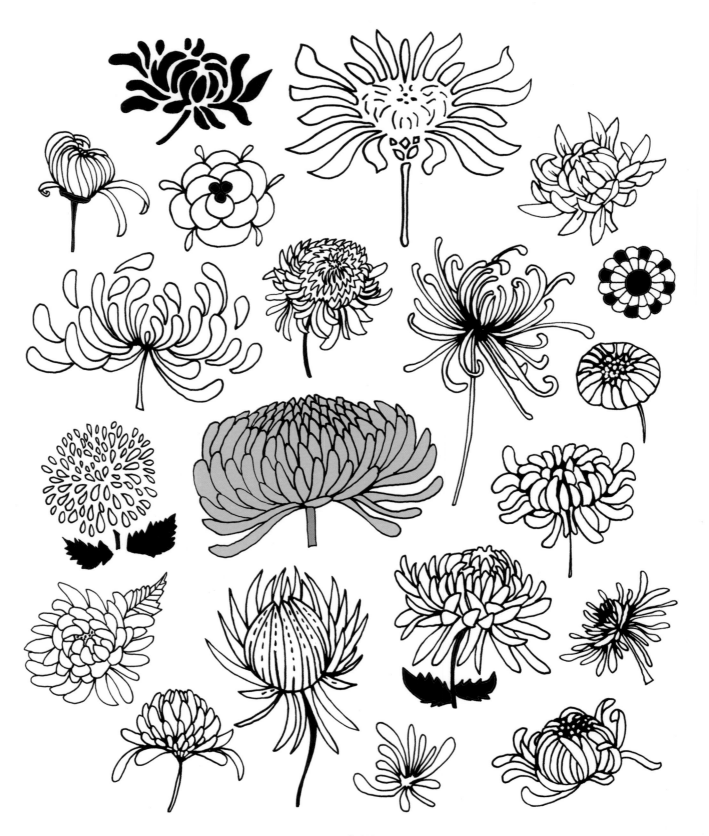

DRAW 20
Chrysanthemums

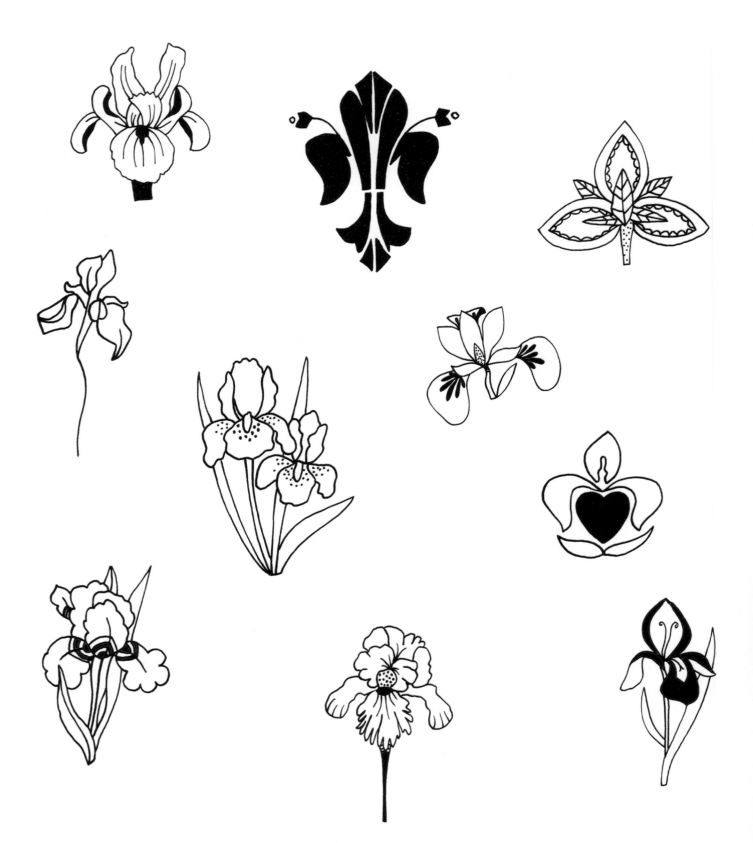

DRAW 20

Irises

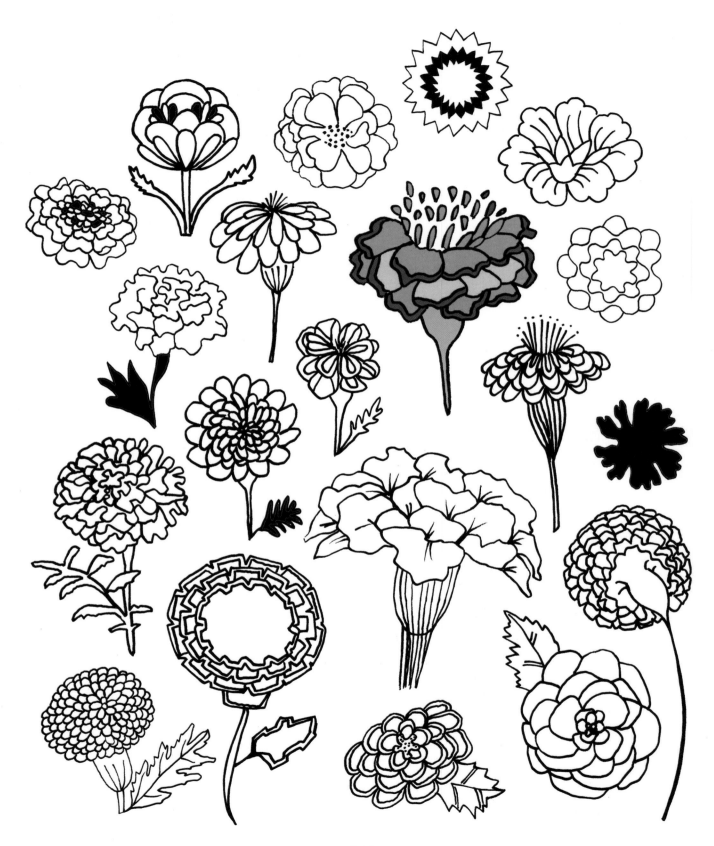

DRAW 20

Marigolds

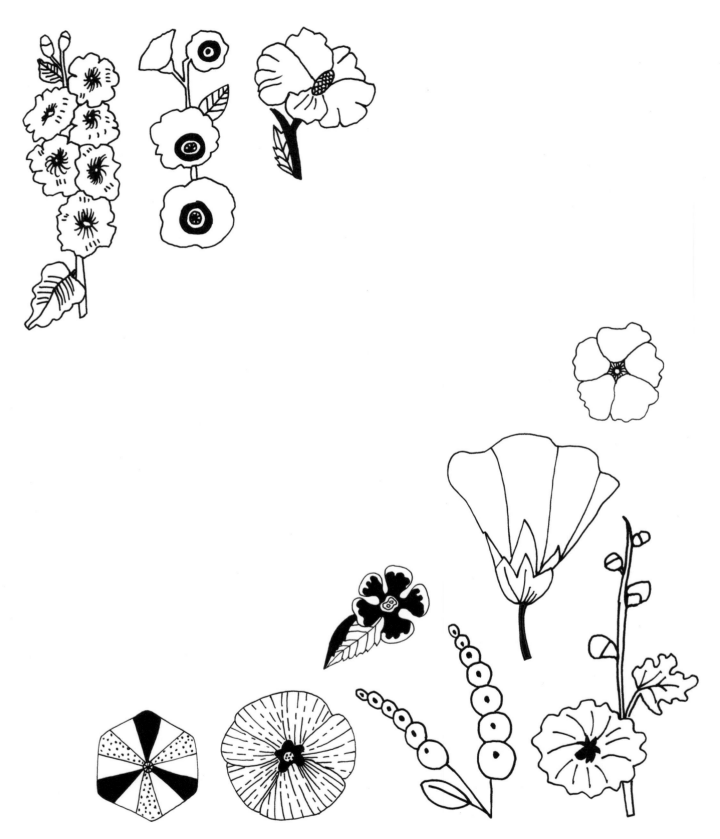

DRAW 20
Hollyhocks

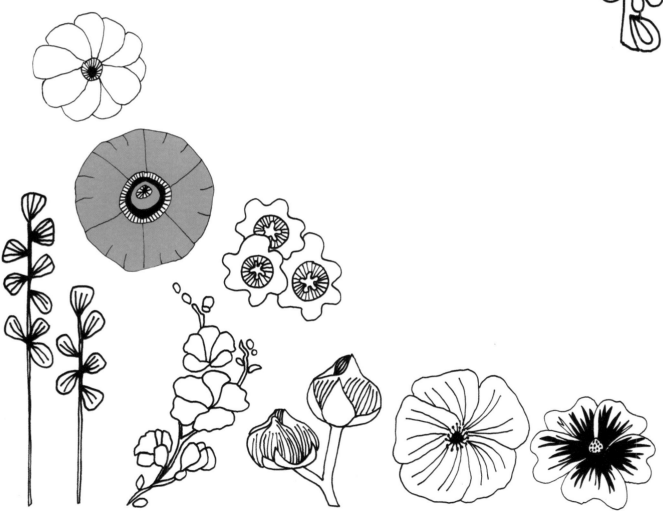

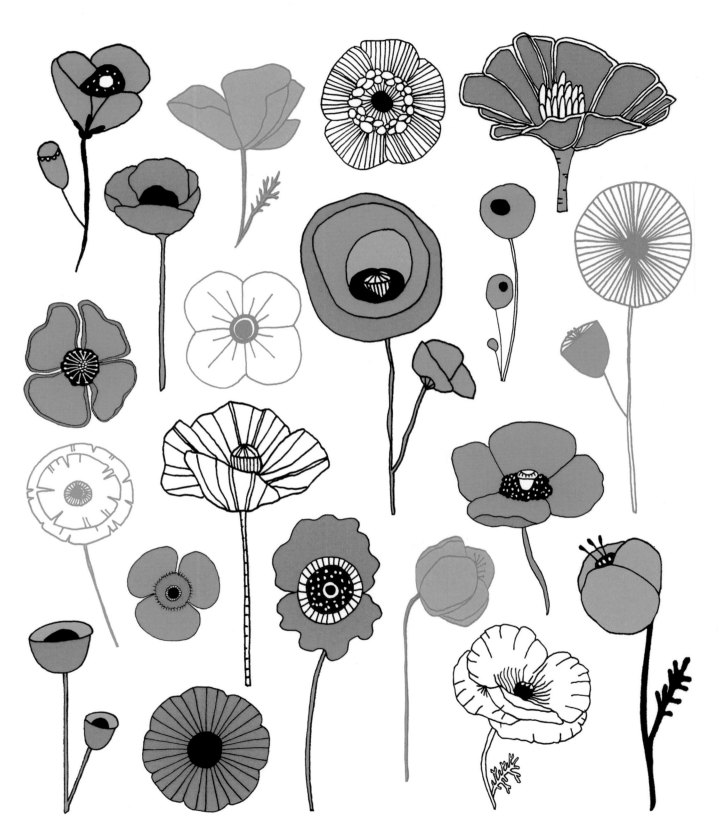

DRAW 20

Poppies

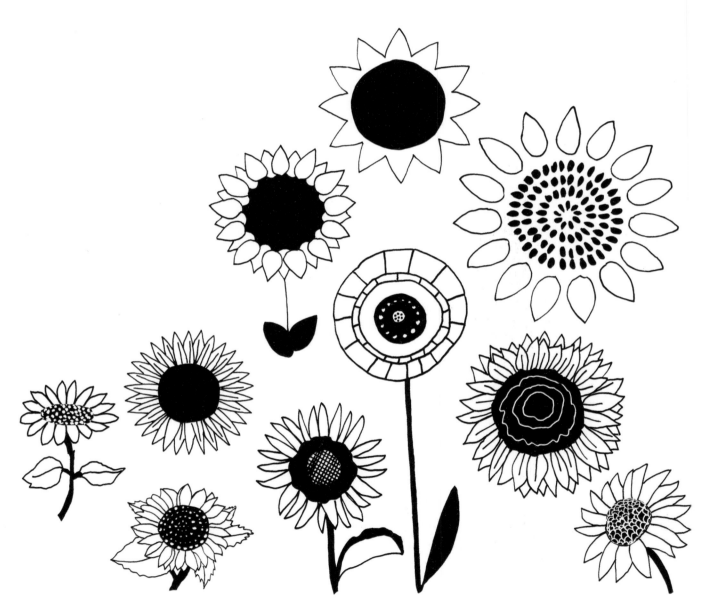

DRAW 20
Sunflowers

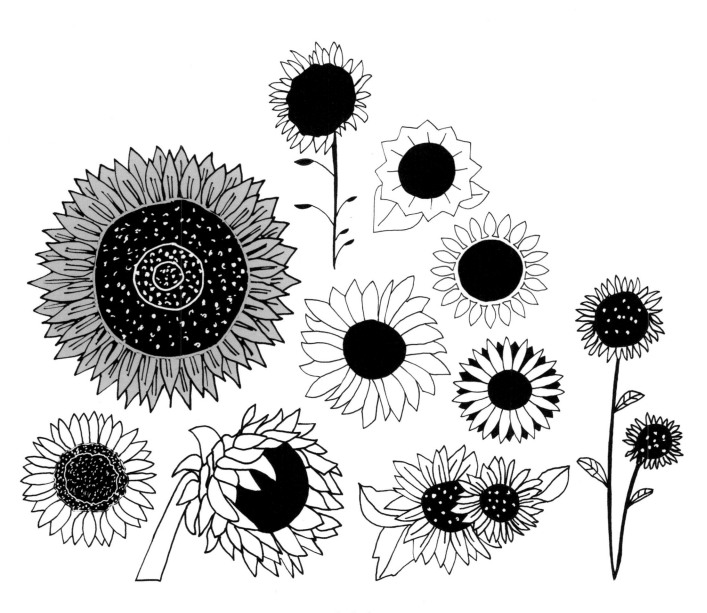

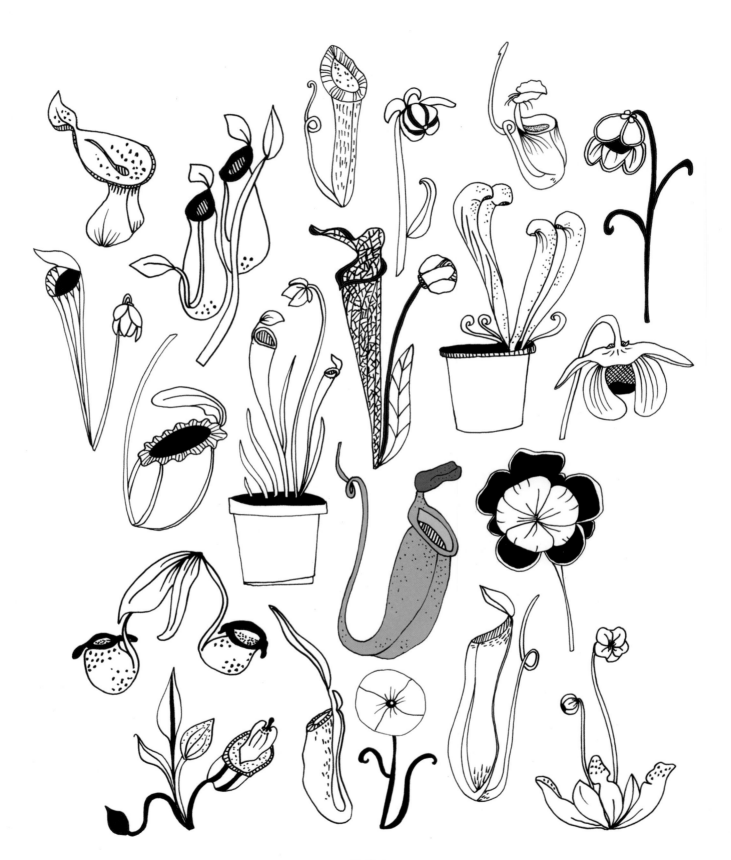

DRAW 20
PITCHER PLANTS

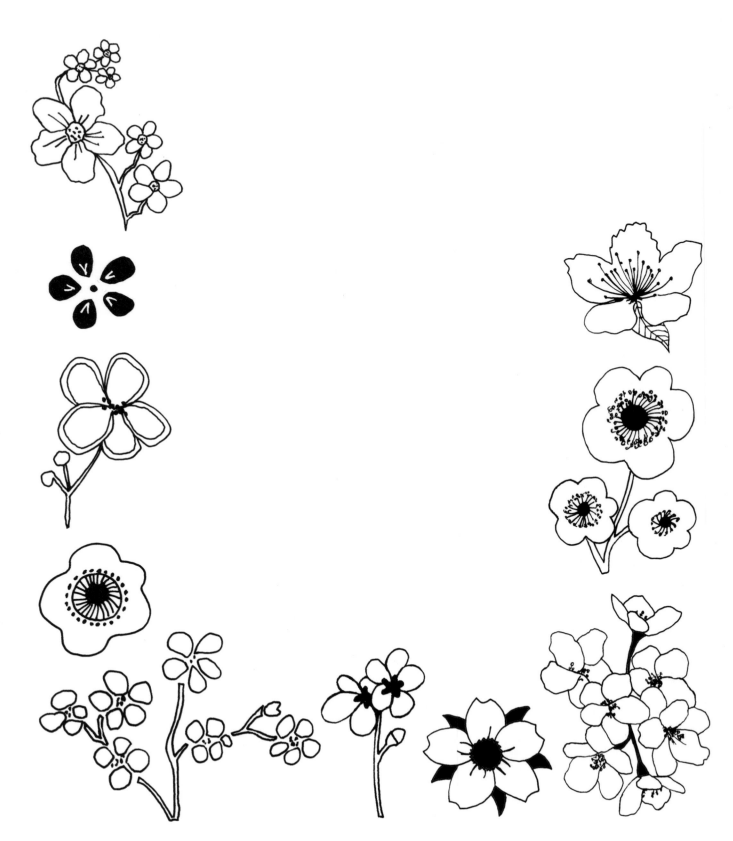

DRAW 20
Cherry Blossoms

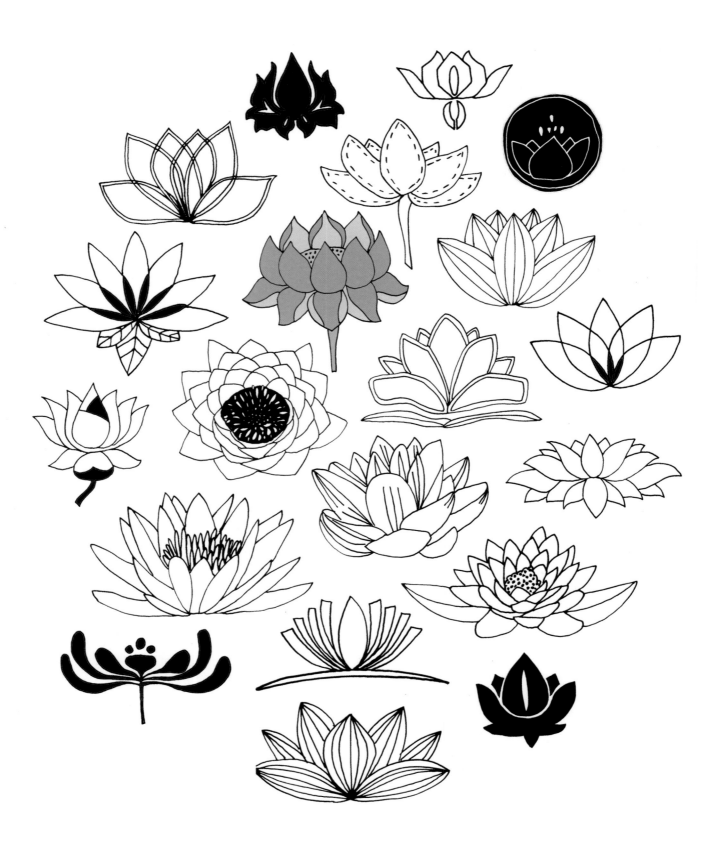

Lotus Flowers

DRAW 20
Heather

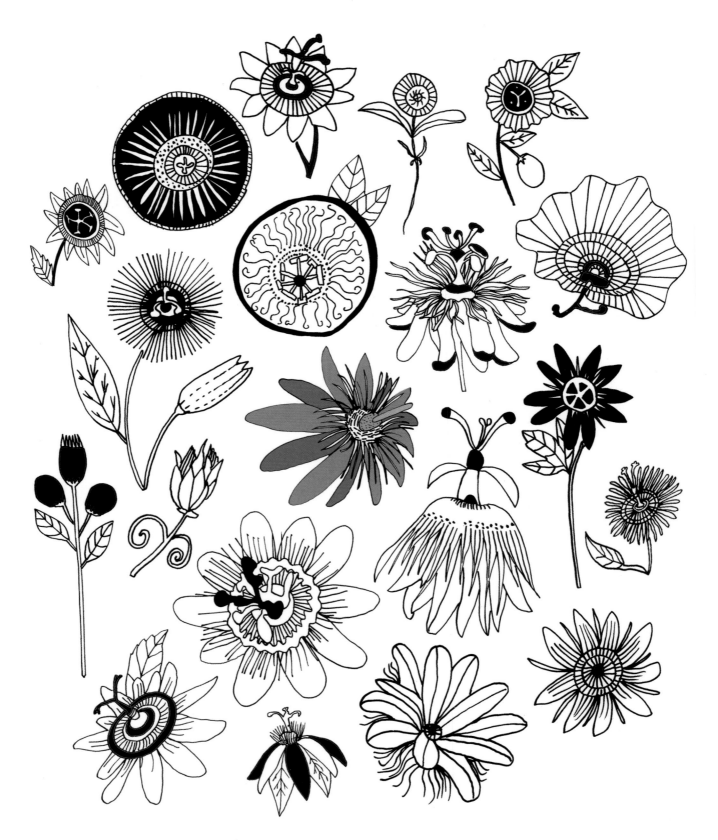

DRAW 20
maypops

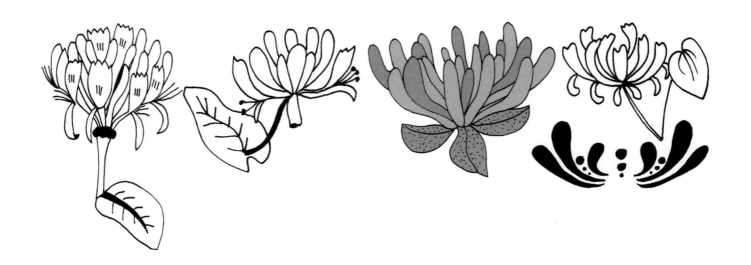

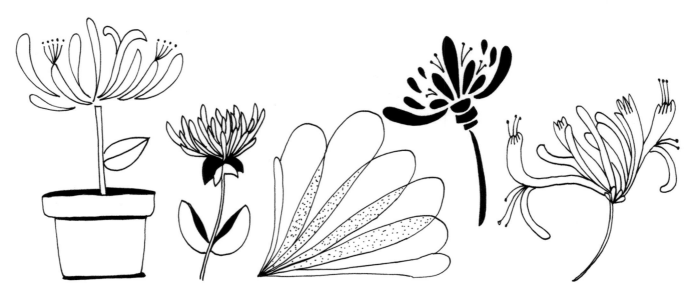

DRAW 20
Honeysuckle

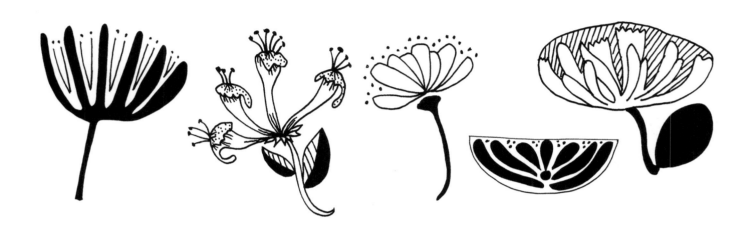

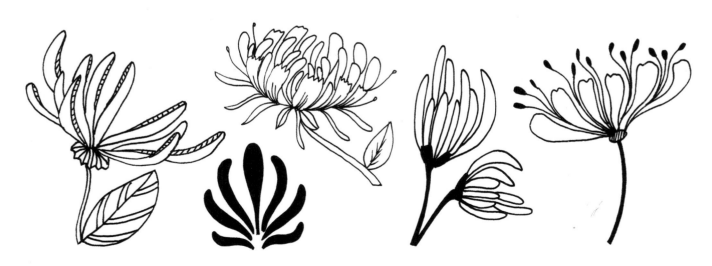

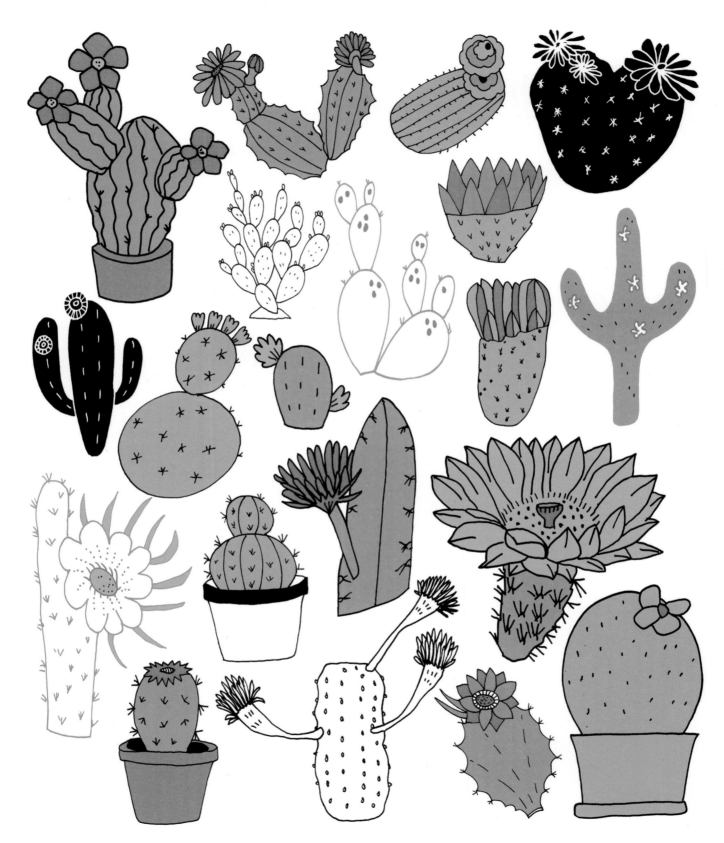

DRAW 20
CACTUS FLOWERS

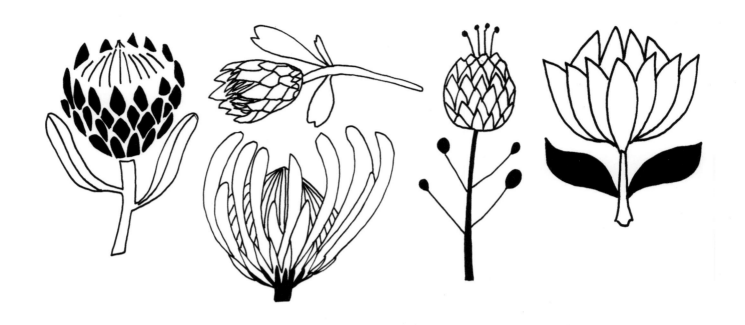

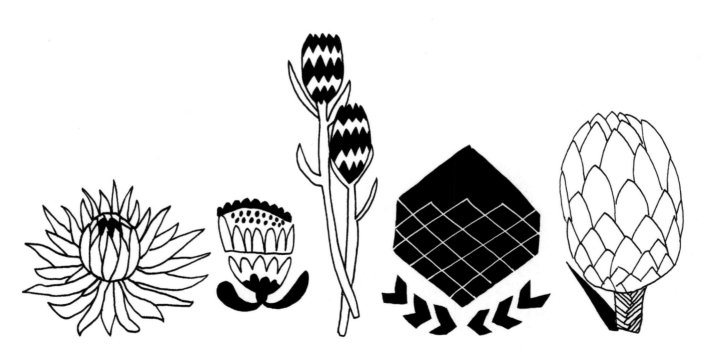

DRAW 20
Protea

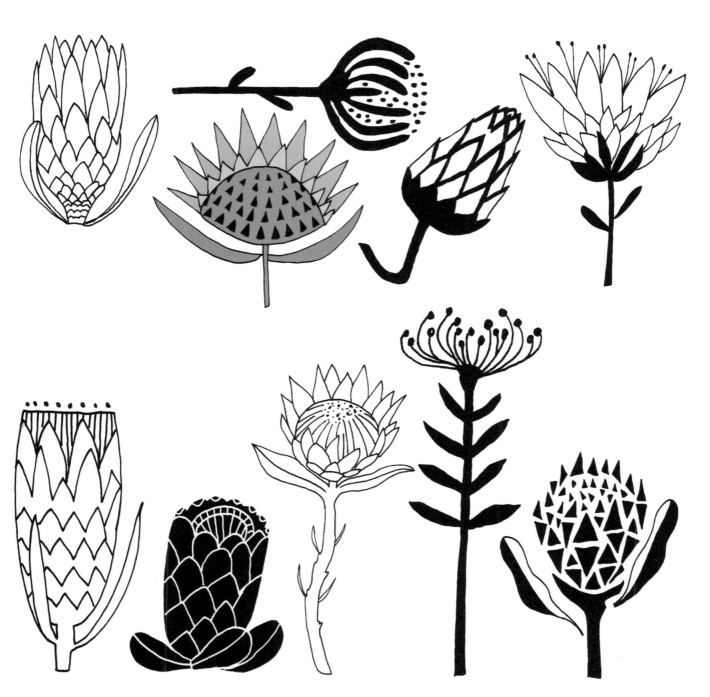

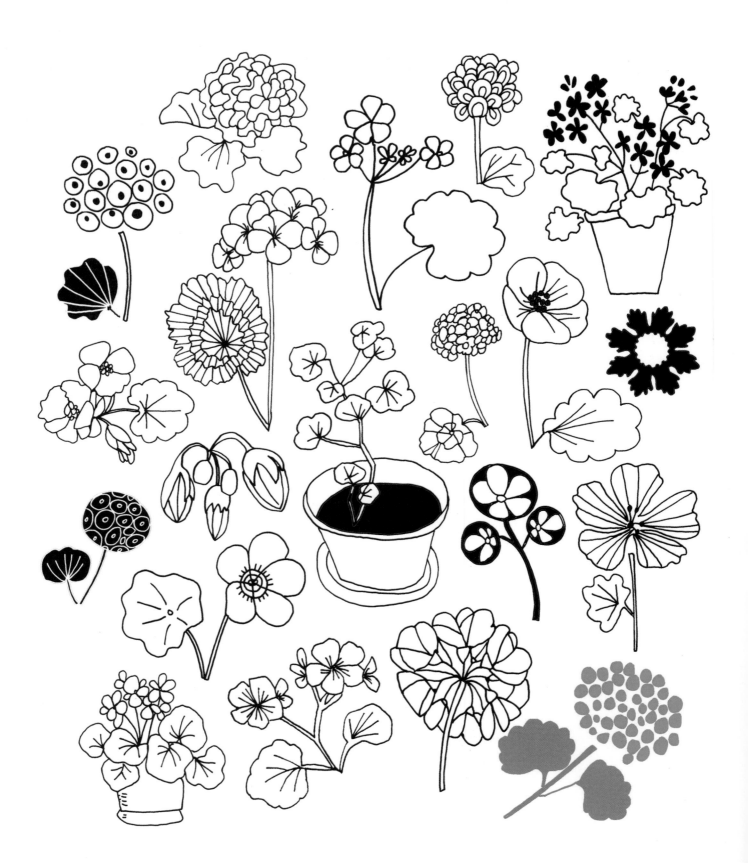

DRAW 20
Geraniums

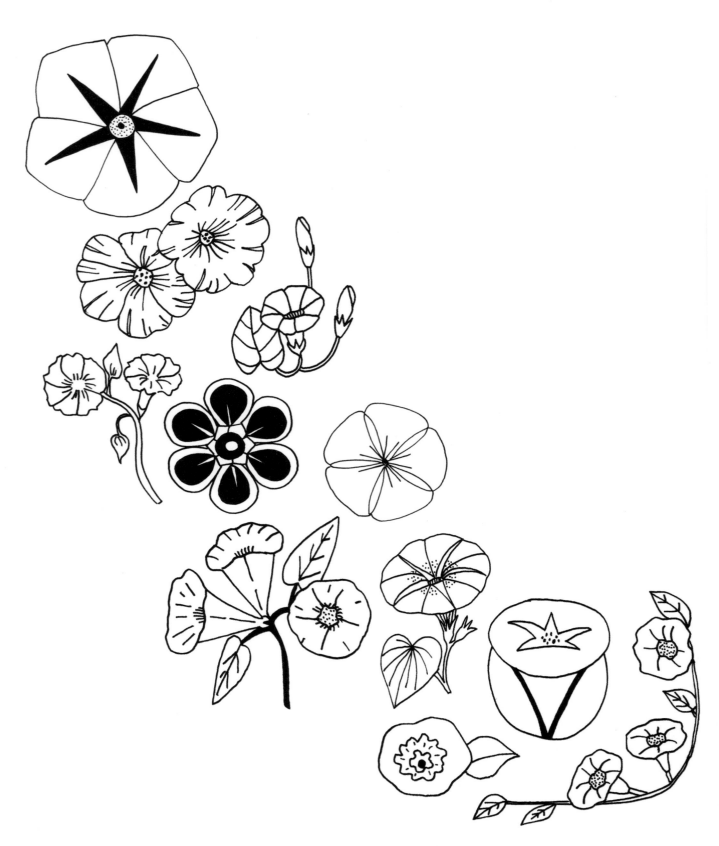

DRAW 20
Morning Glories

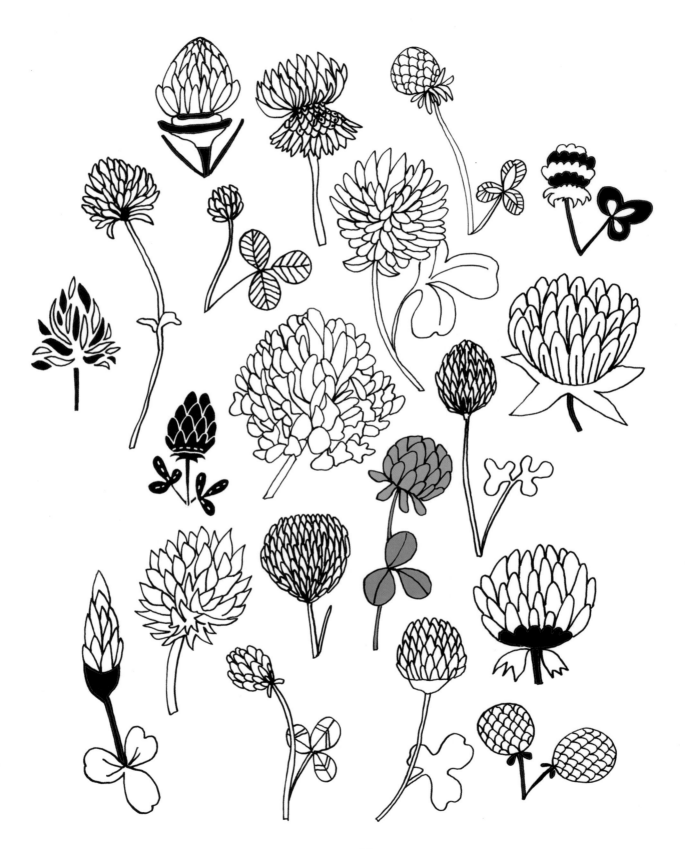

DRAW 20
Clovers

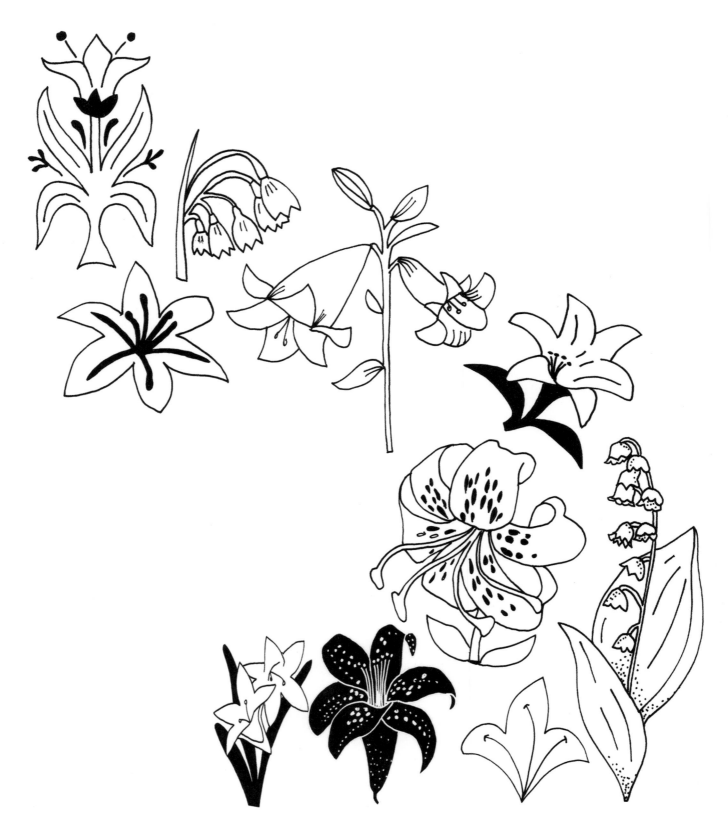

DRAW 20
Lilies

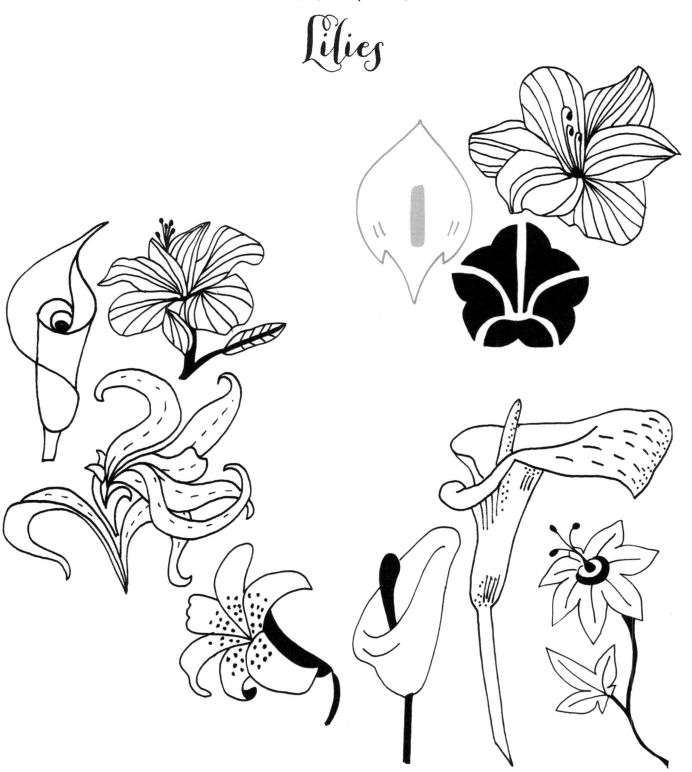

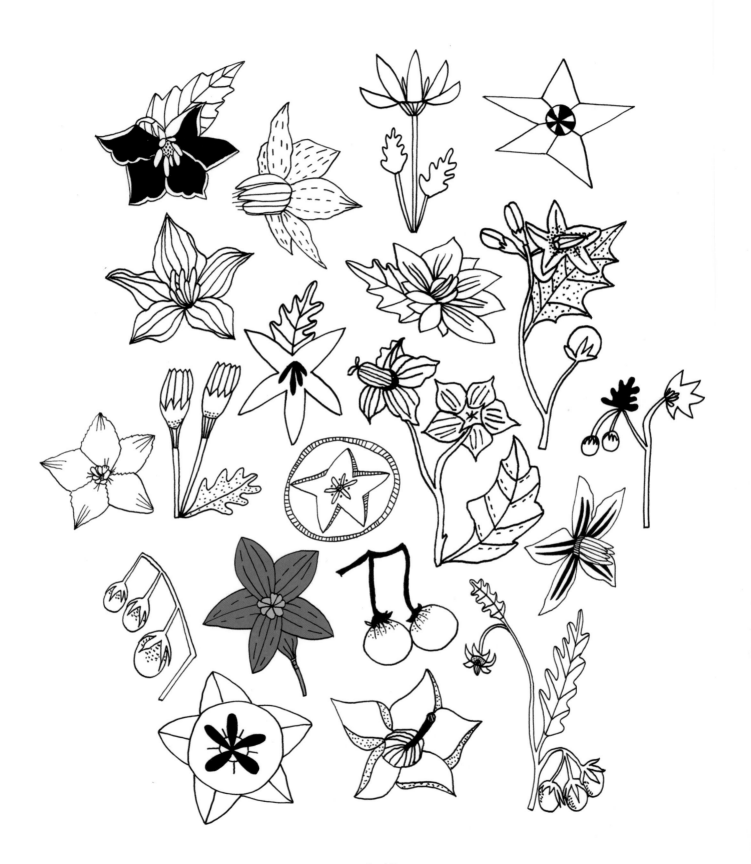

DRAW 20
Horse Nettle

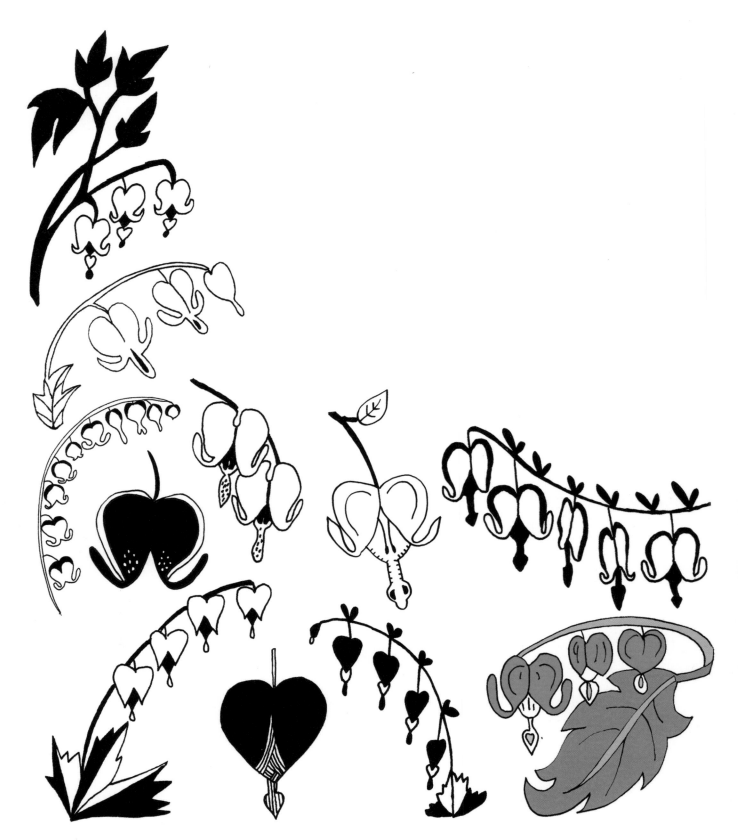

DRAW 20
Bleeding Hearts

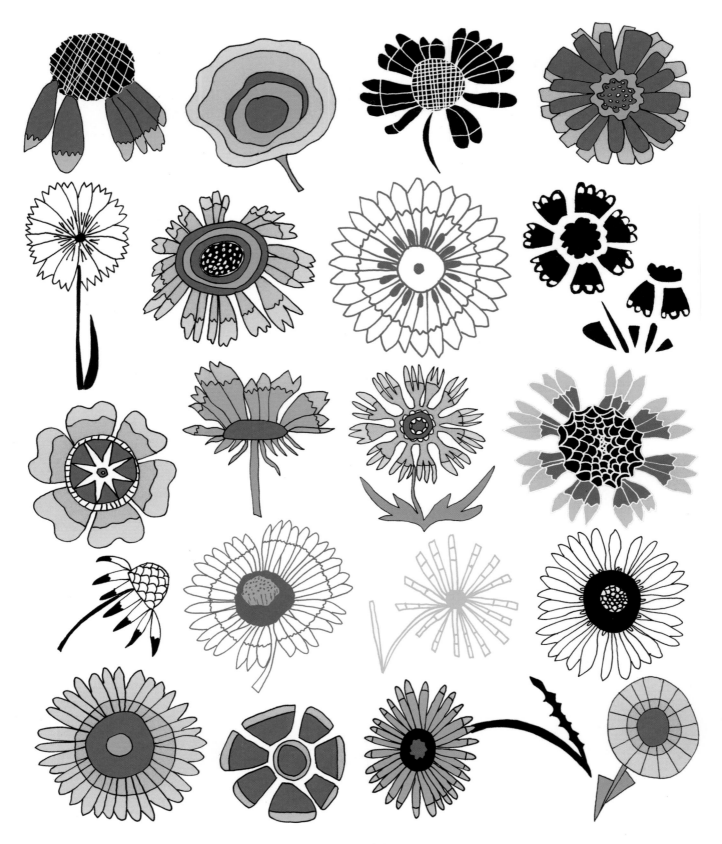

DRAW 20
Indian Blankets

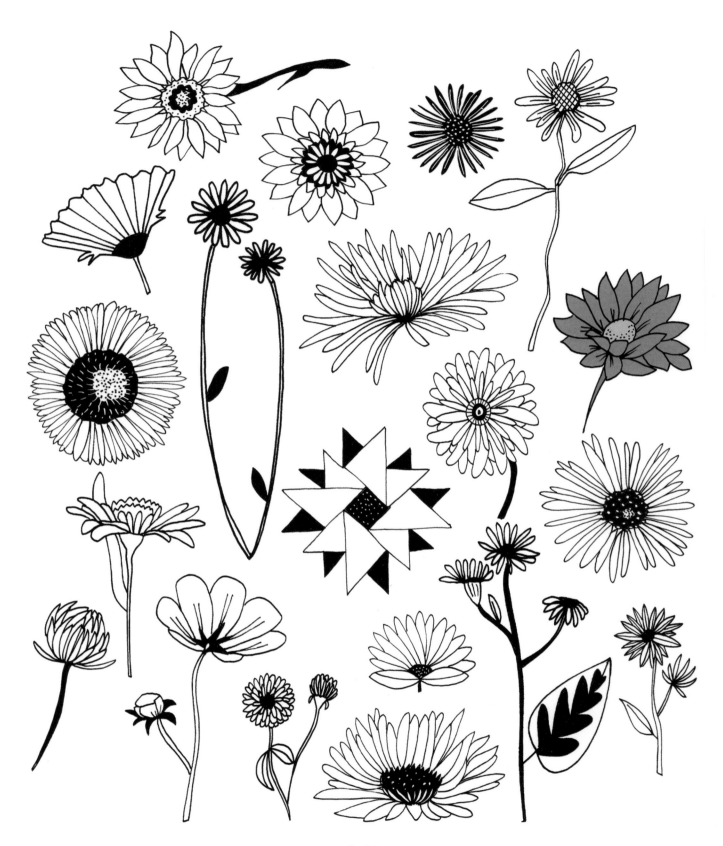

DRAW 20
ASTERS

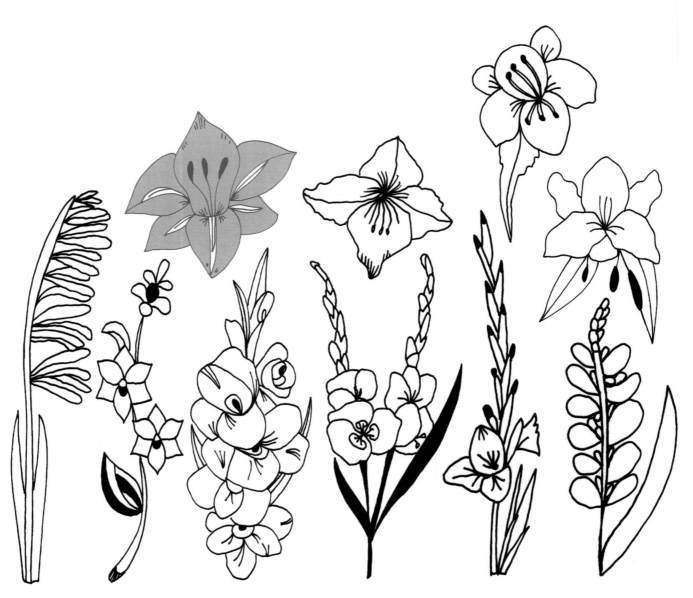

DRAW 20
Gladiolus

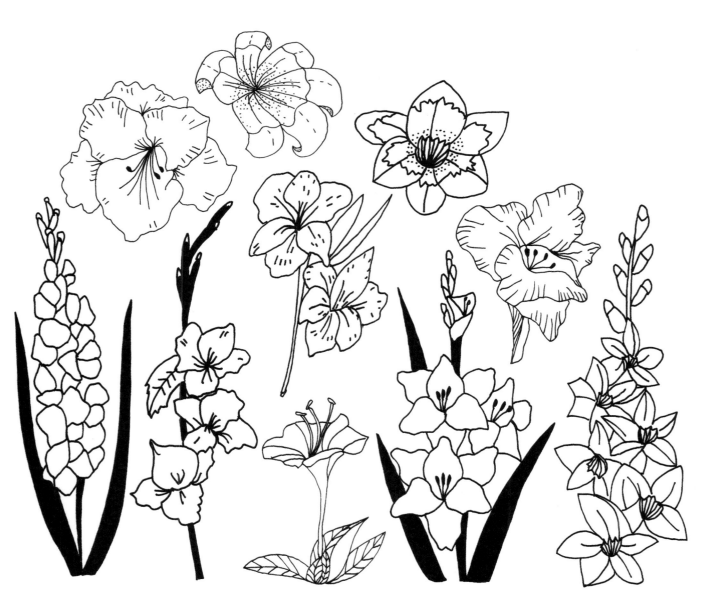

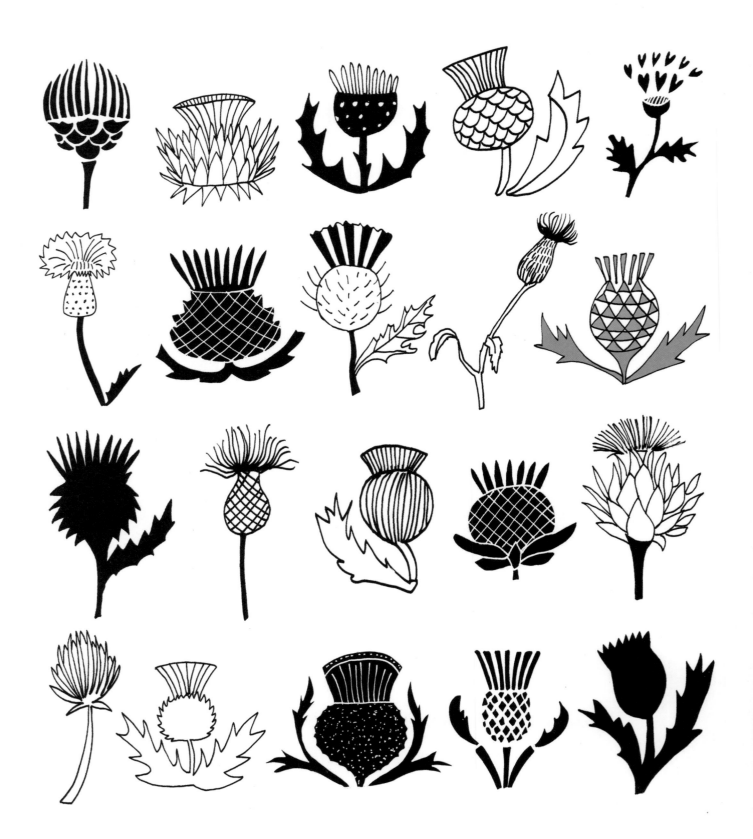

DRAW 20
Thistle

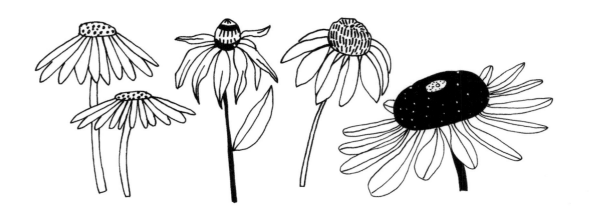

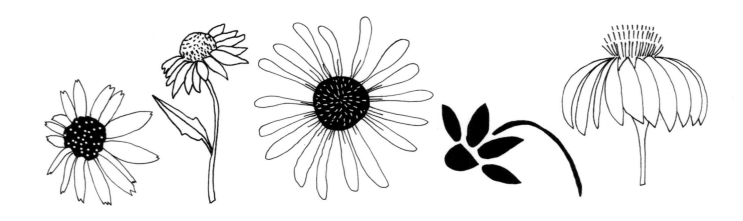

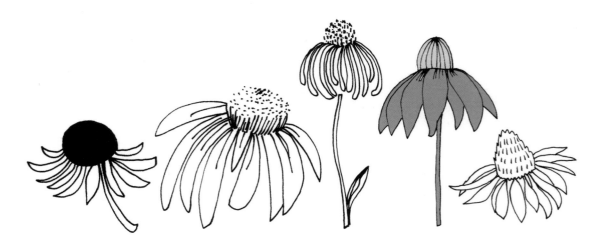

DRAW 20
Cone Flowers

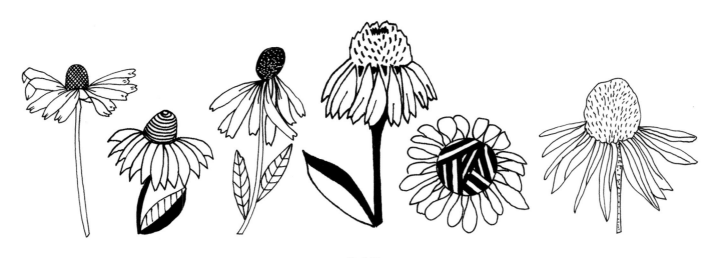

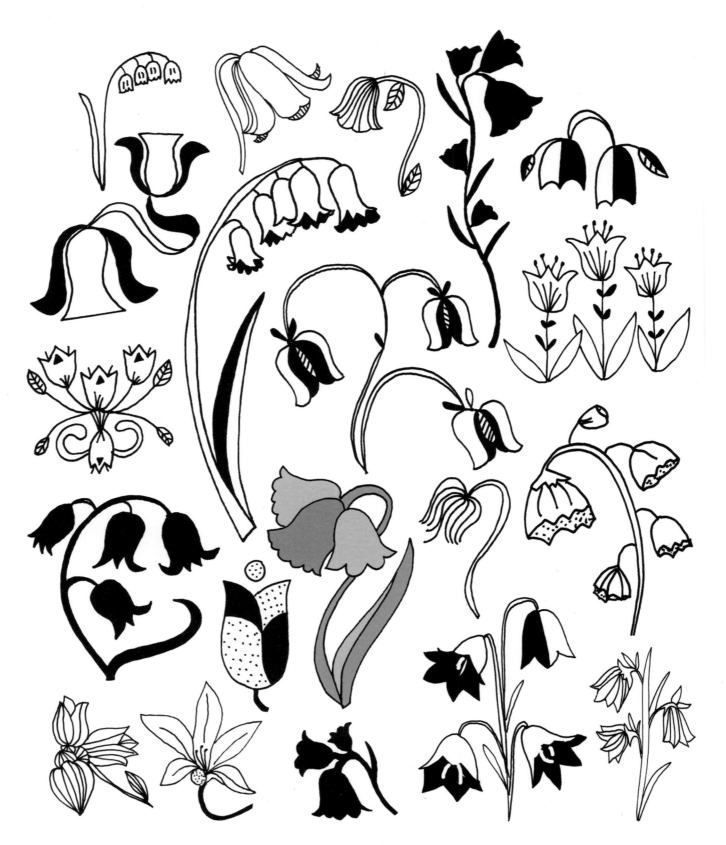

DRAW 20
Bluebells

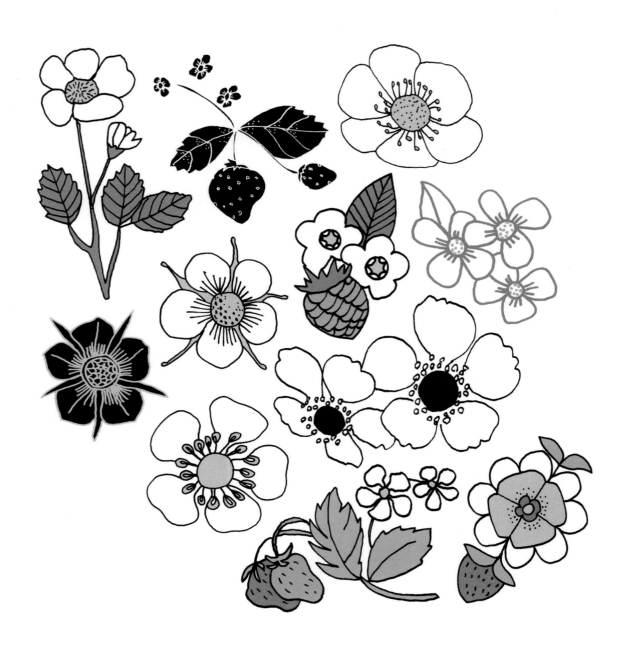

DRAW 20
Strawberry Plants

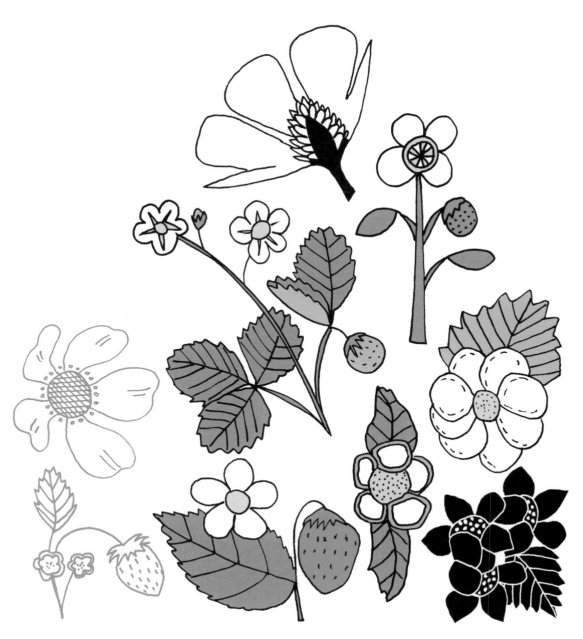

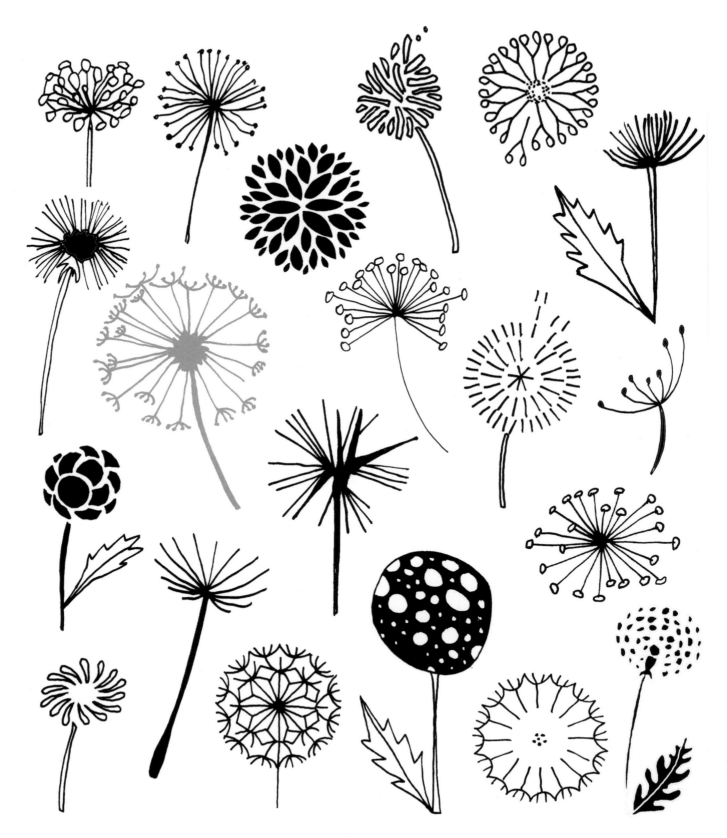

DRAW 20
Dandelions

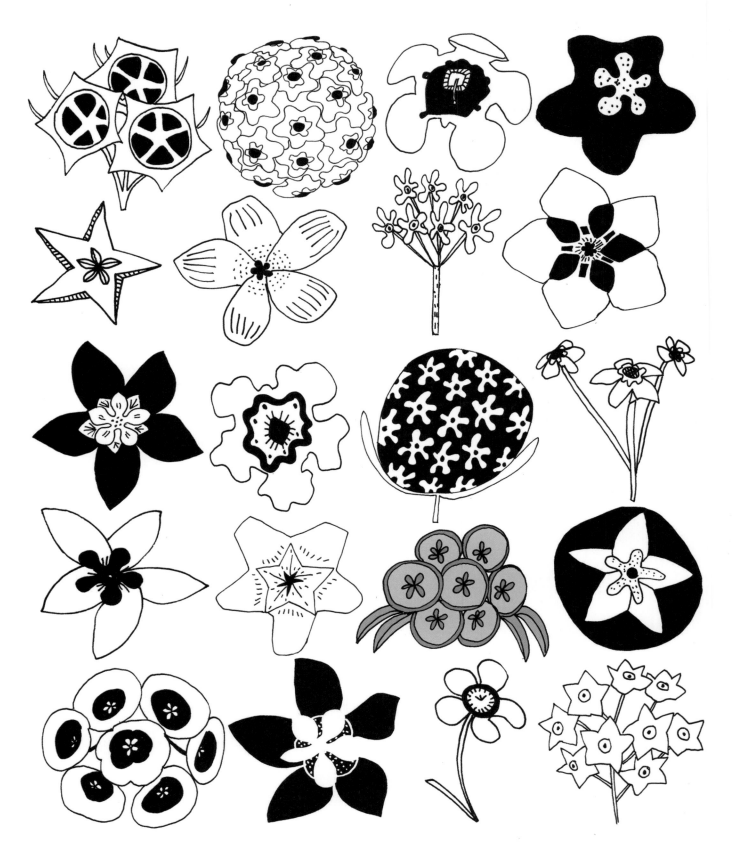

DRAW 20
WAX PLANTS

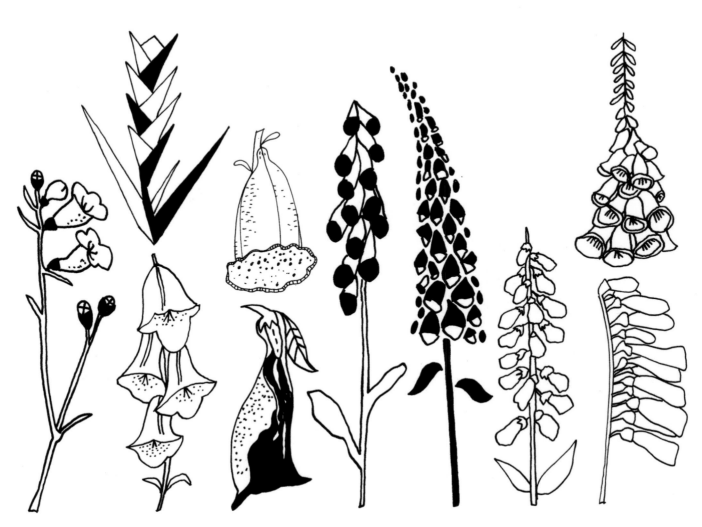

DRAW 20
Foxgloves

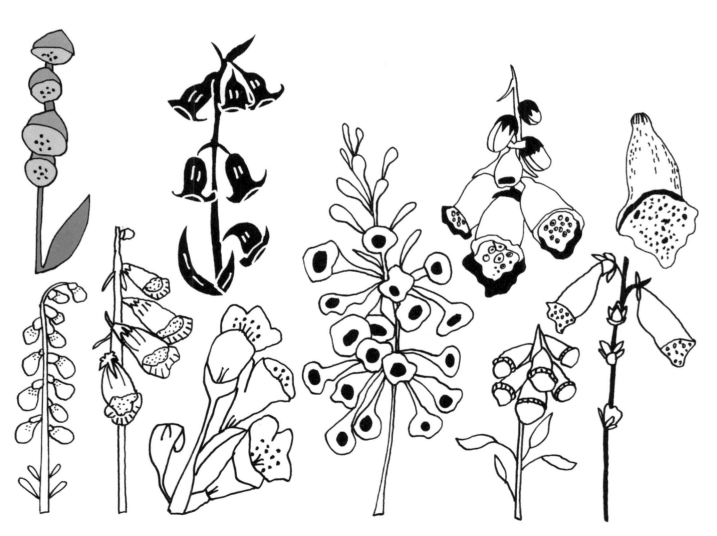

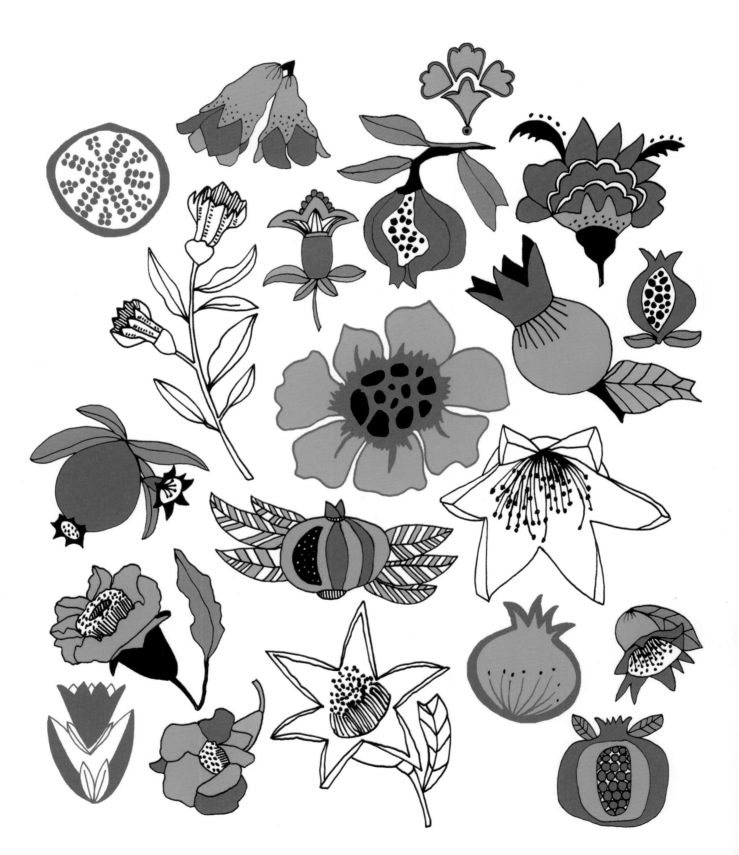

Pomegranate Flowers

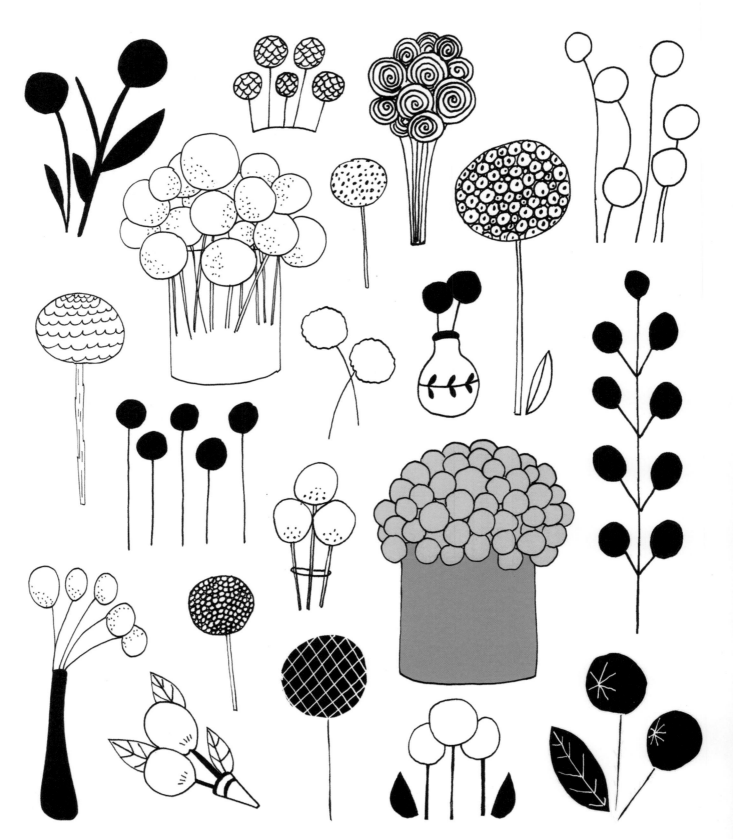

DRAW 20
BILLY BUTTONS

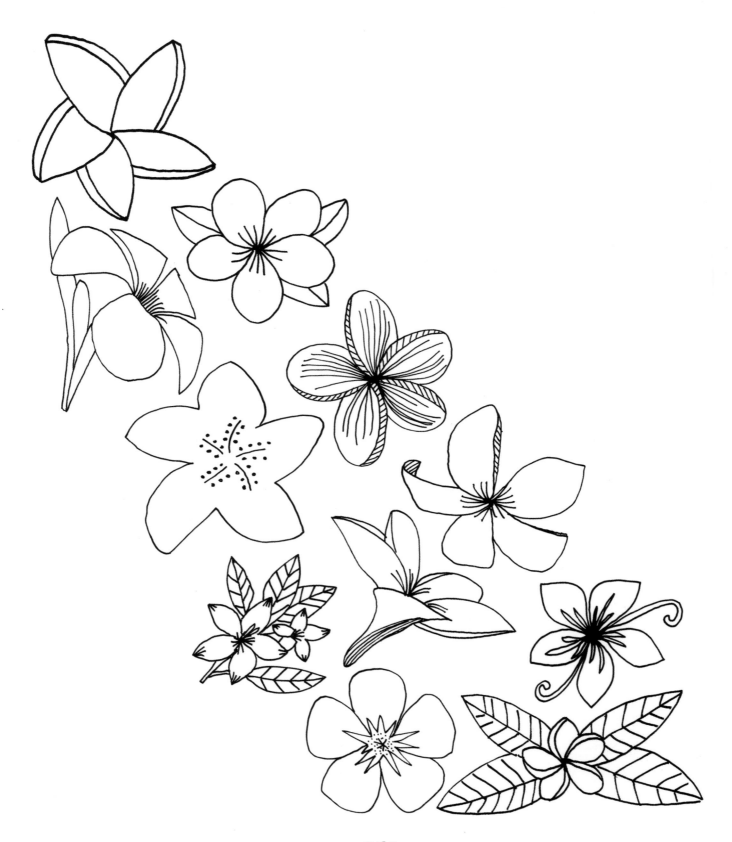

DRAW 20
Frangipani

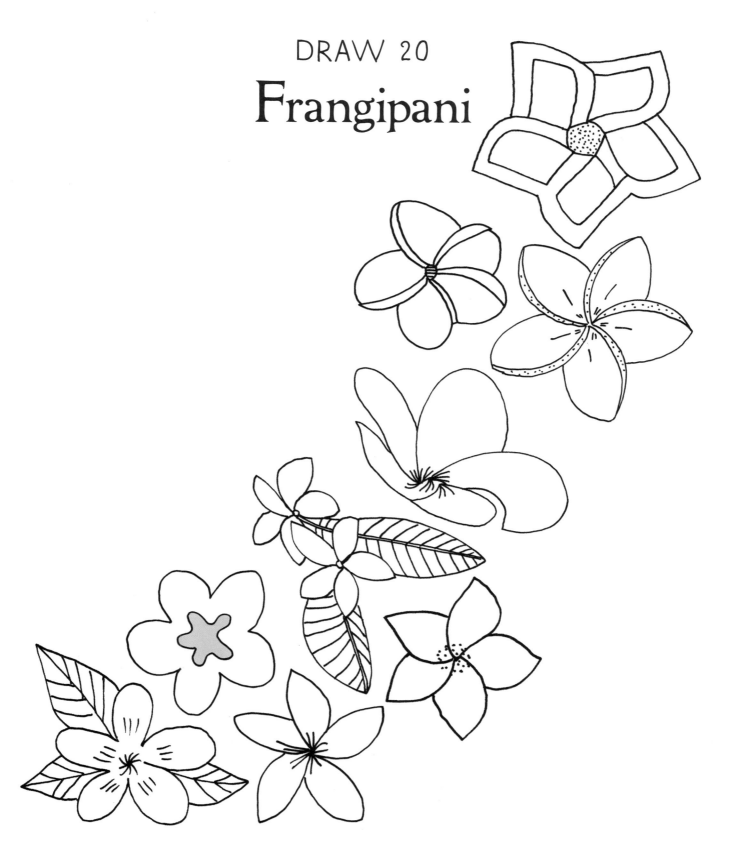

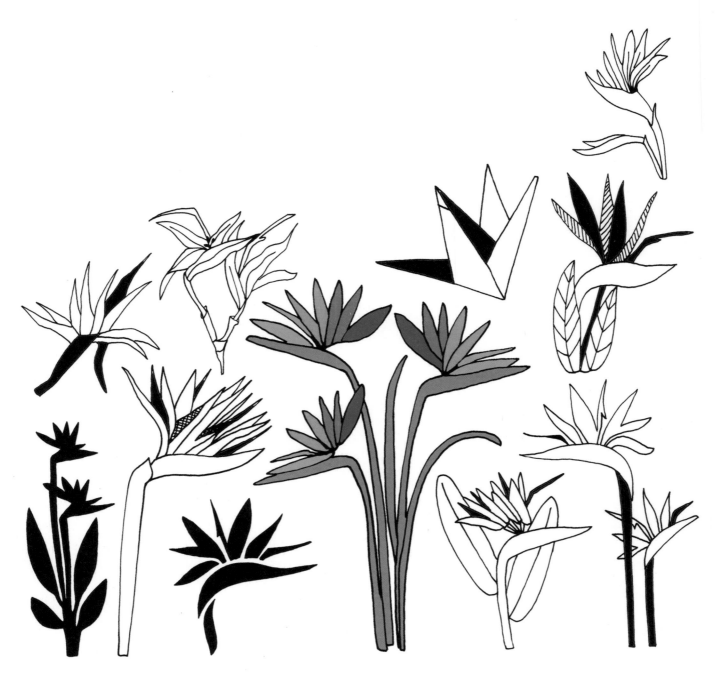

DRAW 20
Birds of Paradise

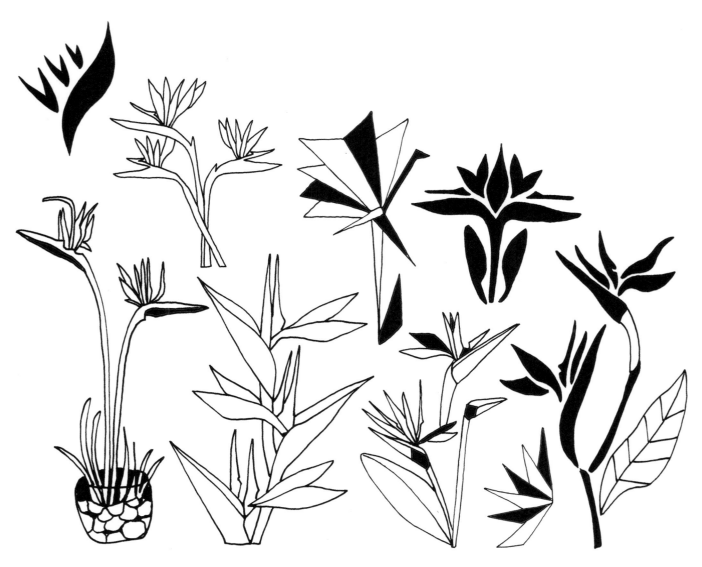

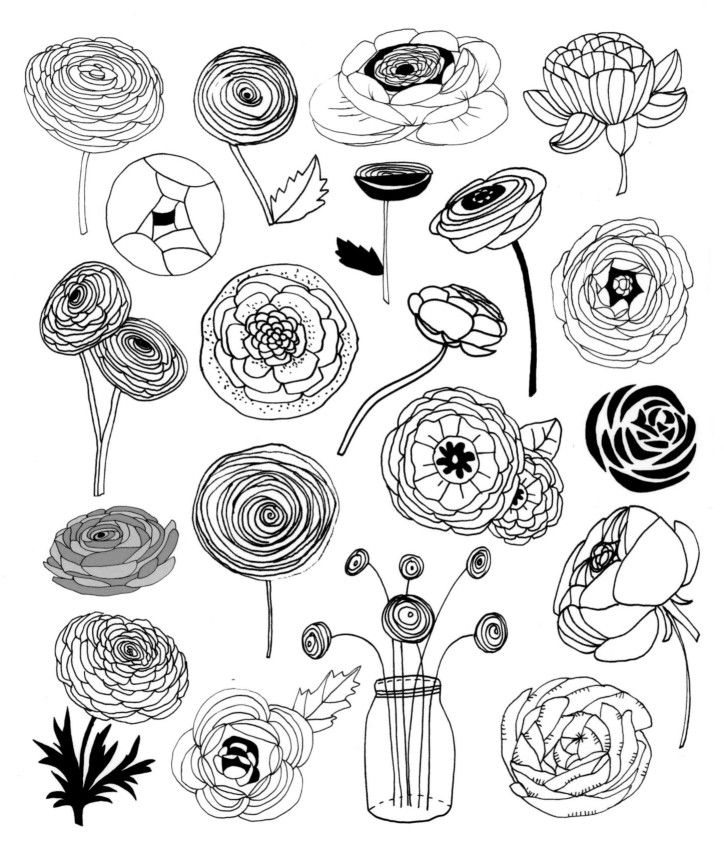

DRAW 20
RANUNCULUS

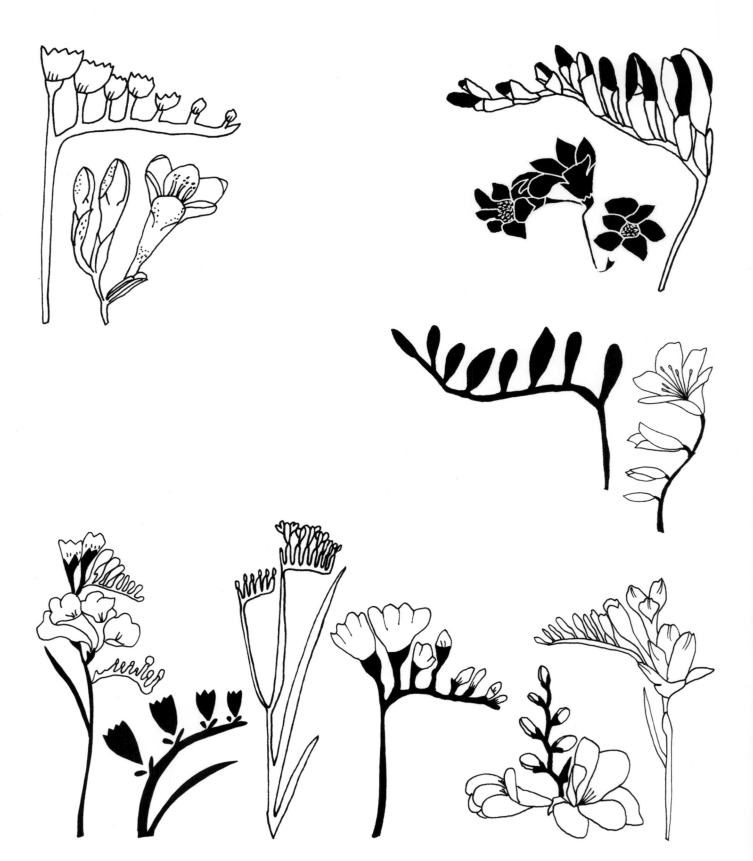

DRAW 20
FREESIA

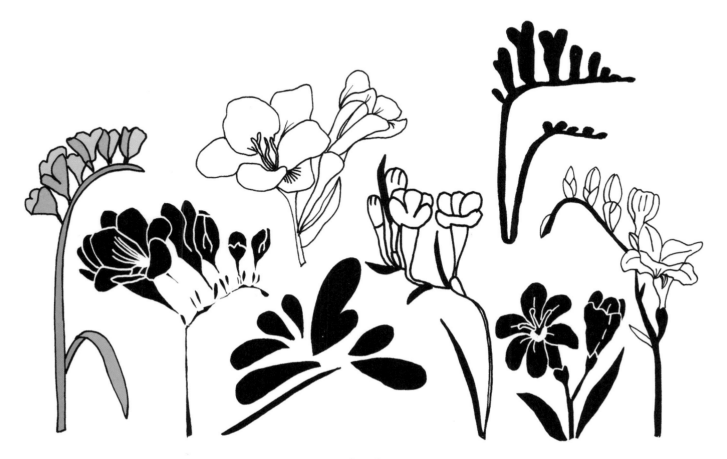

ABOUT THE ARTISTS

Fine artist and illustrator **Lisa Congdon** is best known for her colorful and detailed paintings and drawings. She enjoys hand lettering and pattern design, and keeps a popular daily blog about her work and life called "Today is Going to be Awesome." Lisa's clients include Quarry Books, Chronicle Books, Simon & Schuster, and the Museum of Modern Art, among others. She lives and works in Oakland, California. To see more of her work, visit Lisa's website at **www.lisacongdon.com**.

Julia Kuo grew up in Los Angeles and studied illustration and marketing at Washington University in St. Louis. She currently works as a freelance illustrator in Chicago. Julia designs stationery, illustrates children's books, concert posters, and CD covers and paints in her free time. One of her gallery shows featured paintings of street fashion shots from Face Hunter. Julia's clients include American Greetings, the *New York Times*, Little, Brown and Company, Simon and Schuster, Capitol Records, and Universal Music Group. She is also part of The Nimbus Factory, a collective of two designers and two illustrators specializing in paper goods. Her illustrations have been honored in *American Illustration, CMYK* magazine, and *Creative Quarterly*. **juliakuo.com**

Eloise Renouf graduated with a degree in printed textile design from Manchester Metropolitan University, UK. She worked as a fashion print designer in studios in both London and New York before establishing her own stationery company in 2000. She now designs and sells her own range of limited-edition prints and fabric accessories, whilst also undertaking commission and licensing work for homewares, stationery, and illustration. She lives and works in Nottingham, England, with her partner and three children. **www.eloiserenouf.etsy.com**

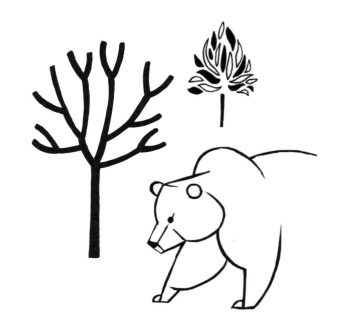

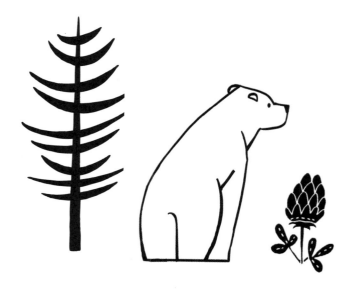

ALSO AVAILABLE

The Illustrated Emily Dickinson
Nature Sketchbook
978-1-63159-123-5

100 Things to Draw with a Circle
978-1-63159-137-2

100 Things to Draw with a Triangle
978-1-63159-100-6

The Paintbrush Playbook
978-1-63159-046-7

The Pencil Playbook
978-1-63159-058-0

The Marker Playbook
978-1-63159-125-9

The Pen & Ink Playbook
978-1-63159-124-2

Sharpie Art Workshop
978-1-63159-048-1

Dream, Draw, Design My Fashion
978-1-63159-097-9